Polly Pullar is a field naturalist, grew up in Ardnamurchan. She contributes to a wide selection of mag Scottish Field, *People's Friend*, the *Scots Magazine* and *BBC Wildlife*. She is the author of a number of books including, *A Drop in the Ocean: Lawrence MacEwen and the Isle of Muck, The Red Squirrel – A Future in the Forest* and co-author of *Fauna Scotica: Animals and People in Scotland*.

Sir John Lister-Kaye is an acclaimed naturalist, writer and lecturer who is also Director of the Aigas Field Centre in the Scottish Highlands. His books include *Nature's Child: Encounters with Wonders of the Natural World, At the Water's Edge: A Walk in the Wild* and *Gods of the Morning: A Bird's Eye View of the Highland Year*, which was awarded the inaugural Writer's Prize by the Richard Jefferies Society in 2016.

A RICHNESS *of* MARTENS

*Wildlife Tales from
the Highlands*

POLLY PULLAR

BIRLINN

This edition first published in 2020 by
Birlinn Limited
West Newington House
10 Newington Road
Edinburgh
EH9 1QS

ISBN 978 178027 636 6

British Library Cataloguing in Publication Data
A catalogue record for this book is available from the British Library.

Designed and typeset by Initial Typesetting Services, Edinburgh
Printed and bound by Clays Ltd, Elcograf S.p.A.

For Freddy and Iomhair,
and Les and Chris's family – Tim, Kathryn, Chas,
Lizzie and Struan

Contents

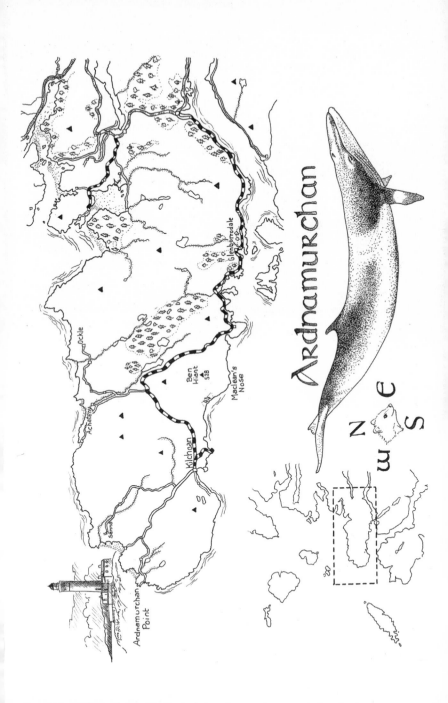

Acknowledgements

I would like to thank the many people who have helped me, both directly and indirectly, to write this book. Firstly, Sue and Dochie Cameron. Not only did Sue introduce me to Les and Chris Humphreys, but over many years she and Dochie have provided me (and the collies) with a wonderful haven where I can write in peace. I would also like to thank Dochie for lugging in a table on each of my visits to Ockle for use as an all-important desk, and both him and his brother Dougie for dealing with water, electrics and various other domestic snags caused by the weather, or the mice!

Thanks also to my son Freddy and my partner Iomhair for unstinting support and understanding. To John and Lucy Lister-Kaye, whose work at the world-renowned Aigas Field Centre provides constant inspiration, and in particular to John for the lovely piece he has written to open my story. To Sharon Tingey for her sensitive illustrations and patience with an ever-changing remit. To wildlife photographer Neil McIntyre for the book's front cover photograph. To Rob and Becky Coope for their input and valuable friendship. To Jim Crumley, wildlife kindred spirit with whom I often discuss our shared concerns for the future of the natural world. To Colin Seddon and Romain Pizzi, whose tireless wildlife work is inspirational and makes so much difference. To magazine editors Angela Gilchrist, Robert Wight and Richard Bath for giving me endless scope to write about what I love best. To Evelyn Veitch, who cares so beautifully for our burgeoning menagerie during my absences from home. To Dr Debbie Shann, who will understand why. Special

thanks to Kevin and Jayne Ramage, and Sally and Dorothy of the Watermill Bookshop, Aberfeldy, for continual support and enthusiasm with literary ventures various. Special thanks also to Andrew Simmons of Birlinn, who is always such a pleasure to work with, and copy-editor Helen Bleck, who has also been a joy as well as an invaluable help. And of course to my publisher, Hugh Andrew, and the rest of the team at Birlinn.

None of this would have come about without the extraordinary dedicated input and patience of Les and Chris Humphreys themselves, who have put up with endless queries and cajoling from me, and sifted through reams of video footage and diaries to confirm information. They have been delightful to work with, and I want to thank them for all they have done and for trusting me with their extraordinary story.

And, finally, Les and Chris would like to thank Sue and Dochie, and Liz and Sandy for all their help and support over the years.

Polly Pullar
May 2018

FOREWORD

The pine marten – a personal view

There is blood on the snow
and a trickle of rowan berry juice

on his bib where the pine marten
stands for a moment like a man.

<div align="right">

from 'The Pine Marten',
by David Wheatley

</div>

Just a memory now, fading but still there. That first glimpse, that splash down into realisation that such a creature still existed. I'd like to be able to say that it was just so, in such-and-such a place, precise and named. A moment so electric and unforgettable that even after all these years I could still tell you when – the year,

the month, the day. I'd like to boast that it spun me into instant
awareness or understanding, or love or obsession, or something
– that it's permanently branded. But no, I'd be lying. It wasn't
like that at all. It was a moment fogged with doubt, even dis-
belief – could it be . . . ? Was that a . . . ? Have I just seen . . . or
am I fooling myself? Perhaps it was a just a cat.

It was so rare back then, rarer than a wildcat and as rare a
sighting as an osprey – that now-much-cherished, cream and
mocha fish-eagle gamekeepers had blasted to the brink of legend
because ospreys had the temerity to eat salmon and trout. That
was the way of things in those days, a relentless, focused perse-
cution of any raptor and any carnivore, a tyranny almost never
challenged. And no one seemed to care. The marten had gone
the same way. After centuries of being hunted by Highlanders
for their glossy, mink-like fur, when Victorian gentry refash-
ioned the Scottish Highlands into a preserve for red deer,
grouse and salmon, and gamekeepers were appointed as armed,
over-zealous warlords to patrol and terrorise their vast upland
estates, all predators were outlawed. Martens were poisoned,
shot and taken with that most vicious of cruel weaponry, the
tooth-jawed gin trap. A singular and determined extirpation
was the only goal. That is why they became so rare. They were
clinging on – just – by a claw and a whisker, and then only in
the remotest mountain wilds.

So not so surprising that I couldn't believe my eyes, couldn't
be sure that I had seen right. But it was. A furry dash across a
twilit, single-track road somewhere up a glen – and I can't even
remember exactly which glen. And then nothing. It had van-
ished into an ocean of impenetrable broom and gorse. I stopped
the car, reversed back, waited, got out, ran forward, ran back,
willed it to show again. Nothing. It had gone. But I knew in
the marrow of my bones that I had glimpsed one of Britain's
rarest mammals – *Martes martes,* a pine marten, the most agile

and beautiful of the British mustelids, the weasel family. That second-long sighting had hoiked it back from literary obscurity. No longer was it just a name on a page or a blurry photograph in a book, as remote and impersonal as an ad on a hoarding. I had seen it in the flesh for myself. It had lived and moved and, for the blink of an eye, it had shared with me its agile, lissom, Bournville being.

That was then: some time back in the 1960s, when much of the Highlands was still a frontier of windswept, echoing emptiness. In the nineteenth century many of its people had fled to the New World or to southern cities for jobs, peeling away from the glens like blown leaves, a diaspora continuing well into the twentieth century, horribly compounded by two world wars. Many thousands of Highland men and boys never returned, leaving their pocket-handkerchief fields and tumbledown cottages to the sheep and the crows. As always happens when you give nature half a chance, wildness had come clambering back, filling the vacant niches, shouldering in with what biologists call 'succession', a land- and a hill-scape silently returning to the solace of its own flowers and trees and shrubby scrubland, its own bugs and bees and secret habitats. For centuries razed by half-starving Highlanders and their livestock, the hills and glens were once again going wild.

Then in the 1970s commercial forestry motored in, ring-fencing whole valleys and deep ploughing the moors for Sitka and Norway spruce plantations. It became a craze — a plague even — transmogrifying entire landscapes into the coniferous uniformity of cornfields as far as the eye could see. Yet, in the way that an ill wind blows nobody any good, those deep, unsightly furrows broke through the blanket peat and iron pans to provide a turnover of nutrients that allowed weeds and other nutritious plants to burgeon. That new growth fostered a brief population explosion of voles, essential food for hen harriers,

barn owls, kestrels, wildcats, foxes and yes, pine martens, all of which enjoyed a short-lived bonanza. As the young conifers established to the thicket stage, no longer able to hunt, the birds drifted away, leaving only an ever-darkening sanctuary for the previously persecuted wildcats and martens.

A decade slid past and those dark Sitka forests yielded up an expanding population of pine martens, unseen, uncounted and unstoppable. That is what happens when you give nature half a chance. The species was clawing its way back from the brink, accidentally rescued by one of the most extensive land-use transformations to storm across the uplands in centuries. But as the conifer canopies closed off the sunlight and the field layer of plants died away, so did the voles. By the 1980s martens were still able to exploit dark forests for safety, but were forced out into the wider man-occupied landscape for their food.

It was during those years that we established Aigas Field Centre in Strathglass. We didn't know it at the time, but that happy resurgence of pine martens was occurring right on our doorstep, in our woods and other people's woods up and down the glen. Eventually, by 1982, a bitch marten had whelped in the roof of an abandoned shed beside the Aigas Lodge cottage. Four enchanting kits entertained us that summer, popping up on bird feeders and delighting our guests. It would prove to be the beginning of a long and happy symbiosis, the martens enjoying our protection and our visitor numbers increasing year on year, as we became known as one of the few places in Scotland where martens could reliably be seen. We built a hide. To this day at Aigas every summer many hundreds of people enjoy close encounters with this special mammal.

To suggest we've become blasé is wrong. We never tire of seeing pine martens. I have long since lost count of the individual animals I have known over the years, literally dozens, but it never palls. We see them at night from the floodlit hides,

and we meet them face-to-face about the estate all the time. We never know where next. It could be in a stable or a barn, skipping along a balcony rail outside the guest accommodation, checking out the hen run in the early morning, or nipping cross a roof in broad daylight.

★ ★ ★

It is the 15th of September and the cycle of our field centre year is almost complete. Today dawned calm, chill but not cold, and as fresh on the cheeks as a splash of cologne. These fleeting moments of the autumn are among those I cherish most. Before the equinoctial gales sweep in from the west and night temperatures crash to ground frosts that sugar the morning lawns, there are great riches to celebrate. The mysterious world of fungus shows its hand. Fruiting bodies emerge from nowhere, bursting out of tree trunks or levering the earth aside mole-like to surface and spread their delicate gills and pores. Eugenia, the centre's creatively inspired cook, heads off into the birch woods with a trug over her arm and a broad cep-and-chanterelle grin herding her cheeks up under twinkling eyes.

She is also to be seen emerging from a thicket or from under a hedge, hair in knots and tangles as wild as the undergrowth where she has been harvesting nature's free fruits. As the first streaks of colour creep into the foliage, as the bracken turns to rust and the deer-grass, *Trichophorum cespitosum*, the common, wiry grass of the uplands, lends a ginger wash to our hill ground, so the branches of every rowan tree are drooped with tight clusters of scarlet berries as blazing as a harlot's lipstick. Eugenia will collect baskets of them to boil down and render into rowan jelly, a mildly tart accompaniment for venison, other game such as grouse, woodcock and duck and, best of all, with good old-fashioned mutton. She will produce dozens of jars of the bright

orange-pink jelly, a supply to keep us going all year. In a week or two these trees will be stripped bare by migrating thrushes, fieldfares and redwings from Scandinavia, undulating across our hills and glens in their tens of thousands, but for now they attract another unusual marauder, as well as Eugenia.

No one expects a carnivore to have a passion for fruit, especially not a fruit that appears to be so unpalatable. To the human tongue rowan berries are almost impossible to eat raw. The soft red flesh produces a bitterness as sharp and dry as a crab apple, with so sour and grimacing an after-taste it leaves your soft palate cringing even when you have quickly spat them out. No one in their right minds would eat rowan berries off the tree. For Eugenia's jelly they need to be boiled down, the seeds strained out and then oodles of sugar and the same quantity of cooking apples added before the bittersweet juices coagulate into a surprisingly delicate and piquant flavour.

No such refinement for the pine marten. He takes his berries raw off the tree – and he gorges on them every September. We don't really know why this is, but it seems likely that they are a rich source of vitamin C, which may be lacking in their diet if other mammal prey species, such as field voles, are in short supply. Pine martens are omnivorous despite their pointedly carnivorous dentition. It is well known that peanuts and strawberry jam will attract them to bird tables, and they consume large quantities of blueberries and blackberries as well as other fruits.

On our bird tables I have tempted them with many delights: rhubarb crumble, apple pie, fruit cake, roast potatoes, baked beans and much more. They take the lot. Once in a week of vicious winter frost I took a hunk of stale fruitcake out for the starving blackbirds to pick at. No sooner had I turned away than a marten popped out from under a bush, leapt up onto the table, grabbed the entire hunk and made off with it back into the undergrowth, all while I was still standing there.

A few days ago I took off with Alicia, our Staff Naturalist, to explore some rowan trees up in the woods to see to what extent martens had raided them. We examined about twenty trees, all laden with dense clusters of fruit. Seventeen had been attacked. The problem for the martens is that although they are excellent climbers, the fruit forms on the outer extremities of the slender branches, too far out and too slender to carry the weight of the marten. So it has to climb up, get as close as it can, bite the twig off so that it falls to the ground, and then nip down and feast on the spoils. Most of the trees we examined had a ring of scattered berries and stripped clusters around them. I had never witnessed this happening, but I see the consequences every year, immediately followed by little piles of marten droppings deposited in prominent places on paths, on gateposts, on boulders. They are unmistakable; the berries are only partially digested and clearly pass through the martens at high speed, looking more like a vomited bolus than faeces – a rowan purge. This intriguing behaviour will continue for as long as the berries are available on the trees.

What it suggests to me is that the martens may have difficulty in obtaining as much live mammal prey as they would like. Field vole populations famously soar and then crash. In lean years, the martens may not be able to get as many as they need to supply them with the essential vitamins taken in by the voles' catholic feed. As Rowan berries are rich in vitamin C, when the autumn bonanza comes along perhaps some curious metabolic alchemy is telling them to gorge while the going is good.

Martens are still limited in their range, but they have spread south and east throughout the Highlands and down into Fife and the Central Belt, even to the outskirts of the great Glasgow conurbation. Here, in these glens of the northern central Highlands, they are now widespread, even common. It is no longer a rare sight to see one dead on the roads – a sure indication of a mobile

population currently estimated at between three and four thousand animals. Alicia tells me we have several individual martens occupying our ground on a more or less permanent basis. She gives them names according to the characteristics of their pelage: Spike, Blondie, One Spot, Thumbs, Patch and so on. Some stick around for several years, others seem to disperse quickly, or perhaps get killed off on the roads or by the few people in the glen who don't like them because, if given half a chance, they will cause mayhem in a hen run. Our resident martens den in the stables roof and occasionally in the lofts of estate cottages and outhouses. I am often amazed by their ability to find a tiny entrance hole, a way in under the eaves. In our hides our field centre guests are happy to sit out the long summer evenings waiting for them to come in to the peanuts and jam we put out.

★ ★ ★

It is dawn, the moment in the day I have always loved most. It's a long standing obsession and it hauls me out, out and about, often doing nothing in particular, just enjoying the lifting light and the world around me pulling on its clothes for the day. September dawns are often still and cool with a tang of freshness all their own. The only bird singing is the robin, tinkling his gentle, melancholic aria that always presages the first light of day.

I have just let out our twenty-five chickens by pulling the cord that lifts their hatch. One by one they tiptoe into the new day with mildly bemused expressions, slightly lost, as though such a thing has never happened before, rather like inexperienced travellers getting off at an unfamiliar railway station. Then something seems to click and they remember where they are and what to do. With a flap and scratch they head straight into pecking mode without any of the wary looking around you might expect of a bird so regularly ravaged by furtive, dawn-slinking predators like

the martens. I throw them a scoopful of grain to reward them for their patience.

I walk quickly away from the hens' paddock and turn up the old avenue of limes and horse chestnuts, picking my way through the prickly shells of fallen conkers on the path. I cross the burn on the little bridge where the water from the high moor, brandy-wine brown, gossips a private conspiracy between mossy stones, hurrying down to join the Beauly River. It is difficult to pass over and I stand on the bridge for a moment or two, smiling inwardly.

Just then I get the overpowering sense that I am not alone. I have experienced it many times before and I've long since given up trying to explain it. If it is a sixth sense, I can't define it beyond observing that it is seldom wrong and I value it greatly. Like a line from a cheap thriller, I feel someone's eyes drilling into the back of my head. I turn slowly. At first I think I must be mistaken, but then, as pure and shocking as coming downstairs and finding a stranger in your kitchen, our eyes meet. At my eye level and only ten feet away a pine marten, the size of a small cat, is perched upright in the central fork of a rowan tree beside the burn. His black front paws rest on a diagonal stem and his long, elegant tail floats below. He is staring straight at me. I am rooted. How long has he been watching me? Why hasn't he run away? Why has he let me get so close? What is going on inside that tight little torpedo of a skull?

He is magnificent. His head is angular and pert, a sharp little face reflecting a sharper intelligence within. The ears are small and rounded. His wet nose gleams in the morning light. Dressed in velvet suiting of dark chocolate, a V-shaped bib runs down his chest and between his forelegs, a bib as orange as the filling of a creme egg. A single cocoa spike-shaped smudge at the bottom of his bib gives him away. He is Spike, a full-grown dog marten we know well, a marten with pizzazz, who visits the hides and

has been around for a couple of years. Unblinking, his eyes are as bright as polished jet. He doesn't move.

A pine marten's life is simple. They are driven by need and fear – those two. Need for food and a mate; fear of man the dread predator, the exterminator. Occasionally a golden eagle, swooping from above will catch a marten out in the open; their remains turn up in eyries from time to time, and just occasionally, very rarely, a marten accidentally gets into a tangle with a badger or a fox or perhaps even an otter, and comes off worst, but man is by far the greatest threat.

So here we are: the man and the marten. I'm glad he doesn't know that we have persecuted his kind to extermination throughout most of Britain and I'm glad that in this frozen exchange he doesn't yet see me as so dire a threat as to trigger instant flight. The seconds tick by. My eyes are locked onto his; his onto mine. My brain has emptied down, nothing to offer. For as long as it will last, time has stopped. He is glaring at me like an angry drunk at the other end of the bar, daring me to look away.

Very slowly I withdraw my wits from his demonic, levelled gaze. I know why he is there. It is a rowan tree. It is his time for gorging on berries and he does not like to be disturbed. He has been to the top of the tree and bitten off several weighty bunches of fruit. They lie scattered on the ground between us. He was on his way down to get them, caught in the middle. His dilemma is twofold: to come down for the spoils, or let discretion win and just flee, to leap away through the trees as fleet as a squirrel. If he ventures down to the fallen berries he must come closer to me. If he flees he could be gone in a flash of chocolate fur. He wants his berries. I know that if I move even an inch, he will go. Indecision and indignation have clashed in his taut little marten brain. For the moment it is stalemate.

I have seen martens on countless occasions, far too many encounters to remember any but the most exceptional, but I

have never been fixed like this before. It is as though I am no longer in control and I have to wait for his next move. The chess analogy is irresistible. We could be here for a while.

Not in a million years would I have predicted what happened next. I had only foreseen one realistic option: that his nerve would eventually fail and he would turn and vanish into the trees. After all these years of seeing and thinking I knew pine martens, I would have put good money on it. Oh! We are so smug. We gain a little familiarity and a little knowledge and we think we've got it sorted. We think that wildlife behaves as it always does, predictable, reliable and you can tempt it in with a bait, trap it, radio-tag it, plot it on a graph and check it all out in a book. Insofar as we're prepared to concede that other species have intelligence or wills of their own we insist that they are locked within the limitations of their species' hard-wiring. All we have to do is read the wiring and we're home and dry. We think we know the pine marten.

I was enjoying this encounter, but the smugness of our own imprinting was wrapping me round like a fog. I fooled myself into thinking my superior brain was back in control. It was just a matter of waiting – yes, a game of who will blink first, and it was I who was in charge. And it would be Spike, as I had determined it must be. But that wasn't how Spike saw things this morning. It was as though he had sussed that I wasn't going to give in – had weighed it all up and carefully considered his options.

Without the slightest hint of panic or hurry he turned away and disappeared down the far side of the trunk of the rowan. Ha! I thought, I've won. I was wrong. Oh God! I was wrong, wrong, wrong. There was nothing hard-wired about Spike this morning. He appeared again at the foot of the tree and in three quick bounds he came straight towards me. From only five feet away a chittering yell of abuse broke from his throat, hurled at

me with all the venom he could muster. Then he snatched up a bunch of berries – his berries – threw me a disdainful glance and vanished back into the undergrowth. Checkmate.

In this charming and profoundly personal celebration of the return of the pine marten, Polly Pullar has provided us with an essential extra dimension to its habits and characteristics – that of people living with martens and other wildlife. It is something us humans are not very good at; our record is dismal. But Polly and her friends demonstrate not just that it is possible to tolerate wildlife in and around our homes, but also that to welcome it, understand it and enjoy it can be an immensely rewarding intellectual and philosophical exercise. It is also vital if we are to protect and maintain wildlife and their habitats for future generations. I salute Polly and her family for their dedication to that wise and vital cause.

John Lister-Kaye
May 2018

INTRODUCTION

A brief glimpse

In the still of an evening I sit by the shore as Loch Sunart sways soothingly. I hear the calls of curlews, and the haunting cry of a distant red-throated diver. I watch quietly as a grey seal appears. It is the watched that observes the watcher, as well as the other way around. It is bottling and snorting, in sea that fizzes with drizzle, with a thin, watery rainbow as its backdrop. Salty droplets cling to its whiskered face as it exhales loudly, poking its dark head up even further, the better to see me. Perhaps I may also see an otter. The sun begins to slip reluctantly into its bed far to the west over an ancient swathe of woodland ornate with plant riches, a natural kingdom of immeasurable value. Close by me the tortured form of an oak has pushed its way forth from out of a fissure in a massive barnacle-covered rock cleft. Now almost horizontal,

it has been kissed by a thousand sunsets over Mull, Coll and Tiree. It is no less impressive than its gigantic English parkland counterparts. In fact perhaps it is more impressive, tenaciously clutching as it does to succour between a rock and a hard place.

The seal has become bored with me and swum off. I sit a while longer, not wanting to stir; the afternoon is drowsy and peaceful, with only the whisper of a vole in the grasses. Then in my silence I catch a movement. Something brown and exuberant is busy on the edge of my viewpoint. It is darting about as if playing, and momentarily vanishes in the waving flag iris on the shore's edge. My foot spasms with cramp but I dare not move to rub it. I wait. A male stonechat with his bramble-black eyes and dark hood alights on a foxglove. I raise my binoculars in slow motion, and there behind him is another movement. A curvy form dances out into the open, wearing a coat of mocha colour and a pristine yellow-cream bib. It is playing with something, and then rubbing its elastic body over it. It picks it up in its mouth and throws it into the air, then leaps to catch it before pirouetting onto a rock. It turns and stands silhouetted against the low light – a pine marten with a vole. And then as quickly as it appeared it melts silently into the shadows.

★ ★ ★

Fleeting vignettes like this, revealing the life of the pine marten and the creatures that share its habitat, have always absorbed me. I have been fortunate to have developed my life's passion into my profession, folding the time I spend in the wild into my working life as a writer and photographer, recording many of the wonderful moments I have spent with our country's precious, diverse wildlife. At home, in Highland Perthshire, my partner Iomhair and I use trail cameras; we have recorded a wonderful range of wildlife that regularly comes to our garden, including pine martens.

The story of the pine marten reveals much about the wildlife of the more remote regions of Scotland; and the observations of an extraordinary, dedicated couple, Les and Chris Humphreys, who have turned their own garden on the shores of Loch Sunart over entirely to martens and a host of other fauna, have opened up fresh insights. Over the past fourteen years, my close friendship with them has added another aspect to my wildlife sojourns in Ardnamurchan – a place that has grounded my passion for the natural world since my early childhood – and given me a unique opportunity, and inspiration, to write about these rarely seen creatures. The Humphreys' story has over the years merged with mine, and as they would never have written it I have agreed to do so.

As a naturalist, I have learnt that whilst I may set out to look for a particular bird or animal, often I will be side-tracked and absorbed by something different altogether – a swathe of flowers I have never noticed before, the colour and detail of tiny lichens and mosses growing on a stump, the sounds and behaviour of a flock of unusual birds high in a tree, or a place where a badger has been digging out a wasps' nest, its claw marks scored onto bare earth. Then the journey takes another path altogether as I become eager to discover more. Being side-tracked is integral to watching nature, and therefore, though pine martens form the thread running through this book, the chapters that follow encompass a far wider perspective. My tales largely revolve around the unique Ardnamurchan peninsula and the wealth of its nature in its many moods, but include a few forays to other remote and wind-hewn parts of the Highlands and Islands too.

The pine marten's collective noun is a 'richness', and though the marten is the leading character in my story, the term 'richness' also usefully highlights the diversity of my meanderings.

Oaks of the western seaboard

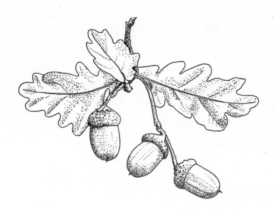

When I was seven years old, my parents owned the Kilchoan Hotel in Ardnamurchan. We had moved from rural Cheshire at the end of the 1960s because they wanted a complete change, a new challenge. They were concerned about encroaching development on the Wirral peninsula, and my father was fed up with running an inherited timber business in Liverpool. He was totally unsuited to it, and knew this. They took the plunge and moved to another peninsula – this one Britain's most westerly. Our lives would never be the same again. They certainly found the challenge they were looking for.

For me as an impressionable, inquisitive tomboy with a mad passion for wildlife right from the outset, our decampment northwest was to prove significant, and gave me the grounding

for a love that swiftly became a way of life. Ardnamurchan is at the root of my very being, and its diverse wildlife and wild places quickly forged my burgeoning fascination for the natural world. Soon after we moved I was fortunate to see a host of species I had previously only dreamed of, including wildcat, otter, red deer and golden eagle. And what was more, I saw all of them, with the exception of the wildcat, on an almost daily basis, and even the wildcat was still occasionally seen towards the end of the 1960s, and on into the early 1970s. I became increasingly absorbed and was seldom in the house, even on the wettest days. I feel fortunate that I had parents who understood my need for freedom, and my fascination and love for the wild; my mother's own childhood in rural England had also been dominated by nature, and my father was fascinated by red deer, their natural history, and the traditions and management surrounding stalking. I could wander almost anywhere I wanted to go and the dangers of the sea, the cliffs, or being lost on the open hill in dense low cloud were things I learnt about very quickly, and grew to respect.

It seems perhaps odd to reflect back and realise that as children growing up in that remote Gaelic-speaking village more than fifty miles from the nearest town, Fort William, no one worried about health and safety issues, and we all made our own entertainment – nature being very much at the heart of the matter – thankfully. It fills me with horror now to think that had I been born half a century later, things might have been very different.

The Corran Ferry, one of few remaining mainland car ferries, traverses the racing currents of Loch Linnhe between Nether Lochaber and Ardgour, providing a vital link to the Ardnamurchan peninsula. A drive from Strontian to the village of Kilchoan, almost at the peninsula's end, reveals some of the most dramatic oak woodlands in the British Isles. The importance of these woods was finally recognised towards the end of

the 1970s, and since then work has continued in an effort to restore and regenerate them back to their former glory.

Gnarled, wind-sculpted and massaged into extraordinary forms by the salt-laden gales that drive in off the Atlantic, the Sunart oak woods are some of the largest surviving remnants of this important type of woodland, and provide vital rich habitat for many creatures, from the smallest invertebrates to the largest mammals. These exceptional woods contour the rugged coastline, their roots spreading far as they struggle to hold tight to thin soils. A scattering of other oak woods of equal importance is found in Knapdale, and Taynish on the Kintyre peninsula, and on Mull and Skye, whilst a few survive further north along the western seaboard, creating a lush pelmet dripping with lichens and polypody ferns where burns tumble down the steep hillsides in their hurry to reach the sea.

In my formative years, when my family lived here, I spent a great deal of my free time wandering in one particular oak wood. I could ride my pony so far along the shore, and then leave him to happily graze on an area of old pastureland whilst I went off on my expeditions into the trees. It is one of the loveliest places I know.

Ben Hiant, roughly translated from the Gaelic as the enchanted mountain, is a small hill that dominates the area. It is but 528 metres high, but despite its size has the strength and character of a far larger mountain. From its steep-cragged summit above the Sound of Mull, the view wanders out to the islands of Mull, Coll, Tiree, Rum, Eigg, Muck, Canna and, on clear days, north to Barra and the Uists. And the sylvan glory of the ancient oak wood that grips its western flank is of unsurpassed quality, the domain of raven, buzzard, eagle, otter and pine marten. I return to this special haunt on a regular basis for it refuels my soul; there is little doubt that those early childhood explorations are embedded in my psyche, and helped inspire my love for the

wildness that is Ardnamurchan. Sadly, though largely unaltered over past generations, these oak wood remnants are now heading towards the end of their natural life, and grazing pressures from sheep and deer mean there is little natural regeneration.

My family nicknamed the grassy area where I left my pony at Ben Hiant's feet 'the cricket pitch', simply because it is one of few flat and green places around. From there, scrubby trees edge a walk along a shore strewn with bearded rocks and dense but gale-tortured blackthorn, twisted rowans, shining dark green hollies, tangled thickets of hazel and banks that in spring and summer are stippled with a wealth of flora and glow buttery yellow with primroses. Behind the tide line, under jagged rock overhangs, massive lichen-covered boulders provide ideal places for otter holts and pine marten dens. Spraints from both mustelids adorn worn pathways between the bramble groves below cascades of wild honeysuckle. Then the oak wood begins its sprawl up the hillside, from a distance appearing as a greenish-ochre blur, an infusion of watercolour paints dabbed across a page. Indeed, many of the oaks struggle so close to the tide line – some grow horizontally and cover large areas. The constant malevolence flung at them by the climate puts them firmly in their place – low to the earth – what little earth there is, for the soils here are thin. Further into the wood these ancient trees are festooned in some of the finest examples of lichens in Europe, and draped with ivy as well as wreaths of knotty honeysuckle; the understorey becomes extravagant with mosses, soft emerald cushions, beside liverworts, and a maze of ferns. Brambles dominate, their strong tendrils stretching out far up the banks providing a snare for the unwary, and a vital food source for a host of birds, insects and invertebrates. Many types of fungi thrive in these ideal damp conditions, their magical forms momentarily spotlit by shafts of low sun that wink randomly through the trees with the fleeting brown tweed dash of a

departing woodcock that erupts from the leaf litter. In spring the wood is visited by migrants: chiffchaff, willow warbler, redstart and the increasingly rare wood warbler, its call – like that of a coin spinning on a marble surface – echoes through the wood, where tiny waterfalls gently trickle off the hillside, or transform to irate torrents in one explosive cloud burst. Cuckoos call, echoing back and forth to one another. The smell of bog myrtle mingles with the salt sea tang driving in off the Sound, and at low tide rock pools teem with life – flamboyantly coloured marine gardens framed with crimson anemones and weeds of jade and amber. From the rock pinnacles red deer watch and sometimes an eagle passes, playing on the thermals above, and is mobbed by persistent hooded crow pilots and ravens.

I have often sat hidden in the ferns, back firm against an ancient wizened trunk, watching as an otter cleans its salty pelt in the burn's clear pools. I have watched pine martens here at dusk, and seen them in autumn, stuffing themselves greedily with berries, their scats laden with red rowans like a string of crimson beads – they have eaten so many, they go almost straight through the system.

For as long as I can remember, the ravens have favoured the same nest sites, alternating between a few. Their current towering stick pile is now adorned with blue and orange bale twine, as well as beastly colourful plastic detritus picked up from the shore. Beneath this maternity castle the ground is spattered with black and white droppings: there are pellets containing grain, sheep's wool, small bones and mussel shell. Tatty black feathers have forgotten their blue-black, shot-silk sheen and drift idly in the wind. Around the peninsula golden eagles alternate between two or three sites too.

This is a place that seems untouchable – and sometimes even calling my dogs seems too much noise to inflict on this world. On still days I can perhaps hear the sounds of a fisherman on his

small boat chatting on his mobile phone on the Sound of Mull, the bleating of sheep, the soft contact mew of a hind communicating with her calf, oystercatchers and curlews, or the snort of a seal. Even the blow of porpoises. But I hate to make any sounds myself and talk to my collies instead with hand signals. Most days I hear nothing but the sough of the wind.

This oak wood, like many of the others around Ardnamurchan, is simply one of the most beautiful places in Scotland, but when a gale rages and the rain comes down the Sound in horizontal sheets, it becomes a werewolf, savage in its wrath and hostility, and somehow, yes, equally as beautiful as in its calmer moments. It is largely due to the exceedingly high rainfall, in unison with the massaging warmth of the Gulf Stream, that it has such an abundance of wildlife and rare species. And it is due to the strength of the prevailing wind that the trees' shapes have become so contorted, almost ethereal. It is as if the winds have forced them into advanced yoga positions.

It is important to value and recognise that an Atlantic oak wood, like its Amazon counterpart, provides an equally astonishing habitat. Though there are many different types of oak, the two types that dominate the woods of the western seaboard are the sessile oak – *Quercus petraea* – and the pedunculate oak – *Quercus robur*. In Scotland they support over 500 different species, many of them considered of high priority in the UK Biodiversity Action Plan. An oak tree teems with invertebrate life and there is not a crack or crevice, fold or ridge in the bark that does not provide an important link in the woodland ecosystem.

Oaks do not favour high places and most do not grow above 200 metres, but they may grow in some highly inaccessible locations and, as here, can be seen on the sheerest of hillsides, clinging on despite the difficulties. Other important native tree species also grow in abundance in oak woods – hazel, rowan, ash, holly, gean, alder and birch – and are an integral part of the whole.

The priceless value of these woods is oft overlooked. The modern schoolchild is probably far more likely to hear about the Amazon Rainforest during geography lessons, and to be aware of its tragic ongoing destruction, than to know about the equally important ancient forests we have in Scotland. Indeed, probably few adults realise they even exist. But this is indeed Scotland's own unique rainforest.

Most people think of the oak as a mighty tree, quintessentially dominating a verdant English Robin Hood-type landscape, with weighty boughs and massive leaf canopy sweeping towards the heavens. Though the oak may be imposing in stature and live to an impressive antiquity, it is also a glorious feature of some of the most rugged landscapes of all.

For centuries we have revered and made use of it. Incredibly strong and rich in grain and colour, oak has been sought-after by cabinet-makers and craftsmen from all walks of life, and is still used to make the finest furniture today. Oak is also often used for coffins, though during medieval times the interior of a felled oak would only have been roughly hewn out to encompass the body of a person of great social standing, or perhaps a member of the nobility.

Between the 1600s and the 1800s, oak was used for fuel and was a staple of the Industrial Revolution. Oaks have also been the mainstay for ships and houses; indeed entire cities and navies were forged from oak. In the fourteenth century Robert the Bruce is said to have planted 500 oaks on an island on Loch Lomond to be eventually used for a future Scottish navy. In much of Britain, and in particular in the west of Scotland, oak was important for charcoal-making and whole hillsides were coppiced; this work led to full-time employment for many of the locals. Charcoal produced in Argyll from the rich oak woods there was taken to the shore with packhorses and then transported by sea to iron-ore smelters. Oak timber was used for pit props, and oak

bark is still important for tanning superior-quality leather, and also for making dyes. It is also used for medicinal purposes and folk remedies. The oak has long been seen as a sacred tree and played an important role in witchcraft, superstition and religious festivals.

Though we have worshipped and found many uses for the mighty oak, we have also sadly abused it. At the beginning of the twentieth century, thousands of oaks were felled in the interests of grazing to provide more pasture for sheep and cattle. Intense grazing totally alters the ecology of an area and has taken its toll, and the voracious mouths of deer, sheep and cattle quickly nipping any emerging saplings negate the possibility of any natural regeneration. In many areas of western Scotland, the introduction of the invasive, fast-spreading rhododendron during the Victorian era caused much damage to oak woodland as well, for it smothers emerging trees and blocks valuable light. It is a constant battle to keep them under control, and in Ardnamurchan, particularly around Glenborrodale and in the RSPB's reserve there, it is an eternal task to cut and burn the rhododendrons. Some areas are being fenced to allow for much-needed natural regeneration, and other areas are being planted with young nursery-grown oak trees, often from acorns collected locally.

There is hope that we may not be too late to preserve the fragments of the woods that have been so important to generations living and working in the Highlands, and that they may again become as valued as they once were. For wildlife, including the pine marten and dangerously threatened wildcat, and the wealth of other vital species, their value is even greater.

2

Early encounters

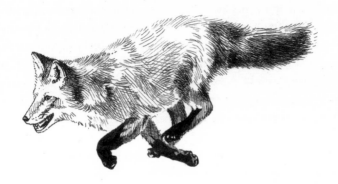

I was mad about wildlife long before we moved to Ardnamurchan. We had previously owned a small holiday cottage in a remote part of the mountains in North Wales. It was a beautiful place set in landscapes filled with birds and wild goats. One morning a group of keepers with a pack of feisty rough-haired terriers passed the cottage. They had been out looking for foxes and had a very young injured badger cub squeezed into a bloodied game bag. They stopped to talk to my mother over the garden gate, and by the time the conversation was over she was in possession of the beleaguered cub. It was my first real experience of hand-rearing a wild mammal. Sadly, though Mum did her best, the cub clung onto life by a thread for barely a week, and then it died. The dogs had apparently caused irreparable internal

damage and it succumbed to peritonitis, and doubtless the stress induced by being separated from its mother and the other cubs. I was devastated and cried my eyes out – in fact I was inconsolable for days – but soon learnt that if you love animals, you must also learn to tolerate the terrible pain of their departures. That first proximity to death was not a comfortable experience.

On a subsequent visit to our retreat I found an adder in the garden, probably dropped by a passing buzzard. It was an extraordinarily beautiful creature patterned with V markings, and black, grey and umber coloration resembling herringbone tweed. When I went to pick it up, my mother yelled loudly for me to leave it well alone. This was my first encounter with Britain's only venomous snake. I have had a healthy respect for the gorgeous adder ever since. It raised a question about why people had always referred to snakes as slimy, for there was absolutely nothing slimy about this fascinating reptile.

When we moved to the hotel in Kilchoan, I could often earn a little extra pocket money by washing up the glasses in the deep sink beneath the public bar. The bar counter was very high so if I kept quiet no one on the other side even knew I was there. It was a job I really quite liked, for I could hear the soft Gaelic voices of many of the local regulars, and best of all loved to listen to their Gaelic singing on Friday and Saturday nights. Often someone played a fiddle or a squeezebox too.

One evening the door blew open and a man came in carrying a large fishing bag. In it there was a salmon wrapped in newspaper that he gave to Mum with a big wink. I could hear much laughing and joking, this time in English, and lots of questions about the origins of the freshly caught, gleaming silvered beauty. Some questions are best left unanswered, besides, the truth would have been elastic anyway. But he had something else in the bag too, also wrapped up in newspaper. He put it on one of the bar tables for everyone to see. It was about the size of a large ferret – I

knew about ferrets as I had been out rabbiting with two polecat ferrets – but this animal had a luxuriant cocoa-coloured pelt and a creamy patch beneath its throat. Its eyes were glazed over and dull, and its mouth was slightly open, revealing sharp little teeth, its lips curled back in a macabre death smirk. I didn't know what it was, and neither did any of the other occupants of the bar, although someone said it was a mink. The unfortunate beast had been caught in a snare. I was devastated and almost burst into tears for it seemed so perfect, and now it was ruined. It was described as a marten cat, a rare creature that was seldom seen in Ardnamurchan at the end of the 1960s. Given that the stunted Atlantic oak woods that form the wooded fringe around large areas of the peninsula provide such ideal habitat, it is likely that it was previously here in healthy numbers. I stood, and stared and stared. There were many comments about its thick fur, and I noticed that, unlike the dead foxes I had seen in the back of crofters' vans, and the ferrets I had handled, this animal had no smell.

From a very early age I have been able to recognise the aroma associated with many different animals, foxes in particular, so much so that when we used to play Cowboys and Indians (I was an Indian by default), my Indian name was Always Smelling Foxes. This is something that makes me laugh, especially as the fox is an animal I have always loved and admired. It has remained an ongoing family joke ever since, and I can still smell a fox or recognise other animal scent with ease. So it was of particular note that the pine marten had no instantly recognisable smell. I was later to learn that the pine marten was nicknamed 'sweet mart', while the polecat was nicknamed 'fou mart' because it stinks so badly.

After that initial unforgettable but unfortunate encounter, my views of pine martens were sporadic. I had little more than the occasional fleeting glimpse of this mercurial mustelid. A hasty dash across the road, or on very rare occasions the dogs might

put one out of a den close to the shore, and that was really the sum total. However, even a dead pine marten can stay in the memory; it became yet another animal about which I yearned to learn more, but there were few books on the subject and I did not see them often enough to learn about them in the field.

The pine marten has been persecuted for centuries. The animal's fabulous rich, dark brown fur was eagerly sought, though in medieval times only royalty were permitted to wear it. Someone once commented: 'the higher your rank, the more rank the fur'. Since, unlike other mustelids, the pine marten's fur is free of pungent aroma, it was unfortunately all the more highly prized.

The pine marten's name has had various spellings – martern, martyn, martin, and finally marten, to differentiate it from the bird. Its Latin name is *Martes martes*. Once nicknamed 'the scourge of the glens', it was seen as a detestable fiend. Game records from various estates from all over the north of Scotland, and indeed in England and Wales as well, reveal astonishing numbers of pine martens in their depressing death tallies – more frequently listed as 'marten cats', particularly during the Victorian era. Yes, pine martens are up there in droves, alongside golden and sea eagles, harriers, kites, buzzards, owls and any other birds with hooked beak and talons, foxes, badgers, stoats, weasels, otters and even red squirrels. Between 1837 and 1840, ironically no fewer than 246 pine martens were killed on an estate adjacent to the now exemplary Glen Feshie Estate in the Cairngorms, where impressive restoration ecology is reaping benefits for a host of animals great and small, including the pine marten. It is sad to look back to a time when the Victorian killing fields were responsible for the loss of species on a scale that is gut-wrenchingly hard to imagine, and from which we still struggle to recover today.

The pine marten was viewed as being particularly voracious, a pest to ground-nesting game birds and songsters, and a terminator if it ever entered the henhouse. There were even fallacious

stories of them killing sheep. Eyewitnesses claimed to have seen them ripping the throats out of ewes, and then wrestling the helpless beasts to the ground to finish them off. I am not sure what these eyewitnesses were imbibing at the time, but their tales are the stuff of myth and legend, making the fairy-telling skills of the legendary Andersen and Grimm fade into oblivion by comparison. Perhaps the illegal hidden stills operating all over the Highlands had a particular hallucinogenic potency? Or perhaps the eyewitnesses that saw pine martens terrorising sheep flocks had been eating magic mushrooms.

In 1888, author, naturalist and sportsman Charles St John wrote in his book *Wild Sports of the Scottish Highlands* of the problems relating to pine martens and sheep:

I remember starting one [a pine marten] amongst the heather in the very midst of a pack of dogs of a Highland fox-hunter: though all the dogs, greyhounds, fox-hounds, and terriers were immediately in full pursuit, the nimble little fellow escaped them all, jumping over one dog, under another, through the legs of a third, and finally getting off into a rocky cairn, whence he could not be ejected. 'It's the evil speerit hersell,' said the old man, as aiming a blow at the marten, he nearly broke the back of one of his best lurchers. Nor did he get over his annoyance at seeing his dogs so completely baffled, till after many a Gaelic curse at the beast and many a pinch of snuff. The marten cat is accused by the shepherds of destroying a great many sheep. His manner of attack is said to be by seizing the unfortunate sheep by the nose, which he eats away, till the animal is either destroyed on the spot or dies a lingering death. I have been repeatedly told this by the different Highland shepherds and others, and believe it to be a true accusation. They kill numbers of lambs, and when they take to

poultry-killing, enter the henhouse fearlessly, committing immense havoc: in fact seldom leaving a single fowl alive – having the same propensity as the ferret for killing many more victims than he can consume.

From this it is clear that there was no love lost between the supposed sportsmen, shepherds and crofters of the day, and the hapless pine marten. Pine martens are indeed fiendish little killers, but the idea of one tearing out a live sheep's throat and eating away at its nose seems farcical. There are still some people around today who will swear it's true.

Other writers of the time had a different opinion of the pine marten, though equally recognised its strength. Oliver Goldsmith, in *A History of the Earth and Animated Nature* published in 1855, wrote: 'Of all the animals of the weasel kind, the martin is the most pleasing; all its motions show great grace as well as agility: and there is scarcely an animal in our woods that will venture to oppose it.' From this it is clear that the animal's name was still spelt 'martin', and changed later to avoid confusion with the bird, as previously mentioned.

In 1981 the Wildlife and Countryside Act was passed, bringing legal protection for a list of wild mammals and birds, but it was not until 1988 that the pine marten was finally included and received protection too. Since that time it has made a spectacular comeback and in many areas of the Highlands is becoming a more common sight; it is also an animal that frequently takes advantage of bird feeders, much to the delight of most garden owners. Yet even today in our more enlightened times, it is still loved and loathed depending on which circles you move in. And sadly, it is still illegally persecuted.

I admit that the marten's penchant for killing hens and game birds does little to help push it up the popularity stakes. But when

you think about it carefully, when it comes to evil deeds, none has so great a knack for ruination on an unsurpassed scale than man himself. With some 40 million pheasants reared and then released into the wild, is it any wonder that predators, including various birds of prey, take advantage of what is after all the equivalent of us shopping in a massive retail park with everything on hand? It is so much easier and involves far less effort. Think of seals and otters tempted by thousands of writhing salmon in a fish cage too, and who could blame them? I accept that it would be wrong not to recognise the fact that the pine marten is indeed a ruthless and highly efficient killing machine, especially where hens are concerned. I speak of this from first-hand experience.

One winter's morning I went to let the hens out but was earlier than usual; a grey darkness still lay like a duvet over the farmyard, and I was in haste to leave early for a meeting. On these sombre mornings, like us the hens are less eager to rise from their beds and don't always rush out when their pop hatch is opened. I didn't see them emerge, nor did I think there was anything odd about this. However, I did note that there was a large piece of sacking blowing about in the run that I had never seen before. As it was unusually windy I presumed it had blown in from the neighbouring horse field, thought no more of it, and dashed off.

On returning home I went to feed the hens as usual. On opening the door I was met by a massacre scene. Five hens lay dead with neck wounds oozing dark glutinous blood, the cockerel was emitting strangled choking sounds, and had blood drooling from his bill. The only uninjured hen was cowering on the top perch, with a backside as bald as a vulture's head. The henhouse resembled the aftermath of a pillow fight. A stray beam of light that I had never noticed before shone through a little round opening close to the roof, sending a pool of golden rays onto the sawdust of the henhouse floor; a spotlight illuminating

a violent battlefield. A pine marten had been in. I was pretty sure it was a pine marten as I had been seeing one on our wildlife trail cameras, and the scene had all the hallmarks of such an animal.

We are staunch in our resolve to shut the hens up at night, particularly in winter when darkness falls early, allowing hungry predators plenty of opportunity for nefarious business. We have foxes, otters, badgers, the occasional mink and numerous pine martens in the area of Highland Perthshire where we live, and all are partial to a chicken takeaway. The wildlife writer David Stephen once wrote that the fox was never given a key to the henhouse, and I have found this statement to be true. Now I was investigating the scene of a murder. Fowl play par excellence!

I am of the opinion, and someone else may explain it differently, that when it enters a henhouse, the pine marten does not kill through greed. I imagine our little murderer went in lured by the scent of hens and keen to filch some eggs, the birds panicked as brainless terrified hens are wont to do, and the cacophony of flustered fowls triggered a mad adrenaline-induced killing spree in the pine marten. It instantly becomes rather a game spurred on by shrieks and cackles – a game of death, a wild frenzy of flying feathers. This is simply the way that nature works, and is the nature of the beast I am talking about. However, it had left devastation.

I picked up my poor, beautiful cockerel and cursed myself for not going in first thing, as he had clearly been having a protracted, agonising battle. I stroked his battered feathers and took him outside, where he finally emitted his last ghastly gasp before going limp in my arms, his crowing days extinguished. That night we set a live trap with eggs and strawberry jam in order to confirm our suspicions. By morning the eggs and jam had gone and the varmint had fled, first breaking the trap, but leaving a little swatch of tell-tale cocoa-coloured fur. I was astonished that the strong metal trap had been broken, but this is a powerful

animal, and like its relatives the stoat and weasel, has strength far outweighing its size. However, I still don't believe it will rip out a sheep's throat.

My fascination with pine martens continued, with erratic but increasing sightings on my walks in Highland Perthshire, and I found fresh scats on an almost daily basis. I knew that here they tended to run the gauntlet of sporting estates and often fell foul of the pheasant release pen. It was always on my return to Ardnamurchan that I was fortunate to see them more often, for there are no driven pheasant or grouse shoots here. I could often hear one scrabbling about in the attic space above my bed in the cottage I stay in at Ockle on the north coast, or I might see another deep in the woods in the late afternoons, feasting on the seasonal glut of berries. Scats laden with partially digested rowans and speckled with wild cherry stones, and left on prominent tree roots or lichen-covered rocks, always brought a wry smile to my face – for who can resist gourmandising at a time of plenty? And such greed usually has a laxative effect on the consumer.

On occasions at the busy village shop in Kilchoan, pine martens have been regular customers, albeit not entirely welcome for they are not always the most reliable of payers. However, knowledge of their presence in turn attracts tourists on the off-chance of a sighting, and one hopes that this in turn leads to a little extra spending in the local shop – so in a roundabout sort of a way, they may also be bringing in a little more revenue. Once, in the lead-up to Christmas, one gourmet marten's sweet tooth got the better of it when it discovered a passion for mince pies. During nightly raids this greedy animal tucked in to a new box but favoured the expensive luxury brandy-laced ones over the economy variety on the adjacent shelves. It became such a pest, consuming so many and opening several new boxes each night, that the shop owner caught it in a live trap and took it

back up the peninsula to Glenuig. That was not the end of the saga, and when he regaled me with the next instalment he was weak with laughter: some wag, hearing of the mince pie fiasco, had sent him a postcard with a photograph of a pine marten, with the simple message HAVING A LOVELY TIME, WISH YOU WERE HERE. Signed, P. MARTEN.

Used to receiving obtuse and odd telephone calls concerning injured and orphaned wild creatures, I once had a call about a 'legless' pine marten found in a pub in Kinloch Rannoch. The caller was adamant that the animal had been found in a bar and I was adamant that it was a wind-up, though I did indeed once receive a 'legless' hedgehog that had been scoffing fermented apples in an orchard and was literally falling over. It was simply tiddled on rough cider! When the marten arrived, wrapped up in a towel in a shopping basket, I discovered that it was a poor, thin old lad with few teeth, weak and starving, definitely at the end of the road, and it did indeed have a missing leg. He had clearly been living for years with only three, for the fourth hind stump was perfectly healed, with fur covering the place where once there would have been a leg. It was apparent that he was all but finished, but I felt admiration for this animal that had clearly survived in the wild, despite the odds against living, for perhaps years, as a tripod. I reckoned he had been caught in a snare. Before he was put down, I felt he was deserving of a gourmet last supper: strawberries, day-old-chick, a chunk of steak, peanuts, jam and digestive biscuit. His preferred option was the jam and strawberries, and these were hastily devoured first. No wonder his teeth were little more than brown stumps. Sugar is disastrous.

3

Eggs for tea

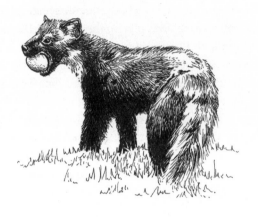

I was devastated when my family decided to move away from Ardnamurchan, but unlike them, I have continued to spend as much time as possible there ever since, and when I do Ockle becomes my base. It was during one of my stays that the cottage owner, my close friend Sue Cameron, said, 'You have to meet the Humphreys at Glenmore. Not only would you have much in common with them, but you would absolutely love to see the pine martens that come into their house every night.'

Shortly after this I found myself sitting in Les and Chris Humphreys' beautiful house overlooking Loch Sunart, drinking tea whilst eating a slab of cake large enough to fob off a pack of wolves. We chatted as we sat looking out of the large windows onto the bay. Within minutes an otter and cubs drifted into

view, swimming effortlessly through the flat grey sea with only their heads, rounded backs and tail tips visible. They emerged wetly on a weed-embellished rock and disappeared over the other side. I could also see a great northern diver in the bay, its distinctive large head and stocky body making its outline easy to recognise. A ministerial heron stood in his grey vestments, his eyes missing nothing, waiting patiently to stab the next meal, a sentient being on the russet-coloured shoreline. Then there was a flurry of excitement and the announcement of the first arrival. A pine marten had come to the feed table situated against the open study window in the next room. Now I only had to look at a massive screen at the side of the room. It was linked to a camera outside so that all the activity there could be easily viewed. 'Oh, it's Graham, he'll be in shortly. Polly, take this egg and just sit still holding out your hand,' Chris said. I sat motionless, grasping the egg in my hand and scarcely daring to breathe. Shortly, a sharp little face with a dapper creamy-coloured cravat peeped around the sitting-room door and Graham came over towards me, hesitating to sniff the air whilst giving me an intense visual examination. Then he tentatively got onto the sofa beside me, before politely taking the egg from me, ensuring he slotted it crossways across his open mouth to avoid breaking it. I noted how gentle and careful he was, so much so that it made a great impression on me; I wanted the moment to last. He gave me another quick once-over and then bounced off the sofa and bounced back out again. His aroma seemed almost sweet, akin to damp leaf litter on the woodland floor.

This was an astonishing experience, so different from the fleeting ones I had had previously. It literally opened a door onto an entirely new view of the pine marten, and was the beginning of an extraordinary foray into their world. Ever since that first intimate experience I have been enjoying these wonderful interludes with Les and Chris at their home, which since their

retirement has been turned over entirely to the rich diversity of wildlife that frequents this maritime habitat. It is the pine martens, however, that are the dominant feature as, without planning it, the Humphreys' lives have become deeply entwined with theirs, and a remarkable saga has been playing out ever since.

In fourteen years of studying and enjoying martens, Les and Chris have made some revealing discoveries and have had dozens of different animals coming to their garden, some for years, others for mere fleeting visits. They have watched and recorded a fascinating range of marten behaviour, most never previously witnessed. Mothers visit with kits, and there is much interaction with other wildlife, including foxes, otters, badgers and hedgehogs. Their garden has been bugged from end to end with camera traps. It doesn't matter at what unearthly hour the visits happen, the moment will be captured and is monitored and recorded on Les's state-of-the-art gear. Every morning the night's footage is minutely studied over tea and toast as more revelations unfold. A combination of the perfect surrounding habitat, a garden packed with wildlife-friendly plants and shrubs, and the lure of peanuts, jam, grapes, eggs, day-old-chicks and digestive biscuits, makes this a pine marten paradise. And let's not forget Chris's Victoria sponge cake, or the fact that martens have an insatiable sweet tooth.

The pine marten is indeed a skilled opportunist. Some come right inside the house, and often appear looking for their human associates if the smorgasbord of delights is laid out a little late. The animals are always fed at the window on a table specially made for them. This minimises familiarity with other human beings outwith the area, and keeps them away from the road. So far the martens have shown no signs of being familiar with other people except within the confines of this 'safe' house.

When the Humphreys, who lived on the Welsh–Cheshire border, first came on holiday to one of Sue and Dochie Cameron's

cottages at Ockle twenty years ago, they had not long driven off the Corran ferry when they spotted their first marten crossing the road near Strontian. They became instantly fascinated, so much so that they started what was to become a biannual pere-grination to Ardnamurchan, and they frequently saw martens at Ockle. Eventually this led to them taking the major decision to sell their farm – dairying was undergoing drastic changes and the future did not bode well in that particular sector – but they had never previously thought of moving north, and never imagined themselves living in such a remote place.

Very hard grafters, Les and Chris's life on the dairy farm was a constant round dominated by milking. They both loved wild-life and went to great lengths to farm in harmony with their environment and to ensure the best animal husbandry practices possible. Their two children, Tim and Kathryn, were brought up on the farm and were equally keen and knowledgeable about animals. Many pets became a part of the family, and included rescued marmosets and a red deer hind, as well as Irish wolf-hounds and numerous others. A fox that took advantage of the under-floor heat provided by the fermenting silage pit chose to snooze each day in a tyre holding down the plastic cover. It was always left in peace.

The prospect of selling their farm was a heart-rending deci-sion; they had wondered about how they would fill their days when they retired. Then they began to wonder if perhaps they might indeed move to Ardnamurchan, and mentioned it in passing half-heartedly to their family. Soon after, their daughter found the house at Glenmore advertised on the Internet, and they took off immediately to have a look. They loved it from the outset and went straight to the estate agent in Fort William to lodge their interest. Coincidentally, the previous house owners had run a B&B, and had been putting food out nightly for pine martens, much to their guests' delight. It was this simple fact that

helped Les and Chris to make their final hard decision to sell up in Cheshire and move to Ardnamurchan. 'I was, however, still filled with doubts, but our daughter told us in no uncertain terms that we should go for it, and so we did. I don't think either Les or I would have been happy joining the local bowling or tennis clubs down south somehow, so suddenly our lives took a completely new direction,' Chris told me.

After that first marten sighting on that initial Ardnamurchan holiday in September 1997, the Humphreys realised that they were hooked and returned home eager to find out as much as they could on the subject. They scoured the local bookshops in their hunger for information but only found a few historic stories. The most recent work on the subject was *Pine Martens*, by H.G. Hurrell, a man who had studied captive animals, and the other was a comprehensive study by Johnny Birks published by the Mammal Society – otherwise there was nothing. Pine martens were hardly on the radar.

The Humphreys had enquired a lot about the martens that had been visiting their new home, but there appeared to be little information. The only one that seemed of note was 'Frantic Freda', who had appeared, bringing her kits with her, on a regular basis. However, she was extremely nervous, hence the name, and would merely snatch a mouthful of biscuit before dashing off quickly.

During their first winter at Glenmore the Humphreys began to recognise Freda and a much older male whom they christened Graham, after the Cheshire livestock auctioneer, Graham Martin, who had regularly sold their stock through the local mart. There were also two others they recognised – an older male with a damaged right eye, whom they appropriately named Nelson, and another young marten born in 2004. At this early stage they had no outside lights to help with identification so had to use a torch to help them with identity parades. Soon Les

would start his first endeavours to record each marten with his camera, but for now identification was none too accurate.

'We managed to gain their trust during this early period through regular nightly contact, and it was not long before Graham in particular was tolerating us at very close quarters. We put out all the food including eggs, for which they had a particular liking, on a feed table just outside the open window. During the lighter evenings when food was put out on the board, the local herring gulls were beating them to it and snatching every last morsel. As the study window is reversible, it was easy to leave it wide open to impede the gulls' landing. Whilst this worked perfectly, the martens soon took advantage and came into the house to investigate and help themselves. By the year's end, Graham regularly came in to hurriedly snaffle an egg before disappearing into the woods with it,' Les explained.

The previous occupants of the house had offered the martens jam, biscuits and peanuts, but Les and Chris began to experiment with a varied menu that, as well as these staples, included digestive biscuits (a food I have personally always found is liked by most animals and birds, and is useful to tempt a waning palate), honey, peanut butter, raisins, red grapes (green are apparently shunned), eggs and day-old chicks, as well as blaeberries and cherries. If Michelin awarded stars to this marten restaurant, it would gain five without hesitation.

The Humphreys have also tried strawberries, but though the martens pinch them out of the garden in season, they show no interest in them otherwise. Though they like both honey and peanut butter, they are very messy and tend to stick in the coat, and peanut butter, unless spread very thinly, appears to also stick in the throat. During the autumn and winter months when mice move into houses and sheds, the martens often receive 'mouse mail' from a thoughtful neighbour who drops them off on the Humphreys' doorstep as she passes. Other friends staying in local

holiday houses have also begun to do this. No mouse is ever wasted.

Due to the amount and variation of food required, a weekly foray to Fort William takes Les and Chris over the ferry to stock up on fresh food, and they are regularly spotted by other locals in the supermarket ferreting about through trays of eggs, trying to find the smallest ones so they can easily fit in marten mouths to be carried off for caching. Young kits struggle to pick up eggs to begin with but they quickly learn to use different strategies. Some roll them off the feeding board, whilst others drop them over the side of the plank so that they smash on the ground. One young marten carried an egg to the top of the lawn then, using the natural slope, pushed it with her nose all the way down until it fell over the wall onto the gravel below. In order to supply the martens with more protein, day-old chicks specially bred for falconry birds are also added to the menu. As few frozen chick suppliers will send them direct, for it appears they view Ardnamurchan as an island and therefore won't send anything frozen, Les has to venture to the Scottish Borders to stock up on supplies, and is often away from the peninsula. It has been said that he is away looking for chicks, something that in the past in such a small community has caused a raised eyebrow or two.

Identification was the first thing that Les and Chris wanted to master to aid them in their observations so that they could accurately describe each animal in their diaries. Martens have a creamy yellow-coloured bib, sometimes referred to as a gorgette. The majority of animals have different markings on this throat patch, which is stippled with blotches, dots and streaks the same colour as their brown coats. Every animal's markings are unique, so if the bib area is clearly visible it is simple to identify individuals; however, some have very few markings on their bibs, making identification far more difficult. In these cases, close study of the irregular patterns on the edge of their cheeks and

necks must be used. This can also be difficult, especially when an animal has its head firmly down, intent on eating.

Les and Chris soon noted that every animal approaches the feed table in a different way and seems to have a different attitude, and though this is not always easy to establish, over time they began to clearly recognise certain individuals. The position they take up whilst eating on the board, and the particular food they prefer to eat first, also helps to identify them. Some martens remain standing to eat, whilst others prefer to lie down and eat in a crouched position. Some will face the window, but the nervous ones face out, keeping a wary eye on the garden.

The older martens try to avoid open ground as much as possible. Some zigzag across the lawn from the bushes to the house, whilst others rush across at great speed and with real purpose. Younger martens are always far more laid-back, as they are clearly not very streetwise, and after feeding will quite often return to the lawn to play. Breeding females can be much more nervous, especially if they visit when they have left young kits that they are still suckling alone in a den somewhere. Once a female appears and brings her kits, though she remains wary, she is visibly more relaxed, especially as the kits get older.

Les and Chris now employ a system for naming individuals, but at first they didn't have one. The first three kits were named after the shape of markings on their bib: Horseshoe – the shape of a horseshoe on the side of his bib; Ringpull – self-explanatory; and Zippy looked as if he had a zip running down the middle of his bib. The following year two kits were born, by which time Les and Chris had become more organised, and in order to keep far more accurate records they decided that they had to begin to name kits in alphabetical order.

In January of the Humphreys' first season at Glenmore, a huge storm with gale-force winds coinciding with very high spring tides washed out roads and bridges in the area and brought down

many trees. The electricity was off for four days. Les and Chris were soon to learn that, living on the edge of the world on Britain's most westerly mainland peninsula, this was all part of the norm.

In February they had planned a trip to North Wales to see their family and friends. Their Freelander had always been parked outside the house in the yard because the previous owner's furniture still partially filled the garage. On opening the bonnet to check oil and water prior to departure, Les was horrified to discover that a marten had been inside the engine compartment and had not only chewed the insulation and soundproofing under the bonnet and bulkhead, but had also been tinkering with the wiring, though luckily no wires were severed. They wondered if a female marten gathering some unusual bedding for nest-making had done the damage. Despite regular servicing, when the mechanics finally noticed some three years later, much to Les and Chris's amusement they simply commented, 'We think you have a vermin problem.'

Some experts have suggested fitting radio-tracking devices to discover where the martens venture during the day, but though the Humphreys appreciate the value of this in other areas, they are extremely against the martens in their garden being disrupted and perhaps put off their visits. They are adamant that the welfare of the animals must always come first. Television and film crews have heard their story and long to come and record the scene, but again, due to concerns over the welfare of the animals and birds in this continuing drama, all are politely turned away.

A question of feeding

Les and Chris Humphreys never set out with the intention of taming the many martens that visit their garden, but when they first moved to Ardnamurchan they did know that they wanted to encourage them, in order to watch whilst learning as much as they could in the process. By providing food on a regular basis, it was, however, inevitable that the animals should become habituated, to a greater or lesser degree. It is something that perhaps could be criticised, and there are purists who might say that as a result the martens become dependent on an unnatural food supply, and even that this may change their behaviour and jeopardise their future in the wild. Les and Chris fully acknowledge that with food always available, the martens' behaviour will indeed alter, for perhaps they will no longer require

such a large territory in which to hunt and look for natural food.

However, let's put this into perspective. Compare the regular feeding of martens with the fact that every year we apparently fork out an estimated £200 million on an extraordinary mixture of food, including nuts, seeds, fat and dried and fresh insects, for our garden birds as well as for mammals such as hedgehogs, squirrels and badgers. Why should feeding martens, or indeed any wild creatures, be any different?

In attracting the martens to their garden the Humphreys have not only built up a burgeoning database of information and learnt to recognise most, if not all, of the animals that appear, they have also observed many previously unseen behaviour traits and interactions between particular animals that dispel many of the observations made in early work on these mustelids. It could perhaps be said that these observations and the animals' actions have only come about due to the unnatural situation of a food glut, but as we shall discover later, their findings run remarkably parallel to those of a renowned ecologist and pine marten expert.

So how far do we take this, and would it in turn indicate that many of the extraordinary things we have learnt about garden birds were only discovered because they were put into an unnatural situation by our feeding? After all, there is little criticism of feeding garden birds; perhaps cynically, we could speculate that this is merely because of the boost to the economy of all that money pumped into the ever-growing wild bird food industry. We are also constantly told that this supplementary feeding is extremely important for birds. Some say that it is acceptable to feed birds in the winter months but that we should cease in the spring and summer. However, I take issue with this, for with the continuous damage done to the environment with pesticides and intensive industrial-scale farming, the uprooting, bulldozing and felling of vital hedgerows, woodland and wetland, and the

addition of new roads and sprawling development, natural food dwindles at a frightening rate. To stop feeding birds just at a time when they require help to rear their broods and get through our increasingly insect- and invertebrate-depleted, sodden summers seems madness. Either feed 365 days a year or do not feed at all, seems the sensible approach.

Weather seems to be a major factor in the number of visits that the martens make to the Humphreys' garden each night. On darker moonless nights, or when it is particularly wet and windy, the number of visits increases noticeably compared with the numbers on bright, moonlit nights. Perhaps brighter nights make the animals feel more vulnerable to predation. Or perhaps it is simply that these nights are more suitable for hunting in the woods.

It is important to note that Les and Chris's story is anecdotal and stems from a background of love and fascination for natural history. They are not scientists and do not record their findings with the eyes of such, but they have recorded every last creature that shows up and in so doing have provided a valuable record of the wildlife of the Sunart oak woods. As they have turned their retirement over entirely to pine martens and other wildlife, this has brought great joy and interest, as well as understandable heartbreak, for it is hard not to become involved in the personal dramas of animals and birds that you watch so intimately every day. Their years of recording events in their garden have revealed how much we stand to lose if we do not love, nurture and respect our native wildlife. They also show the vital importance of unspoilt habitat to promote a healthy ecosystem that burgeons with life, from the tiniest microscopic insects to the largest UK land mammal, the red deer.

As pine martens have successfully recolonised many of their old haunts, we in turn have become increasingly aware of their presence. They are now lured and attracted to many gardens, though few people will know the animals that visit as well as Les and Chris have come to know and recognise 'theirs'.

Looking out of the windows of their house at Glenmore, the undisputed wealth of wildlife that still largely thrives in this area is constantly on display. Hundreds of small birds visit throughout the year. Seals and otters put in an appearance in the bay on a daily basis, and the Humphreys had a spectacular sighting of a group of at least twenty common seals hunting a shoal of fish as they drove it right close into the shore. Red-breasted mergansers, a sawbill duck with a smart crest and impressive chestnut, military green and white livery, are usually busy in the bay. Whooper swans appear during the winter and may spend a few days in the bay's shelter, feeding and resting. Great northern divers, and the occasional red-throated diver are also to be seen, as well as the omnipresent shag and mallard. Ringed plover too are usually busy at the water's edge. One spring Les and Chris were delighted to find a pair had made their nest in their rockery just below the sitting-room window. Four eggs lay in a scrape amongst the periwinkle, decorated with a scrap of moss and a few feathers. Though all garden activity around the nest site was suspended to avoid disturbance, and for some days the birds flew back and forth to the beach, the martens were probably also watching, for one morning the eggs had vanished without trace. It was not a safe place to have a maternity suite.

In the springtime greylag geese can be seen as they graze on the lush emerging grass, and are often viewed picking over the banks of seaweed on the shore. Later in the season their broods of goslings will accompany them. It is only in the past twenty years or so that they have stayed here year-round. 'There are far too many geese' is a comment frequently made by the locals, and there is no doubt that geese do succeed in devouring copious quantities of the all-too precious spring grass. The truth of the matter is that actually there are far too many humans.

I am far more used to watching wildlife whilst being consumed by midges, sodden by rain and iced and buffeted by hail and gale.

On frequent occasions the sun beating down from a cloudless sky has also done its share of adding to my weatherbeaten look, so it amuses me greatly to visit after I have had a long day out on hill and shore to sit with Les and Chris, enveloped by a capacious luxurious armchair, from where I may even see porpoises, the occasional dolphin, and the shining brilliance of white gannets a little further out. Theirs is a room with a bay view to die for. And the bay is without exception punctuated with the leggy exclamation mark of a heron – often there may be many. They stand on their long, thin legs dressed in grey garb like morose courtroom clerks having a committee meeting, waiting to stab out a comment, in this case a fish, eel or other slippery snack. Often they come into the Humphreys' garden, particularly during the frog-breeding season, when they will plunder their pond. Herons are like vigilant watchmen that miss nothing, and for as long as I can remember they have been ubiquitous all around the peninsula. There is a heronry quite close by. During their breeding season, it is an intriguing spot where I love to go.

★ ★ ★

Visiting a heronry with my parents is one of my earliest childhood wildlife recollections. It was then in an extensive hazel thicket on the west side of the peninsula, not far from Ardnamurchan Point, its diminutive trees twisted into the maddest shapes by the ceaseless wind. First we heard the noise, a continuous raucous bickering and squawking, accompanied by hisses and clicks. As we neared the natal scene a stiff sea breeze carried an overpowering stench of fish. The ground was spattered yellow-white with glutinous droppings, plastered everywhere like spilt paint.

I clearly remember that I had on new red sandals and I was very proud of them. Mum called them 'Pol's new beetle squashers', something I found amusing. I wasn't wearing any

socks and the white sludge squelched under my shoes. We stood and looked up and above us, all latticed into the leafy canopy, was a mad shambles of stick piles. Due to the lowness of the wind-sculpted trees it was quite easy to see the occupants – on some nests there were a couple of reptilian chicks, with eyes and bill poking out of a face that appeared too small by comparison. They had wayward feathers, wisps that blew in the breeze like an old man's comb-over. Their oddly pulsating, bulging throat pouches fascinated me. Mum told me that the adults fed their chicks by regurgitation. On other nests there was an adult bird sitting incubating eggs, or perhaps brooding hidden chicks. It seemed rather odd to see the birds like this, having only ever seen them standing on the shore before. People once believed that given the length of a heron's legs, they would have to make a nest with a hole in for the legs to protrude from. A second heron, the partner to the nester, stood guard on a branch on the nest's edge and peered down at us. We didn't venture too close as we were liable to have a load of stinking fish disgorged onto our heads. We didn't linger long either, as we were worried we might disturb the busy herons. However, the guano and its odorous pungency did linger, as it had seeped into my sandals, and even onto my feet. I didn't mind in the slightest for I thought the herons were like some of the reptiles I had seen at the zoo – ancient, quaint and fascinating.

I often used to visit one of the oldest crofters in Kilchoan for he had a wealth of stories, many about birds and beasts. He told me that there was once a vast heronry on the sheer sea cliffs at Ardnamurchan Point that was apparently abandoned by the birds during the 1930s. It must have been hard for them to succeed in such a defenceless spot, so exposed to the elements from every side. This is presumably the reason why they moved on.

5

The loch

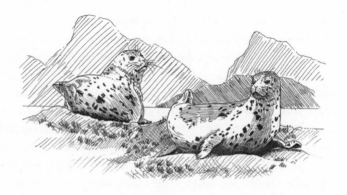

Loch Sunart is an important sea loch nurtured by hundreds of racing burns and rivers that run off the surrounding hills. Some cascade through rock-clad moorland, and open hill saturated with peat bog and sheep-bitten heather. Others pass through lush, verdant oak woodland. These continuous outpourings carry further vital nutrients to enhance the loch's already vibrant marine life, adding to the ebb and flow of its heartbeat. It is an area famed for its abundance of shellfish, its langoustines, lobsters, crabs and scallops, and its shores lined with mussel and whelk beds. All is further enriched by the addition of strong currents from the Atlantic that constantly filter down through the Sound of Mull as cold water meets warm, resulting in a unique and often turbulent marine habitat.

The loch's curvaceous form hugs the jagged coastline and creates dozens of little bays dotted with stances of contorted, wind-blasted oak, birch and rowan, between skerries and islets fringed with weeds and kelp beds. If the winds don't stunt the trees then the deer surely will, keeping them firmly in check with their desperate browsing, particularly during the long, wet winters when their need becomes ever greater. At low tide sheep may venture out onto a tempting rock in search of a green bite, and they frequently misjudge the tides. Then they may be stranded and have to perch precariously on the only unexposed area. That is if they are lucky and it remains above the water-mark. More often they will simply drown, their attempts to swim ashore thwarted by sodden heavy fleece that quickly drags them under. The wild red deer, which are by contrast excellent swim-mers, are far more attuned to time and tide, and often choose to travel out to graze on seaweed, or to browse on the small verdant islets. They can swim considerable distances with ease.

The loch is never still. It is a mirror with a constantly changing reflection, flat calm, steely hammer-marked grey, deep navy blue, electric turquoise, or a flat neutral-coloured sheet, blurred and blotted with mist and moisture, and hidden under a blanket of ceaseless rain. Then there may be nothing to reflect at all, and the mirror needs a good polish. At times the mirror is grey-green, or changes to a deep shade of blue-black that dances with angry white lace caps on its tumultuously jigging surface. In autumn it glows gold-yellow, ochre, orange, saffron, even crimson, copper, bronze, burnt umber and ruby. The oak woodland and tweedy-brown hills russet with bracken are absorbed and blended into the surface palette as if they are but one. And as the first signs of snow stipple distant corries, the loch may be flecked with whiteness mirroring the pristine undersides of herring gulls, or the brilliant shining purity of gannets that are seen further out in summer, particularly during furious storms. At sunrise and

sunset, if the sun has risen from its bed, the loch may blush deeply with pink, magenta, purple, rose and mauve, and it will be painstakingly etched in silver, highlighting the outline of every bay. A heron or curlew emerges in silhouette against a dark prow, or a herd of deer is there against an opaque sky, a passing eagle, buzzard or raven, and all will add their imprint to the reflection on the loch's surface. The loch is a mirror for the natural world, accurately reflecting its endlessly changing humour.

★ ★ ★

Both grey and common seals are abundant on Loch Sunart and, like the fishermen, take advantage of the abundance of marine life. It is rare to sit awhile on the shores here and not soon to have a curious seal peering out of the depths to see who you are, what you are doing, and what can be gleaned from studying you in equal measure. My collies frequently intrigue the seals, and they cruise close to the shore to have a better look, blinking those big eyes and exhaling loudly, their long whiskers (known as vibrissae) decorated with saltwater pearls, before they disappear into the depths, only to appear again a little further out. Now you see me, now you don't.

Seals haul out onto particular favoured skerries in all weathers. It is important time for lying and lazing, snorting and grumbling to one another, jostling over the best places. I do not think, however, one could say it was to relax, as they never really appear to, and always have an eye out so they can leap back into the water in seconds. Like obese tourists on a crowded holiday beach, these blubber-encased mammals squabble over the deckchairs, and ever seem to be complaining. Seals are extremely vocal and make a range of sounds, all clearly depicting their humour of the moment. Their petty turmoil is amusing and

enlightening to watch, revealing so much of these extraordinary mammals. I often sit overlooking Loch Sunart, my back against a damp mossy bank or leaning on a rock on a high headland overlooking a seal skerrie to inhale this activity, for it intrigues me. All may be calm for a spell, with only the occasional yawn, growl and frequent wind-blast from fish-filled bowels – seals are very loud in this department, and could compete with any brass band in a trumpeting contest, although in a seal's case it would be a trumpet *in*voluntary as there is evidently little thought or control involved in the process.

Then another seal appears across the bay. As it approaches the haul-out, it will initially raise itself high in the water to peer at the pastoral scene planted hugger-mugger, cheek by whiskered jowl, on the rock. Then it will eye up the exact spot at which to pull its ungainly bulk out of the water – this is never a particularly elegant manoeuvre, due to the sheer weight of a seal's body, and the fact that it is simply not designed for agility on land. Its imminent arrival sends a wave of annoyance that ripples through the rest of the group, and the entire dozy brigade is temporarily disrupted. They rudely shuffle and push one another about as the snoozers awaken and open first one, then both big eyes. The newcomer clumsily drags itself onto the rocks, and there are further growls and grumbles as it temporarily squashes an unfortunate beast in the passing. They all continue to moan for a few minutes, and as it wiggles its way into the bunch, peace gradually returns. Tails and heads are raised as some seals adopt their distinctive 'banana'-shape curl, an effective stretch, perhaps even a little moment of relaxation. A flipper is raised to scratch grey-mottled skin, and there is a wide yawn revealing sharp incisors and canines. On occasions when the wind has been in my favour and I have stalked really close, the smell of piscine breath is enough to knock out anyone who suffers from squeamishness. A heron lands close by, and oystercatchers' shrill calls make all

the seals momentarily open their big wistful eyes, and then they fall back to oblivion – never for long.

A seal's eyes are mesmerising, like large pools in the peat hags, deep, soft and sad, blinking and lachrymose. However, a seal's eyes belie the true nature of the beast, for both common and grey seals are highly skilled predators, with an aggression that is equal to the raging sea during a force ten gale. They need this in order to survive. If a seal is cornered or whilst it is in captivity, perhaps due to illness, it will not hesitate to defend itself and sink its fish-filleting knives into any impending threat.

I have watched seal sunbathing and lounging activity too many times to count, and I never tire of it. Through my binoculars close study not only reveals many of the individual characters, the nervous, the brave, the bombastic, the underdogs and the leaders, but also the oozing wounds they inflict on one another as battles become heated and drooling jaws are employed. Bull seals in particular may have an array of battle scars, and as they drag their great weight over barnacle-encrusted rocks, the surface of these rough little crustaceans may add further to the scrapes and marks of their tough existence. Sometimes they come too close to boats and may receive a hideous gash from a propeller. Like a map, these scars are a seal's contour lines, the lines that depict its life. All too often I see that they may have unbreakable nylon netting encased around flippers, or even their necks. Pups will often get caught, and as they grow this becomes in effect a tourniquet which may lead to serious injury and eventual strangulation. And when I see this, I know there is nothing I can do to help, and I am engulfed with waves of sadness, knowing that we are the biggest threat to all our wildlife, everywhere.

Shortly the rockers begin to sing, wailing mournfully, the sound almost eerie. Their tunes reverberate across the bay. This is the true Hebridean Overture, a phocine lament that sends a shiver down the spine of the listener; I have loved to hear seals

in full voice ever since I was a child. No wonder they were once believed to be people under spells – Selkies that could change form. Then as the arias continue another newcomer arrives, and once again the party is disrupted, their equilibrium out of kilter, and so the shuffling recommences. With a massive splash, a body from the far side has had enough and returns to the sea for a little fishing, and then with continual plops and splashes, more decide to follow, and soon the water is dotted with round dark heads. Some begin to limber-up, porpoising noisily across the bay in a series of well-executed leaps and bounds. The sea is their element, to which they are so perfectly adapted.

The grey seal is far larger than the common, and is also far more aggressive. The common seal, despite the name, is actually far less numerous, and is also known now as the harbour seal, but I prefer the name I first knew it by. It has always seemed odd to me that a creature that lives in one of the harshest environments of all should give birth to its young in late October and November, but this is the situation with the grey seal, whereas the common seal has its pups in June – a far more hospitable time of year, one would think. The common seal pup is also more active and can swim and dive very soon after birth compared to the grey pup, which must stay ashore for the first days after its arrival. The grey seal pup is born swaddled in a creamy natal coat known as the lanugo, however the precocious little common seal pup has already shed this inside its mother's womb. A seal's milk is exceedingly rich in fat and contains up to twelve times more than that of a cow.

I have seen seals born on a few occasions, but never in Ardnamurchan, and my most vividly remembered experience was on Islay, one of the most beautifully diverse of all Hebridean islands. The day was wild, the gale tempestuous and erratic, and it drove in off the Atlantic in great threatening blotches, ink on

blotting paper spreading low across an angry sky. As it neared the shore it whipped grey-green waves into white-capped fury and smashed them against rock.

The dogs and I were alone; tall marram grasses etched the skyline. Above us a pair of choughs wheeled and dived, playing with the wind, its force driving them up and down rhythmically as if on a fairground ride. Tumbling and falling tantalisingly close, they mocked the dogs, their black-frayed wing tips outstretched into teasing fingers, their crimson bills and legs cherry bright against the gloom of grizzled November weather. As we battled inadequately beneath them, bent double against the cantankerous squalls, their cackling calls were ironic laughter.

Hail-charged showers left my face raw and burning. The gale raged noisily on, banging and crashing wave to rock, pummelling and roughly massaging the coastline as it had done a million times before, shaping and forming, carving and honing ceaselessly. I pulled my hood up tight round my ears and turned my back for a moment, relishing an overwhelming feeling of inner silence.

Rain seeped down my collar and dripped icily into my clothing. The salted gale made the dogs' coats greasy as the wind teased soft ears inside out. They clung close to my heel. Stunted ragwort still flowered; little glowing yellow-gold orbs that shone like candles amid ebony liquorice slugs dotting the headland.

Through misted binoculars I watched a bobbing raft of eider duck. They disappeared from view then reappeared as gargantuan waves rose and fell like a theatre curtain. Out in the frothing maelstrom a great northern diver and shags briefly entered the stage. Misted views appeared – islands then oblivion, nothing but a dozen tones of drab grey. Stray rays broke through bands of blackness, momentarily illuminating the sea, where rainbows celebrated the victory of light before fading into the abyss.

We stopped on the battered shore. Huge rocks made fine temporary shelter, a brief respite from our exertions. I pulled

sandwiches and flask from a sodden rucksack and cowering beside a massive boulder, ate and drank. The dogs found a dead guillemot in a heap of colourful fisherman's flotsam, its feathers still recognisable but its eyes hollow and empty. Then I heard it – that long, slow, sad psalm drifting between gusts carried gently over the waves, its timbre beckoning – hypnotic.

The Song of the Selkies, ghostly and magical; grey seals hauled up on the beach of Ardnave Island opposite were singing their anthems. I listened, absorbed, then scanned the island with binoculars and saw pale forms lying on the beach. New pups lay beside voluminous mothers. A curlew called. The wind eased. A lone seal cow had dragged herself away to the far end of the beach. I studied her for some time.

In front of me, mere feet from the shore, a yearling seal was revelling in the waves. It seemed to be massaging its belly on the sand as it let itself drive ashore with each new wave impulsion. Then it lay on its back, submerging occasionally beneath frothing waves. It reappeared grasping fronds of shining bronze kelp in its front flippers, rolling and floating over and over in the water.

I turned back to the island view. The lone cow was flailing about on the sand but the wind had risen again and blurred my vision. It tugged my jacket and pummelled the binoculars. I tucked myself into the weathered grooves of my rock and watched the young seal waltzing with its moody partner, the wild sea. Then I turned back to my distant vignette. The cow was straining, straining to bring new life into the gale-crazed seascape. The binoculars steamed, obscuring everything. Shirt cuffs cleared away the fug as I witnessed a blur of white emerging at the rear end of the seal. In seconds, more of the new being appeared then squirmed and wriggled wetly onto the sand. The cow turned, ungainly on the land, as she tenderly nuzzled her pup. The gale was brewing up to fever pitch again. I watched

as the pup struggled to find the all-important nipple, constantly going to the wrong end, the wrong place, while the mother clumsily manoeuvred herself round and round. Soon nipple and pup would unite. Then new life would be filled with some of the richest milk on earth, helping it to grow faster than most mammals, ensuring it too would soon be at one with its environment just like the yearling, the Selkie, that integral part of the waves so close to me on the shore.

Was it the wind and the wildness of the weather that made tears sting my eyes? Or was it the place and its creatures, the ecstasy of witnessing such a private moment. A double rainbow appeared to the west as I wiped away the tears, bent to stroke the damp coats of my two patient canine companions, and gathered myself for the return, the wind at my back.

* * *

The local fishermen and fish farmers in Ardnamurchan have no love for the seal and view it as a threatening competitor. With the increase of bulging sea cages swollen with fat salmon, seals and otters are under constant temptation and, like predators such as the pine marten, fox and numerous birds of prey in areas where there is intensive rearing of game birds, really cannot be blamed for succumbing when a glut of their main prey appears right on their doorstep. Rectifying conflict between man and wildlife is often impossible, and there is a constant cry of, 'there are too many seals, too many pine martens, too many sea eagles, too many gulls' – we lure the latter with all our disgusting litter, and only have ourselves to blame. And there have apparently always been far too many foxes, and indeed a host of other creatures that cause annoyance and inconvenience at any particular moment. Nature is not there for our convenience and sadly, due entirely to us, is now out of balance. Even in Ardnamurchan, a place that

has for so long remained unspoilt, it is constantly disrupted. Yet remote rural communities badly need employment; there are no easy answers. One thing I do know is that it is always the wildlife that suffers, always.

6

A richness of martens

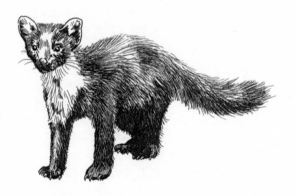

In the Humphreys' garden in Glenmore there have been many martens of particular note – those that have left a far greater impression than others. Graham was the first marten with whom I personally had a very close encounter, that first afternoon I spent with Les and Chris, and he remains etched in my mind. He was also clearly the alpha male and visited for many years, becoming very tame with them in the process. They feel strongly that it was Graham who taught them so much about martens in the early days. Though he fiercely guarded and defended his territory, as well as the youngsters that were clearly his own offspring, he was the gentlest of creatures with Les and Chris. When taking an egg from either of them, he would softly extend a paw and

place it on their hand. They describe this as having the touch of velvet. He would then carefully remove the egg, using his teeth. In the beginning Les and Chris's two-year old granddaughter Lizzie delighted in giving him an egg too, and both she and her brother Struan have since always looked forward to their marten-dominated holiday visits to their grandparents, particularly when they could see Graham. He frequently gave up his own food in favour of his begging offspring and would quickly put down a tasty morsel for them before returning to the table for a little something for himself.

Freda, an alpha female, also became more accepting of the Humphreys' presence over a period of years. She transformed from being a terrified bundle of fur seen snatching food off the board and then diving for cover, to becoming almost as trusting as Graham. Chris and Les feel that his relaxed and easy manner with them must have rubbed off on Freda. After their move to Glenmore, she came for seven years and four months, and during that time produced fourteen young. She seemed to be a particularly dutiful and patient mother and, like most of the lactating females, never reprimanded her kits when they were overly rough with her. Both she and Graham came into the sitting room if Les and Chris were late putting out the food, or if perhaps there was not enough left on the board. And both were eager to gently take an egg from an extended hand.

Graham seemed to have a noticeable affinity with Chris and frequently came looking for her around the house. He often went into the kitchen, and even ventured upstairs to see if she was there. He surprised her one night by sticking his face around the bedroom door and giving her a questioning look with his head tilted over to one side like a quizzical dog. Eggs seemed to be the main reason for his forays further into the house, but he seemed also to have a devotion to her, rather in a way a dog becomes bonded to one person in particular. He did not behave

like this with anyone else. If the window was shut he sat on the outer ledge even in lashing rain and gales. From this watch position he quickly became bedraggled and forlorn, looking and waiting patiently whilst he anxiously peered through the glass. After a while he would give up and wander around the outside of the house looking to see if he could attract attention at another window. It seemed almost as if the more pathetic and miserable he appeared, the more likely he was to be noticed. It was a constant source of amusement. However, he never had to wait very long, for being clever he seemed to know how to manipulate the situation to his best advantage, and Les and Chris were easily convinced.

On the rare occasions that the Humphreys go away they use a number of automatic pet feeders put in strategic places out of the weather, and the greedy eyes of gulls and hoodies. The feeders are well stocked and set to open at different times. The martens quickly adapt to the new system and have all learnt from each other over the years where their food is hidden. However, some are impatient waiting for the next one to trigger and succeed in prising open the lid before the set time, quickly removing the tasty bits before the lid closes. Some feeders have been trashed beyond repair, but the martens never go hungry.

Even when I first met Graham, he was beginning to show signs of age. He appeared to have cataracts in his eyes and the hair around his strong feet was white, with long, pale-pigmented claws. Les and Chris recognised this as a visible sign of the ageing process in all martens. Another trait they noticed was that the older the animal, the longer it seemed to take for it to moult out of its dense, luxurious winter pelage. They observed that breeding female martens moulted first. The obvious explanation for this is that they spend much of their time snuggled up in a warm den with a litter of kits, where the raised temperature of the atmosphere induces an earlier moult out of their thick winter coat.

The first sign the Humphreys would have that a female had given birth was when she came to feed in early April and the infrared cameras picked up swollen teats showing up white. Lactating females also take on a more scruffy appearance, especially around the neck area where they have been ragged and pulled at by boisterous young kits.

In the early days Freda was a nervy animal, always in a rush to grab food and vanish, but as the years passed and she continued to visit she became more at ease in Les and Chris's company. The most memorable and moving moment came when she brought her kits to the open window. Later she miraculously moved off to sit relaxed on the lawn as Les and Chris hand-fed her precious youngsters. This was the ultimate sign of trust, a bond that was forged between the Humphreys and a particularly special female marten.

In June 2005 Freda brought three male kits, whom they christened Zippy, Ringpull and Horseshoe, all named after their bib markings. Zippy, with his zip-like line down the centre of his milky custard-yellow bib, was to become a stand-out marten with an extrovert and playful disposition. During a rare snowfall Les managed to film him with his father Graham and brother Ringpull gleefully taking advantage by diving and tunnelling into the soft snow. This clip appeared on the BBC's *Springwatch*. The night after Les had filmed the trio there was an equally unusual hard frost, and though they tried to play again in this new winter landscape, the snow was far too solid and no longer provided the ideal situation for them. Ringpull and Horseshoe continued to come, often accompanied by a parent or sibling, until early 2006, and Zippy stayed on for a further year.

In June 2006 Freda appeared with two new male kits whom the Humphreys named Buttons and Bows. The latter disappeared after two months, but Buttons stayed for almost three years, and was frequently accompanied by his older brother Zippy. They

ate and played together often with Freda and Graham. It soon became obvious that after weaning, the younger kits relied not only on their parents, but also on older siblings, to help teach them their hunting skills.

Buttons frequently followed his parents' example and if the food was not already out, would help himself from the study table where it was stored. On wet nights he liked to come in to dry off on the rug, and rolled over and over and then lay flat with back legs stretched out behind before pulling himself along with his front legs in a dog-like fashion. He would then turn on his side to stretch and yawn, peering back with an expression of sheer delight on his face. He was once spotted inspecting the nest boxes put up in the alder trees by the burn. This demanded some fast action. Les quickly fitted wire mesh around the openings so the birds could get in but any marten attempts were foiled. Although he successfully eliminated the risk from martens, unfortunately the same could not be said for that posed by the greater spotted woodpecker's DIY activities. It appeared and instantly drilled right through the side to remove all the young fledglings. This is a common occurrence as, like martens, and perhaps more surprisingly red squirrels, woodpeckers are not averse to consuming the chicks of other birds, for they provide vital protein in a time of need.

Craig, Clive and Chloe were born to Freda and Graham in 2007. Craig visited for three years. He was also a regular who frequently ventured inside, and he cached eggs all around the garden. Les and Chris were curious to know who was hiding eggs in different places. As they hand-fed each marten the egg was marked with the relevant animal's initials. They were often found in compost bins, bark chippings used to impede weed growth in the flowerbeds, in the hayrack in the stable, and even in the front of the Humphreys' livestock trailer. Sam and Taff, who appeared in February 2010, were responsible for some of

these. Taff was the one who favoured the hayracks, whereas the neatly placed group in the front of the livestock trailer was all Craig's work. Sam, meanwhile, liked to hide his in the flower-beds and lawn, digging a small hole and placing the egg in point down, almost as if using it as an eggcup. Then he could easily consume the contents. On some occasions he covered the egg over with leaves and moss. This was well patted down with his paws, and he would return a little later to eat it. An amused neighbour, who lives nearly a mile away, once informed them that she had found an egg hidden in a plant pot on her patio. Though it was not marked, they suspected Sam for he had been seen lolloping along the verge, egg in mouth, heading in the direction of the neighbour's garden.

Craig also used a compost bin as a latrine. A massive pile of scats was found at the end of one winter and trail cameras revealed the depositer. Perhaps he preferred the comfort of a covered loo rather than an outside privy. Clive and Chloe were always far more reserved and seemed to lack his buoyant dis-position. Martens, like people, all have distinctive traits and individual characteristics, and whilst some brim with confidence others remain extremely wary. Chloe was one such marten, but though very timid she continued to come to the Humphreys' until she was two years old and of breeding age. Clive came for nearly three years. Then, following an absence of three years, he returned in the winter of 2014, and came to the garden regularly for two further months before disappearing. He has not been seen since.

Out of the fourteen kits that Freda brought to the feed table over the years, strangely only one was female. Kits born in March would be brought to the feeding station towards the end of May or early June. By the time they appeared in the garden they were half grown and seemed to develop extremely fast, quickly becoming sleek young adults. Though weaned by July

and no longer suckling from their mother, the kits continued to accompany her, and were often also joined by their father and older siblings. Frequently Les and Chris noted that the extended family all came at once.

Dan was another son of Freda and Graham, born in 2008, and he came for two years. He used to appear with Buttons, Craig and Clive. Coming into the house with Graham or Freda, he swiftly learnt to open the sitting-room door by pushing it with his nose. He liked to go upstairs and peep through the banisters at Les and Chris before coming into the sitting room in search of an egg. He once stopped in the hall to scratch himself, and let go of the egg he was carrying carefully placed across his mouth. In a fast and immaculately choreographed flash, Chloe appeared and grabbed it from right beneath his nose and immediately dashed out with it. However, Dan was a very confident youngster and would frequently steal an entire unopened packet of biscuits, and if it proved too heavy to carry away, would open them on the study floor. He also removed apples from the tree and cached them around the garden. He was the only marten who ever did this.

From the time that Les and Chris first arrived until December 2009, dear old Graham never missed a night. Then he simply stopped coming and was never seen again. By then he had become visibly elderly, was even greyer and had slowed considerably. He left a great gaping void and though they knew he was an old boy at the end of a long life, it was hard when he did not come back. Every night for months Les and Chris waited and hoped, but they knew that he had simply reached the end. Around about the same time as Graham's final visit, a large, sleek dog fox with a beautiful coat was seen in the garden. Like the foxes that had been in the garden on other occasions, it was also seen ambushing the martens as they left with eggs in their mouths. Usually these were hastily dropped, and the fox made off with the prize.

Following Graham's disappearance, Sam and Taff came together one evening in February 2010 and subsequently seemed to take over the territory. Sam too was already showing signs of age, with his twisty, elongated claws and tell-tale white hairs on his feet. It was blatantly obvious that he was many years senior to Taff. Whether these two martens were father and son or had simply bonded together remains a mystery, but Sam, being the eldest, became the dominant male with noticeable back-up support from Taff. It certainly seemed as if they had a close family link. Les and Chris took hair samples from them using sticky tape on a homemade frame and thought they would have it DNA-tested to try to establish this, but although when they researched the matter fully they found that DNA-testing for animals was being carried out at that time by Waterford University, there was, disappointingly, no response to their enquiry, so the matter was shelved.

Following Freda's example Sam and Taff soon learnt to come in for eggs. Often Les might be dozing off on the sofa when Taff would push the door open, jump right onto his chest and then peer directly into Les's sleepy face, where he continued to eyeball him until he was wide awake. Taff was demanding an egg, and he wouldn't give up until he was given one.

In 2010 Freda had two kits, Fred and Frodo. They only stayed until September of that year and were probably seen off by the two new males, Sam and Taff. Due to delayed implantation, Les and Chris believe Fred and Frodo to have been the last of Graham's offspring.

In 2011 Freda had two male kits, Gus and Glen. The latter only stayed until the end of August that year. These were the last of Freda's kits and must have been fathered by Sam.

Gus was destined to become a much-loved favourite. Gentle in the extreme and a quick learner, he soon became adept at opening doors and, like Taff, would readily take an egg from Les

or Chris's knee whilst they were sitting on the sofa. Different martens learnt to open doors by either pulling or pushing, depending on the direction they swung. However, Gus was the only one that stood up on his hind legs to reach up and pull the door handle. It was remarkable to watch – I witnessed it on several of my visits.

Gus seemed to be a companion to numerous young martens whilst constantly maintaining non-confrontational relationships with the resident females. He was often seen playing and hunting with younger animals. It seemed as if he really enjoyed teaching them what to do. At the time of writing he has been visiting for seven years overall, but his visits became increasingly sporadic during 2017. As he got older he seemed to go off for weeks at a time, only returning to eat on very rare occasions. If he met up with any of the resident martens on these visits he was given a warm welcome as they scent-marked and nuzzled each other.

★ ★ ★

Les and Chris put up a bridge for Sam, a four-metre plank linking the lawn and the feeding board, to enable easy access to the food because he had damaged his leg. This in turn facilitated ease of access for hedgehogs too. Gus saw off any marten rivals and wouldn't tolerate any outside male intruders, though many did manage to sneak in for a free feed. Towy, who was later to take over completely, was one of the animals who was hastily chased off. As Sam continued to age he rarely defended his territory in the same way as he once had, and being less agile, rather than taking an egg from Les or Chris, he preferred to take his from the floor. It was obvious that he was taking a step back and was content now to leave things to the other male family members.

When Les and Chris moved to Glenmore in 2004 it was understood that Freda had already raised at least two litters of

kits. She stopped coming at the end of January 2012. Once more a fox had put in an appearance that week. The relationship between fox and pine marten is clearly an aggressive one. Foxes do indeed harry the martens to persuade them to drop their food, in exactly the same way as a hooded crow on the seashore will pester an otter feeding on an eel or fish.

Following the departure of Freda, a new young female appeared at the start of March of that same year. A gentle marten, she became the alpha female, and was later christened Kiera after a little girl who came to visit with her family from Crieff. Her older brother, Craig, was amused to learn there was a marten with his name coming to feed. Soon after their visit, Les and Chris had a letter asking whether, if they ever had a new female marten, she could be named after their daughter Kiara. Unfortunately Les and Chris spelt and pronounced the name wrongly, but by the time they found out, 'Kiera' had stuck.

Kiera didn't raise kits during her first season in the garden. However the following year, 2013, she gave birth to two kits, Hettie and Hamish. Hettie was later destined to become alpha female, taking over from her mother.

Kiera bonded with Sam, Taff and Gus, and regularly visited with them. During the five years and two months that she put in an appearance in the garden, she produced seven kits. Kiera appeared to thrive on punctuality. Every evening she was always the first to come for food, and Les and Chris could set their clock by the timing of her visits. Her ability to stack pieces of biscuit in her mouth was little short of brilliant, placing one on top of the other and picking up the pile before disappearing into the shrubs. Most martens would pick up a biscuit, holding it crosswise across their mouth, and then be unable to pick up anything extra. Not so Kiera. Not only a dutiful mother to her own kits, she also brought her daughter's kits to the feed table, with or without their mother Hettie.

In 2014 Kiera gave birth to two male kits. As no suitable names could be thought of they became simply Kit 1 and Kit 2 – this quickly evolved into K1 and K2. As in previous years, these two kits were readily accepted by all their extended family. Sam, like Graham – as witnessed in earlier years – would give up his food to these begging youngsters. However, they were none too sympathetic towards their elderly father, and their rumbustious games often led to poor Sam having his tail pulled or being bowled over by their exuberance. Despite this, in the short time they were together Sam was never seen to reprimand them. It was not long before he too disappeared.

Later, when the kits had started to venture out on their own, K1 became frightened when visiting the feed station one evening. Terrified by the noise of a raucous marauding herring gull, he shot into the house through the open window. Unaware at the time, it was only when Les and Chris where going to bed and about to shut the window that they discovered a little marten cowering under the blanket chest in the hall. After checking the camera footage it revealed that K1 had spent over two hours in the house. K1 and K2 were to remain within the family group for over two years.

The Humphreys' garden has always seen an itinerant population of visitors along with the regulars. Some stay longer than others, but all take advantage of the delectable takeaway arrangements. Towy the bully was one such marten. He was first identified and given a name in November 2012. From the start he caused disharmony and aggression with all the resident martens. At first he sneaked in stealthily to eat during the night and had to endure countless attacks. He would employ devious tactics in order to steal in behind Sam and Taff's backs to snatch food. Whenever they caught him at it, there was a great deal of bad language, growls, grumbles, spitting and hissing, followed by heated battles in the shrubbery. One night when he was taking

advantage of the food, Taff came onto the scene. There was much growling from Towy. Taff hastily retreated, only to return five minutes later with reinforcement in the shape of Gus. Towy was unaware of the feisty duo creeping along the gravel beneath him. All of a sudden all hell broke loose, with Taff and Gus performing a pincer movement on the unsuspecting Towy as they attacked him from either side, chasing him out of the garden in a whirlwind of wrath.

None of the other martens liked Towy from the first moment he arrived, and frankly neither did Les and Chris. He was gaining power over the regulars in the garden all the time, and would soon take over completely. When Sam the alpha male stopped coming, Towy upped his game. Taff became his main victim, although he was able to hang on for another twelve months. However, it didn't take long for Taff to become the underdog. Towy then began to turn his aggression on the females. Les and Chris knew both females at that time were suckling young and they feared dreadfully for their safety. What would happen to the helpless kits waiting in dens somewhere for their mothers' return if Towy harmed either of them? However, a few days before the mothers brought their young into the garden for the first time, Towy went missing. He did not reappear for about three weeks. By this time Taff had stopped coming. It was extraordinary to note that when Towy finally returned to take over the role of alpha male he was far less aggressive and became noticeably more submissive with the two females. Over the years, Les and Chris have recorded that for the first few weeks when the female marten brings her young kits to the feeding table the males are noticeable by their absence, and then come in to feed much later in the night.

In the spring of 2015 Kiera appeared with only a single kit, Josh. Had she perhaps lost others or had she only ever had one? Meanwhile Hettie, her two-year old daughter, had successfully

reared two – Jack and Jill. She was obviously an inexperienced mother for she brought out her kits when they were still very young. They were the youngest and smallest that Les and Chris had ever seen. She even abandoned them on the lawn whilst she came to the window to eat. One of them soon followed but the other lost sight of its mother and panicked, tumbling over the wall onto the gravel below. After this incident she often temporarily lost them and was seen running around the garden calling frantically to them.

Later Hettie moved her youngsters into the hay shed. It seemed ideal – warm, dry and safe, with room service on hand too. A trail camera first recorded her darting across the garden to take food in to them. Soon after this the two kits were filmed playing in the hay, sharp little faces peeping out of the gaps between the bales, playing tig and hide and seek in frenetic bursts before crashing to sleep curled up around one another on the hay. One wet and windy afternoon the weather was so squally that Les was able to creep in unnoticed to set his video camera up in the doorway. They were oblivious and his presence did not disturb their games. The resultant footage revealed blissful moments of play-fighting and the sheer devilry that surrounds all pine martens.

Kiera's extended family group were particularly relaxed with one another. They fed and played together and clearly had a strong bond. Jack and Jill were last seen in August 2015. Their time coming to the feed table was alas woefully short – only ten weeks. Then they simply vanished, and neither of them was ever seen again. Les and Chris felt that it was highly likely that Taff was their father and therefore Towy had driven them out. It is also possible that he might have killed them. After they had gone, non-resident youngsters accompanied Josh and they all ate and then played together on the lawn. The following year, again Kiera raised two young, Kim and Kevin. The latter did not

stay around for long and was last recorded in September 2016, however his sister Kim remains a regular.

Gus had been a regular visitor for many years until April of 2016, after which he disappeared for several months, not returning again until mid November 2016. On this visit he came to the table with resident male, K2. Despite his absence, Gus clearly remembered the routine and came straight in through the open window and padded up the hall, having first opened the study door. He peered around the sitting-room door before hopping up onto the sofa, where he politely took an egg from Les's hand, just as he always had done. Like all the best friends, with whom one can pick up exactly where you left off following a long absence, it was indeed as if he had only seen Les and Chris the day before. Certainly, it was clear they were not forgotten. Gus's intelligence was always very evident. He continued to make regular appearances until mid January 2017, then, following a heated dispute with the dominating Towy, poor Gus fled. However, there is still hope that he will return during the winter months. At the end of 2017 Towy was still in prime position as the alpha male. Hettie appears to be the alpha female and brought two new kits, Leo and Letty, in May. Kiera vanished in May 2017. Then after a long absence of nine months, she reappeared on 1 February 2018 and was given an effusive welcome from all her family. Her two daughters, Kim and Hettie, as well as Hettie's offspring, Leo and Letty, seemed delighted to see her. On each of her subsequent visits over the ensuing fortnight she was accompanied by one or more of her family members, and sometimes by Towy. At the conclusion of the story in March 2018 she is still visiting most nights.

In most early text written on the subject of pine martens in the British Isles, they are described as solitary, living alone, with males covering a large area and rarely interacting with other martens. Over the early years when Les and Chris were first

recording marten visits they began to question this theory; they accept that perhaps having a regular food supply may alter their behaviour, but do not think that would alter it to the extent they have witnessed.

They soon observed that the alpha male held the territory for life, aided by his male offspring. As he began to age he seemed to rely heavily on his son's support. When Graham and then Sam were alpha males, they were never challenged by any other male marten.

The alpha female also holds the territory for life, relying on the alpha male and her male offspring to see off rivals. Neither Freda nor Kiera was ever seen to attack other martens, a little tail-pulling was all the Humphreys ever observed. Hettie appears to be the exception, as she sometimes attacks other female family members, as well as visiting females.

During the years that Les and Chris have lived in Glenmore, the maximum number of martens coming to feed in any one night has been thirteen, seven of which were resident. They have identified and named 126 different martens in this period. Many more have been recorded, but only made a fleeting visit, staying for just a few nights. These animals therefore remained nameless.

Les and Chris were curious to know the average weights of some of their visitors and in the autumn of 2009 they set up some veterinary scales with their digital readout some distance away to avoid disturbance. They baited the scales with food and recorded the results using some willing participants for the trial. They discovered that Freda weighed 1400 grams, Graham was 1700, Dan 1900 and Craig 1800.

Sea eagles and spectres from the north

It is a sharp afternoon in late October, light silvering the sea. Cloud drifts between Muck, Rum and Eigg, blending them into one island instead of three. I stand at Achateny, a remote shore on the north coast, on sand carpeted pink and yellow with tiny broken shells. The collies are racing one another crazily up and down the strand. Their pied coats are sodden and speckled with sand and salt, and they are happy. After they have burned their energy we will find a place to hide and watch.

Grizzled blackfaced tups graze on the salt marsh. The sap is rising, their testosterone levels mounting and they are in grumpy humour, an upper lip lifted in flehmen response, lips curled back, a foreleg raised, and the position held for some minutes

as they sidle up to one another. Many mammals behave in this manner, and in the case of sheep, it is a frequent sight at the start of the breeding season, triggered by the scent of stronger hormone-laced urine and pheromones. They test the air, exploring the pungency with heightened senses. They are eager to mate. Earlier I watched them clashing with one another, bickering like youths on a street corner eyeing up the talent. Deep thuds made me wince as gnarled horns locked during repeated jousts. But these old boys have existed together all year and have long sorted out serious battles. One has dried blood around the horn base, and due to the incessant wet, they have foot rot. Tups always have a tendency to go lame just when they need to be on all four pins for the start of the annual ovine orgy. Shortly they will be gathered off the shore where they have idled away their days for the past few months, and taken to the in-bye ground to rendezvous with the ewes. Not a bad life being a tup, though it must be exhausting, nothing for months, and then it all happens at once: ewe, after ewe, after ewe. Their strong smell mixes with that of the rotting banks of seaweed washed ashore by recent storm tides. Starlings and hooded crows pick at a rich medley of invertebrates, a raven pulls at something dead on the foreshore with its dagger-like bill. It sees us approaching and takes off in a hurry, circling a few times before landing on a rock further away. It lifts off again as we pass. Its sentry box is well used, bespattered in droppings and littered with pellets revealing its diverse diet – beetle cases, sheep's wool, red deer hair, feathers, bones, fish scales and grain. The moment we are clear of the area, it will be back to finish its repast.

I find my usual rocky crevice, from where I have a wide view of an extensive area of shore, and begin to settle. The gulls have been here earlier and have left the remnants of a long-dead fish. The dogs want to investigate; a roll would be nice. Eventually they are reluctantly persuaded to leave well alone, and resign

themselves to another snooze. They lie down and shortly fall into slumber. Rocks, saffron yellow and lime with crusty lichens, serve us well as a hide.

Further out on a skerrie my eyes pick out a shape. It is hunched like an old man, curvaceously round-shouldered and stooped. I look through my binoculars and see that there is another right beside it. Two white-tailed sea eagles are in the splash zone, wing-stretching and preening, not doing much other than resting a while, jumping up in the air and flapping almost as if playing whenever a wave smashes close to them. It was here at Achateny that I saw my first sea eagle at the end of the 1970s. It was an extraordinary moment, for I had never seen such a vast bird before.

That day fleeting rainbows danced over Rum's high peaks as rain splodged the steely sea. I had been watching a pair of otters on the rocks tugging at a butterfish, emitting their shrill whistling contact calls to one another; I was fascinated by the way the water ran off their pelts, the sounds of sharp teeth crunching through fish bones accompanied by the pibrochs of a curlew. They had slipped down over the rocks, scent-marking as they launched effortlessly into a jungle of swaying amber bladderwack, their tail tips appearing like two full stops as the weed engulfed them and they gently began to cross the bay. After they had vanished I sat a while, letting the perfect sighting live on a little longer. A pair of rock pipits tweeted to one another, and a wren ticked from a trailing snarl of brambles.

I was quietly basking in my reveries when a movement on the shore caught my attention. There was something large leaning over the remains of a dead sheep. At first I thought it was a golden eagle but it seemed so much bigger and paler in colour; its almost lazy appearance had that of a huge vulture. Through my binoculars I could only see its back view as it pulled vigorously on the carcase. A hooded crow appeared and dive-bombed it cheekily,

aggravating the large bird like a school playground bully. I was struck by how tiny the hoodie seemed in comparison. The great bird continued feeding but was clearly irritated, ducking its head whilst trying to avoid the unwanted intrusion. Then it suddenly roused its feathers, sending beads of moisture off in a spray, and effortlessly lifted off the sand. The sight of massive talons made me gasp. It was a sea eagle. The impressive bird skimmed out over the bay, great wings outstretched in a stupendous eternal glide. Within minutes it was almost at the towering sea cliffs skirting Rum, and then lost to view through my rain-fogged binoculars. It appeared so integral to the magnificent island sea-scape, so much at one with the setting, that I almost cried. It was then that I noticed the tide was about to engulf me. I wandered euphorically up the beach to the birch woods and sat a while longer, my back against a weathered stump.

It is now 100 years since the sea eagle was extirpated in Scotland. The last male was shot at North Roe in Shetland in 1918; previously they were found not only in wild mountain country, but also along most of Scotland's coasts and estu-aries, and rivers as well as in some surprising lowland habitats. It was not until the first reintroduction phase began bringing some birds from Norway to the island of Rum between 1975 and 1985 that they were returned to their rightful place as a part of our diverse fauna. Soon we began to see the occa-sional sea eagle around the peninsula – for a sea eagle it is but a short hop from Rum to Ardnamurchan – and eventu-ally they spread far and wide, with Mull being their favoured stronghold, though at the start of the programme breeding was slow.

As I watch the pair on their rock outpost, I think back to that initial sighting, the success of bringing back such an impressive bird. Their comeback is one of the great conservation success stories of our time. Now the sea eagle is a frequent sight in many

parts of the Highlands and Islands and thrives in Ardnamurchan, where I see them most days I am out walking.

★ ★ ★

A mist is coming in off the sea, the light fading, today's eagles playing with the waves on their skerrie rouse themselves, ruffling their fawn-buff feathers, as one lifts off and disappears in the direction of Ardnamurchan Point. The second bird shortly follows. No otters today, but then the eagles have absorbed me, and more time than I realise has passed. I move off and begin to walk back, the dogs close to my heel. Tendrils of mist smoke off the boggy headland, the ground wobbles wetly as we walk fast and light to avoid the deeper areas. I wander towards a birch tree silhouetted against the watery winter sky, and stand for a minute to look back over the bay. Then there is a distant sound, almost a fanfare, as if bugle calls are drifting on the wind. The dogs prick up their ears; heads cocked listening intently too. Whooper swans: spectres from the far north. I begin to make out the shape of their elegant forms appearing through the mist as they travel low over the sea. This is the wild swan, a beautiful bird that often passes through Ardnamurchan and spends a little time feeding on the nutrient-rich sea lochs and shores before moving away to find a sheltered wintering spot.

The cries of whooper swans are hauntingly evocative, and epitomise the wild environments they frequent. It is the whooper that is the truly wild swan, the bird that inspired Tchaikovsky's famous ballet, *Swan Lake*, a swan that is worshipped in various parts of the world. Steeped in myth and legend, the Japanese refer to the whooper as the Angel of Winter, and it is also sometimes called the whistling swan on account of the sound of its great white wings beating against the air and creating a mesmerising winnowing noise.

During excavations of an ancient tomb, archaeologists discovered the skeleton of a baby that had been enshrined in a swan's wing. Was this a sign that swans were also viewed as protectors and guides in the spirit world perhaps? It is a legend that adds to the bird's ethereal aura.

Some 4,000 whooper swans fly to Scotland to overwinter here, and they make a dramatic addition to our wildlife. With black legs and yellow bill with black tip, it is easy to differentiate the whooper from the larger resident mute swan, with its orange bill and dark legs. Whoopers bring with them the essence of the savage boreal regions where they rear their young. Swans pair for life, though if one of them dies, the survivor will quickly seek another mate. There are only a few sporadic records of whoopers staying in Scotland to nest, usually birds that have been injured and are unable to migrate back to their summer breeding grounds in the far north.

Sadly, though they are not shot in this country, those that fall victim to collisions with pylon lines are often found to contain large amounts of lead – many are shot at in other countries, or as they begin their journey to our shores from the high Arctic, Scandinavia and Russia. In recent years numbers of whoopers and their close relative, the equally lovely Bewick's swan, have plummeted. Some winters there appear to be many more than others. When I was a child they often spent long periods on the shore at Achateny, though nowadays, with the increase in winter snipe and goose shooting, they are easily disturbed so are seldom seen here.

Whooper swans have an extra long trachea, and when air is driven through it it can make an otherworldly sound, a sound that has given rise to the term 'swan song', for a final act. I once had an injured whooper swan in my care; unfortunately, it died, but as it took its last breath that strange sound did indeed sound like a last dying gasp, a melancholy farewell from a spectre from the north.

8

Bugged

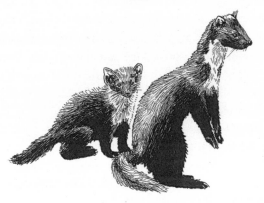

Les's early attempts to film the wildlife in the garden as darkness fell proved very unrewarding. It wasn't easy holding a video camera in one hand and a torch in the other, and led to some extremely wobbly footage, although he did succeed in filming their much-loved Graham playing in a rare snowfall with two kits on the back lawn. However, despite this success, it was now time to investigate some far more sophisticated lighting arrangements, and thus began a continuous, complex illumination quest during which Les upgraded his gadgetry and delved into a minefield of technicalities. A powerful light was first installed, with several others strategically placed around the garden. Les and Chris noted that the pools of light that now spotlit the nocturnal comings and goings of increasing numbers of martens did not

perturb them in the least. In short, they were not averse to the limelight.

Most evenings there seemed to be a rush-hour period when Les was able to use his old Canon XM1 video camera, setting it up on the window ledge to record until it ran out of film or battery, or both. This was far from ideal and it was quickly upgraded to a Canon XL2 that produced footage of a slightly higher calibre. A sequence recorded with this camera was shown on the BBC's *Nature's Top 40*.

'We really needed to know which marten was appearing at the feed station so we purchased a device that activated a beeper from the study window as soon as a marten crossed the beam. When we had human visitors for dinner, many a meal had to be put on hold as, alerted by the beeper, we all trooped to the screen, intrigued to see who had come in for a snack. One night we emerged from the dining room immediately the alarm sounded only to find both Graham and Freda trotting down the hall to meet us. It was the first time that they had actually taken advantage of the open study window to enter the house. This was the start of many such visits, and things soon began to change,' Les told me.

Now Les set his sights higher and began to buy motion-sensitive trail cameras to set up around the garden too, as he was determined to find out more about the comings and goings away from the window. The first camera was placed outside the window, but this achieved mixed results. Often all that was captured was the tail of a fleeing marten as it disappeared down the plank from the feed table. The trail cameras appeared to have minds of their own, were unreliable, sometimes did not trigger at all, ran out of batteries, or were set at the wrong angle to capture the action, and even then the film clips were woefully short. One night one particular camera, sited adjacent to a box for hedgehogs, had over eighty entries. Les and Chris were

intrigued but when they played the entries back only found it contained eighty clips of frenetic wood mice. One particular clip revealed a most determined mouse dragging a piece of toast and jam many times larger than itself across the ground.

Though trail cameras proved temperamental, they could not be overlooked as their portability was to prove most useful and they could be placed in strategic spots to capture other wildlife without disturbance. The first excitement was of an otter and her two cubs catching frogs in the garden pond, a heron standing sentinel under the bird feeders waiting to catch and then swallow a whole unsuspecting mouse – probably pre-stuffed with peanuts – and a marten posing nicely whilst peering directly into the camera with two frog's legs protruding from the corners of its mouth like a droopy moustache. Then the camera also captured perfect footage of a hedgehog self-anointing by the pond.

Hedgehogs have always been a feature in the Humphreys' garden, with many different ones coming to the feed table at night. They have also recorded a female gathering nesting material over consecutive nights, and taking it under the garden shed where she hibernated safely in close proximity to the odd snack if and when her need arose. Hedgehogs can be very pugilistic towards one another. They will huff and puff with their spines erect and at their sharpest as they barrel into an imposter whilst they rudely endeavour to shove it out of the way, particularly where food is concerned. Hedgehogs are extremely greedy and make considerable appreciative sounds as they tuck into a surprising array of foods. Like martens, they are omnivores and easily adapt to a mixed diet.

Despite more success with the trail cameras, the Humphreys were still not receiving enough information to start accurately recording and identifying each marten. Les needed to delve into things more deeply and start a new plan. The problems were soon remedied when their family gave them a wireless CCTV

camera as a Christmas present. Les set it up in his study over-looking the feed table and a large area of garden, and a signal was then beamed back to the TV screen in the sitting room. Now not only could they watch the action on their television, but they could also keep recording for twenty-four hours a day nonstop. Woe betide an intruder in this garden.

The new arrangement provided what one friend described as the most comfortable wildlife viewing hide on earth – no midges, rain, or cold, no hushed voices or camouflage kit, it all just happened directly from the comfort of a huge, soft arm chair, and usually with a drink or cup of tea in hand. When speaking to Les it becomes very clear that though he claims to be hopeless with technicalities, he is in fact a gadget buff. Though it seemed quite satisfactory, this new system did not last long and the camera was shortly upgraded to one with far higher definition when two infrared lamps were installed to enable better night vision in order to make pine marten identification even easier. Then just to really make things perfect, a small television was set up next to the large one so that Les and Chris could watch a television programme on one, whilst not risking the chance of missing a new arrival outside on the other. Multi-tasking genius! The two Glenmore Lounge Lizards, like the martens, were determined to have their cake and eat it.

Inquisitive martens coming into the study frequently inspect this latest camera, and it is not unusual for it to capture a close-up of an eye peering directly into the lens. On occasion the camera also gets knocked off, or moved so that it views a totally different perspective and angle on the room. As it has no method of recording the timings of visits, Les and Chris were unable to work out when their visitors were appearing. In order to overcome this, they placed a clock on the study window-sill that would be seen when the camera was triggered and also appear in the footage. This, like the camera, is frequently closely

Plate 1. The badger heading for a snooze in the hedgehog box.
(Plates 1–17 by Les Humphreys)

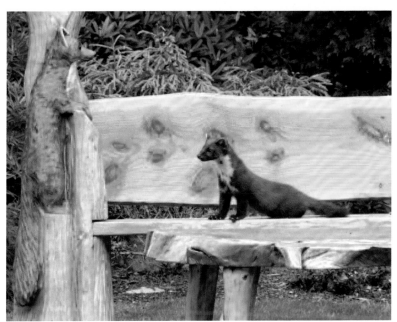

Plate 2. K2 relaxing on an appropriate bench.

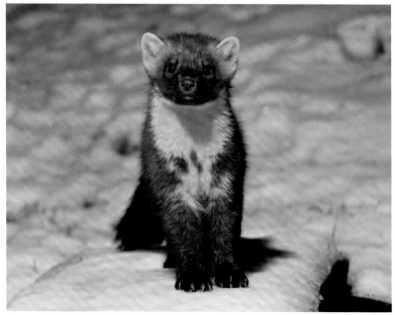

Plate 3. Towy – the bully.

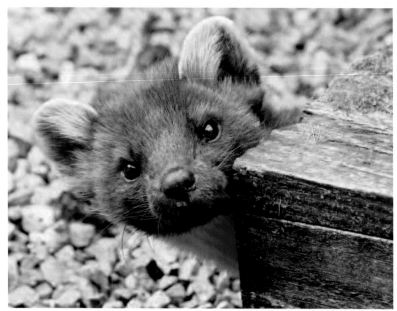

Plate 4. Can I come out yet?

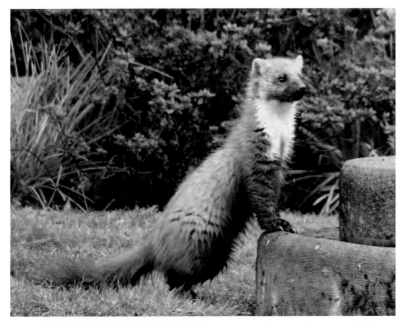

Plate 5. Admiring the garden water feature.

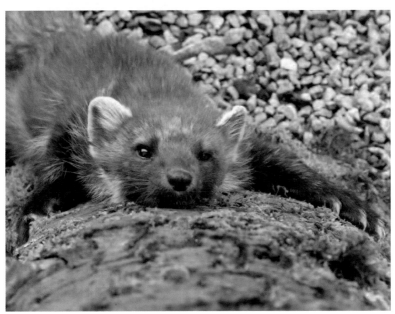

Plate 6. Enjoying a scratch.

Plate 7. Good strong teeth.

Plate 8. Peanut thieves are always present.

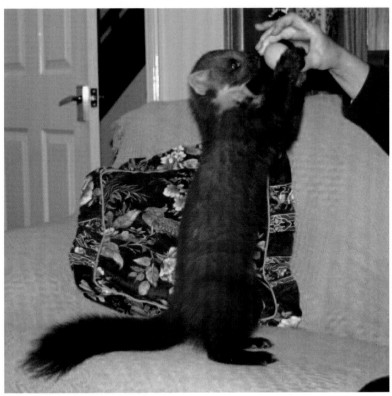

Plate 9. Graham takes an egg from Chris.

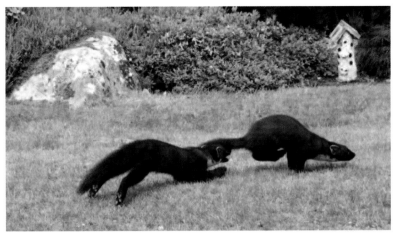

Plate 10. K1 and K2 at full tilt.

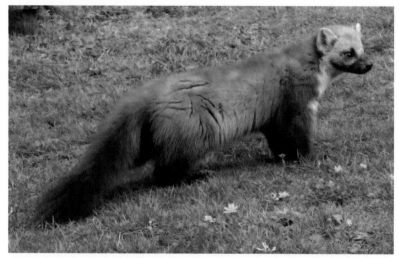

Plate 11. A lovely winter pelage.

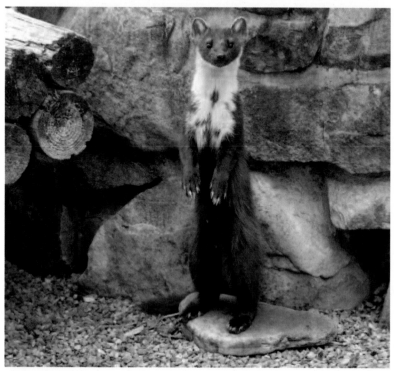

Plate 12. Kiera.

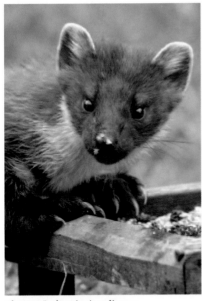

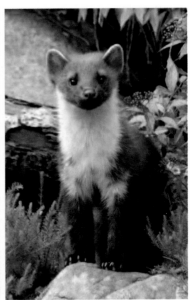

Plate 13. Josh enjoying dinner.

Plate 14. Leo aged five months.

Plate 15. Reggie: Do not disturb.

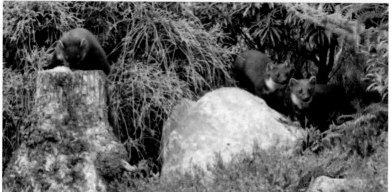

Plate 16. *Top*. Otters frequently pass through the garden, particularly in frog breeding season.

Plate 17. *Above*. Kiera with K1 and K2.

Plate 18. *Right*. Hettie.

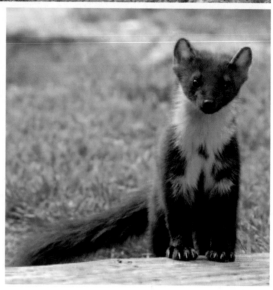

Plate 19. At home with her hand-reared red deer hind, Ruby.
(Plates 19–34 by Polly Pullar)

Plate 20. Les and Chris with Polly's dogs Molly, Maisie and Pippin at Ockle.

Plate 21. Achateny, looking towards Rum, Eigg and the Cuillins of Skye.

Plate 22. Beautiful demoiselle, well named, one of the most glorious of the damselflies.

Plate 23. Loch Sunart and the oak wood.

Plate 24. Ben Hiant and Camus nan Geall.

Plate 25. Herons are present all around the Ardnamurchan peninsula.

Plate 26. Ardnamurchan Point on a calm day. Waves here can be higher than skyscrapers.

Plate 27. Wind-sculpted trees, a feature of the Atlantic oak woods.

Plate 28. The beautiful fox, despite eternal persecution, is a true survivor.

Plate 29. The fabulous frog has fascinated the author since childhood.

Plate 30. Fine hill staggies in the oak woods.

Plate 31. Hedgehogs are fairly common in the oak woods, but like elsewhere in the UK are in decline here too.

Plate 32. *Top.* Ben Hiant and Mingary Castle, which has recently been renovated and is now a luxury hotel.

Plate 33. *Left.* Common seals haul out on suitable skerries, and like the greys sing Hebridean laments.

Plate 34. *Above.* Polly at Ockle with her tawny owl that was kept in supplies of fresh mouse courtesy of Kilchoan's village shop.

Plate 35. Treasure from a perfect marine garden – starfish and sea urchin.

Plate 36. The author's dogs Pippin, Molly and Maisie enjoying an island sunset at Ockle.

inspected, often nudged and moved, and as the visitor departs, it is also frequently scent-marked. Les and Chris are undecided as to whether this is flattering, or perhaps a warning to stay clear of it. On the other hand, as the scent is placed directly on a clock, depending on the time of year, it could simply mean, 'if you have the time, I have the place, come hither'. The jury is still out.

With the limited range of the new camera, Les and Chris were still unable to watch the activity of their visitors once they moved any distance away from it. And they really needed to know what was going on in the rest of the garden. Outside CCTV cameras were therefore added around the house. Some can be easily controlled from the sitting room, and may be zoomed in or out, or rotated through 360 degrees. As these cameras have wires, Les quickly realised that the trailing cables were an open invitation to hone climbing skills. Some enterprising visitors used them as climbing walls, whilst those with teething issues found them a magnetic attraction for testing emerging teeth. After losing an important collection of films and images recorded on one camera through chewed cables, all wires had to be inserted into electrical conduit well battened down to the walls of the house.

Most of the time the martens tend to ignore the presence of cameras as long as they are sited near walls, bushes or trees. However, attempts to set anything up in open ground causes them to be very wary. There was one particular instance when a trail camera had been fastened to a foot-high log and placed on the lawn. Les was endeavouring to catch a different angle of the animals approaching the feed table. That first night not a single marten came to the window. Shining eyes were spotted peering out of the bushes, watching, but very quickly disappeared. Freda eventually came out after some time and spent five minutes hissing and growling at the new obstacle on the grass, but then after a brief look vanished again. The camera had to be relocated in a far less obvious place.

However, garden seats and tables, even when put in a new position, do not cause any suspicion whatsoever; on the contrary, it is as if they have been sited there for the martens' convenience, merely as additions to an already extensive play park. They frequently take food from the feed station and carry it to a bench or table and there enjoy eating it. The bench seems to be a favourite place to take dead mice to be played with before they too are consumed.

Observing martens involves a great deal of lateral thinking, and though he would not admit it, it is clearly something Les is rather good at. His current system continues to be a work in progress as he struggles to keep ahead of the game. It is fair to say that this is a man who is now finally beginning to think like a marten. And after all, martens are clever. Not a flicker of a moth's wing is going to be missed in what has surely become one of the most intensively bugged gardens in the west. It even captured a desperate tourist stopping in the adjacent layby for a pee.

9

Antics

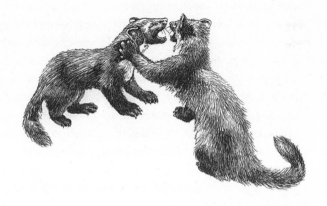

Soon after their move, Les and Chris had ambitious plans for their garden, particularly the area behind the house. They wanted to add more cover for visiting martens, whilst including a wealth of plants that would help attract other wildlife too. Whenever they were near a garden centre they went on a spree and bought a range of plants suited to the mild, wet climate: a selection of heathers and azaleas, some attractive and unusual rhododendrons (not the invasive kind) and many other shrubs, particularly those with berries loved by birds. Each had its individual label still protruding from the pot. As the plants were amassed it looked as if they were going to be busy digging for weeks, but they needed to have everything in place before they could plan their landscape strategy. During the night, however, things would

disappear and the labels were removed. Most were nowhere to be seen, but some lay strewn about the gravel. The strong winds for which the area is renowned were blamed until one night the Humphreys caught one of the label thieves in action. Zippy, then a young kit from that year, was adeptly nicking them. He was climbing up onto the wall and then dropping down behind a cold frame, where he had made a rather big collection.

As well as putting most of the plants into the garden Chris enjoyed filling tubs and terracotta pots for the patio area, to frame the steps around the lawn. But these were frequently rearranged, the bulbs dug out and either removed altogether, or left in heaps in odd places. On one occasion after she had planted dozens amongst the trees, they were exhumed almost immediately but remained undamaged. She put them all back in again. She shouldn't have bothered for they were swiftly removed several more times. However, Chris is tenacious and remained resolute in her mission to make a beautiful garden. And eventually the exhumer grew tired of digging. Perhaps Chris had won at last.

The cedar wood greenhouse has provided another source of amusement; a marten regularly climbs on top. Dan, when still a kit, was seen following his older brother Clive around the garden, almost as if he were looking up to him and could gain some life experience by sticking close. Over the years the Humphreys have often witnessed this kind of behaviour when younger martens are almost mentored by their senior siblings. In the case of the greenhouse, Clive made his usual foray up onto the glass roof and was closely followed by Dan, only five months old at the time. Dan struggled to follow his athletic brother but eventually made it to the summit too. However, as Clive showed off his precarious ridge-walking, finishing with an effortless leap off the end, Dan became visibly nervous and started to panic. He stepped off the metal ridge onto the panes of glass but with nothing to grip took off as if skiing, and slid out of control

straight onto the cold frame beneath with a loudly resounding crash. He immediately picked himself up from this indignity and, luckily none the worse for his degrading experience, raced off to join his brother.

The westerly winds that sweep in off Loch Sunart are salt-laden and destructive. Beans, peas and sweet peas must be protected with plastic windbreaks, though even these are often unable to contend with the wind's velocity. However, there is something about these windbreaks that draws a marten like a fly to a carcase. It seems that using them as climbing frames helps a youngster to hone its skills, and it always appears as if they think they have been put there entirely for their benefit. They find them very easy to climb, and long periods may be spent playing, swinging and play-fighting through the mesh. They have also used them as extremely versatile and comfortable hammocks in which to have a few moments' shut-eye.

One year Les and Chris stacked three large upturned plastic tubs behind the mesh and witnessed two young martens repeatedly climbing to the top of the frame before leaping down onto the tubs in turn, one after another. From inside the house, the noise of their activities sounded like a drum roll, and watching the spectacle kept the occupants glued to the window until the game came to an end. It was as if the juvenile martens actually relished the sound they were creating. Perhaps less appreciated is the modification of watering can and trowel handles as teeth are employed for a little artistic sculpture work. Altering the electric cables on the livestock trailer is another favourite mischievous game when young martens are having teething troubles. This is certainly unappreciated.

Mature oak and silver birch trees in the garden have always proved a popular adventure playground. Here the young martens perfect their climbing skills whilst using the trees as springboards, leaping from one to another. Thus begins their extraordinarily

acrobatic, sylvan lifestyle; the marten is doubtless the Russian gymnast of the mustelid tribe. Some martens climb to the very uppermost branches, where the trees' thin tips sway precariously. This helps with balancing skills, and from here they can still manage to play-fight with siblings or the older, wiser members of the party. Just as a group of children in a playground will have their leaders and daredevils, so too the martens. Some are real stunt artists and swing from the flimsiest of branches before cascading to the ground and then racing back up the tree again to do it all many times over.

Another favourite place to play is on a small, round water feature with two old millstones in its centre. The water is pumped up through a plastic pipe in the middle of the stones. At night when it is turned off and no water flows through the pipe, it is regularly pulled up through the hole in the top stone, and with a spot of chiselling from very sharp teeth is modified to the extent that the pipe frequently needs to be replaced.

The martens have often used a ground-level feeding tray for the birds that has been on the lawn for years as a table on which to occasionally eat their food. One night it attracted the attention of Leo and Letty, who were in a particularly playful mood. Whilst one sat on top the other tried to squeeze into the narrow gap underneath. The tray, having fine plastic mesh in a wooden frame, was treated like a mini trampoline, with Letty jumping up and down whilst underneath Leo tried to up-end it and topple his smaller sister off. This continued for some time until he triumphantly succeeded, then the roles were reversed. Eventually the tray was tipped on end with a kit either side boxing each other through the mesh. When the tray dropped back down onto its legs Leo tried to up-end it again to carry on with the game but in his exuberance turned it right over. Now with the table's short legs pointing into the air he was unable to get underneath to continue his antics, so he attempted to lift it

with his teeth. Grabbing hold of one leg he managed to get it off the ground but then he simply couldn't turn it over. Now clearly bored with this game, which had lasted for half an hour, the siblings took off to continue a new game on a picnic table instead.

There is a large rock under one particular birch tree. For a while a feral cat was a regular visitor to the garden, but she was certainly unwelcome. She liked to sit on the rock watching for mice under the bird feeders. One evening the marten devilment kicked off in the trees behind. An adventurous kit climbed along a branch directly above the cat. The branch sagged down low as it took his weight. Quite unperturbed by the intruder in his garden, the marten dropped lower and lower until he was almost level with the cat. He then cheekily extended an outstretched paw and tried to touch the disgruntled feline. The cat was unamused and jumped hastily off her rock perch, and was then shadowed for a while by a most inquisitive marten. Every time the cat stopped, so did her marten-shadow. Eventually they both melted back into the undergrowth and vanished.

Martens are great innovators. During a spell of particularly cold weather two new visitors appeared to be extremely excited whilst playing in the garden. They had discovered a large plastic plant tray full of water a couple of inches deep that was covered in a layer of ice. This was intriguing. Initial investigations involved scratching at the ice with their sharp claws as they frantically tried to break it. When this didn't work, teeth were employed instead. This didn't make any impression on it either. Instead they took it in turns to bounce down on the hard surface, using it as if it were a trampoline too. After concerted effort, the ice began to fracture, making a loud splintering sound that encouraged their game even more. When most of the ice was broken, wet paws were shaken vigorously, and both moved off in search of further entertainment.

It is of particular note that no aggression between parents and their offspring has ever been witnessed in the garden at Glenmore. Both parents are viewed regularly giving up their food to a begging kit, yet it is generally believed that the males play no role in rearing young. Graham, Sam and Taff were often seen leaving with an egg or another tasty morsel only to be waylaid by a youngster who begged for the treat. These feisty adult males would then gently lay down whatever snack they were carrying in their mouths, before placing it in front of the youngster and swiftly returning to the feed tray at the window for further supplies.

Mothers appear to be exceptionally tolerant of the boisterous and effervescent behaviour of their offspring. On occasions this may lead to the kits nipping quite hard whilst endeavouring to shove, or topple their poor mother as she tries to eat her own food. The Humphreys say that they have seldom, if ever, seen much reaction from the long-suffering females, who seem almost totally oblivious to this behaviour on most occasions. When a mother leaves the feed table and wants the kits to follow she calls to them with a low, almost clucking sound. Any late followers mew like kittens and seem visibly distressed when left behind, but soon bound off to find her. She is never far away.

When they meet up at the feed table, family members usually scent-mark one another. The approaching marten first sniffs under the tail, then the ears and head before both go into a frenzy of scent-marking, repeatedly sliding over each other's back from head to tail. If the alpha male or alpha female are on the board eating and are joined by a juvenile, the adults are subjected to this vigorous sniffing and scent-marking, but ignore the attention and continue to eat. This ritual is not carried out if martens appear at the same time. Perhaps the sniffing and marking has been done in private prior to arrival, or, as Les and Chris have long suspected, maybe some of these martens den together on occasion.

When two martens come together to feed they will usually leave together. If one finishes eating first it will go and wait on the lawn for the other marten to join it. After eating, the resident martens invariably scent-mark the edge of the feeding station, or perhaps the plank leading up to it, as well as various places on the lawn. Sometimes they may even mark the actual food. All scat is vigorously scent-marked and any other previously marked spot is always inspected and viewed with close scrutiny before being thoroughly marked again. This behaviour has not been observed in non-resident martens.

The Humphreys have noted that any scent-marking of food, or indeed the surrounding area, does not appear to act as a deterrent. On the contrary, it appears to act almost as a food map, leading non-residents to the table where fine food awaits. Resident martens tend to snack, eating for up to five minutes, whereas non-residents, if undisturbed, may stay for up to an hour.

When visiting adolescent males venture in to feed, the resident female youngsters sometimes accept them. After inspection they will eat together before departing to play around the garden. Josh, a single female kit who was first thought to be male, hence the name, was one such youngster who delighted in entertaining these young males, and Kim and Letty are now repeating this behaviour.

However, contrary to this playful behaviour by the youngsters, non-residents are not so well tolerated by the resident adults. Sometimes a fight may break out on the board and the new-comer is pounced upon with much squealing and growling as the pair roll about in a heated mêlée of fury and displeasure. Normally the intruder dives for cover whilst making it plain that it is far from happy with the situation as it cries and yowls miserably, until the resident marten gives up and goes off. Only then will the intruder return to eat, but it will remain nervous,

constantly looking over its shoulder for any sign of the fiend's return. Occasionally they will take refuge in a hedgehog box, and some martens have been known to remain there all day, clearly happier to lie low. They usually venture gingerly out the next evening. Les discovers these animals when opening the hedgehog box lid to replenish peanuts in the bowl inside. Almost always he is able to gently close the lid before creeping away without disturbing the occupant.

Females rarely show serious aggression. Hettie is the only exception, diving in when an intruder is on the board. She rudely grabs his or her tail and continues to keep hold of it, forcefully yanking the feeding marten backwards before quickly retreating. One young non-resident, Keeper, would regularly sneak in for food. He must have taken shelter from one of Hettie's furious attacks, for he retreated into the hedgehog box. She had scalped the end of his tail and the hairless tip protruded out of the tunnel entrance to the box. It took six months for his tail hairs to regrow, and he always remained wary.

Usually the newcomer will be chased off, but some may dive for cover in one of the hedgehog boxes, or even under a kennel bought for a badger. This is not a good idea, for once there they may be pestered and persecuted by an irate resident determined to flush them out. The antagonist will run round and round the kennel or box screeching like a soul possessed whilst the trapped visitor makes every bit as much racket from inside. Eventually tired of all this fuss, the resident may relax for a while, and it may be then that the captive bolts for freedom. As it tries to make its escape it will soon have a yowling marten hard on its heels, and the two vanish until the sound of their miserable row finally dissipates into the woodland.

One particular visitor that had spent all day in a small hedgehog box emerged one night to entertain Les and Chris for over an hour. After stretching and scratching himself continuously up

and down the plank, he then pulled himself backwards and for-
wards and didn't appear to be bothered at all, even though he
was being closely watched and filmed. In fact, it seemed as if
he was playing to his eager audience, because he swiftly began
to run through a full repertoire of high jinks. From the plank
he retreated to the lawn, where he started rolling over and over
again, stopping occasionally to look at the intrigued onlookers
watching from the open window; Les said, 'it was as if he really
wanted us to give him a round of applause and was keen to
ensure we were still watching'. Then, following a quick wash,
he was off again. However, in his joyous exuberance he didn't
realise that he was at the very edge of the lawn. He swiftly rolled
off over the edge, dropping a metre onto the gravel below. Not
put off by this he quickly ran back up the steps to give a repeat
performance, keeping well away from the edge this time. All
this was caught on video – 'Yes, it was a real *You've Been Framed!*
moment,' Chris laughed, when she was telling me about it.

When an alpha male stops coming and a new mature male is
trying to take over the territory, life in the garden is tumultuous.
All young resident males are quickly seen off and chased out.
This lasts for a short period, with many youngsters hounded
round and round the house and garden before eventually they
too disappear howling into the oak woods. Adult females become
very nervous at this time and are constantly on guard, aware that
all is far from calm and they cannot afford to relax until peace is
eventually restored and disputes sorted out.

Les and Chris know that the martens inspect the bird feeders,
but usually, though they keep their eye on them, they are left
alone; they all seem happier to feed on the board. Fat balls for
the birds are home-made, with bird seed and melted suet com-
pressed into a half-pint container, then placed into an open-top
suet feeder hanging on a branch. Not content with the food on
offer, one visiting marten decided to raid one of the suet feeders.

Les and Chris watched as he balanced precariously on top of it trying to extricate the contents. Though he struggled in vain trying to pull out the fat ball with sharp teeth, he was unable to get his head into the top of the feeder so he started to use feet to pull at it instead. Making little headway with this method, he became visibly frustrated, clinging on precariously with paws waving in all directions as the feeder, now under pressure from his considerable weight, started to swing rhythmically. Then, as the marten shifted his weight, the feeder began to tip. Suddenly the entire thing, complete with attached marten, plummeted to the ground. Try as he might, the marten found the feeder too heavy to pick up to take away so instead had to content himself with a dragging method, and eventually succeeded in getting his booty up the lawn and away into the bushes. Mission had been accomplished very successfully. The feeder was not seen again.

Les and Chris were puzzled when bits of plastic-covered foam began to appear scattered across the yard. As they had no idea where it had come from and it didn't appear to relate to anything they could think of, they simply tidied it away and dismissed it. However, next day there was a considerable amount more, forming a trail that led up to the field from their parked-up boat on its trailer. On closer inspection, they found that the boat's cover had been lifted off on one corner, and there was a little gap large enough for an informal visit. They began to wonder if perhaps one of the martens had decided it rather fancied having a houseboat. It was a dilemma. Should they go in straightaway to investigate and see if there was serious damage, or would this disturb and frighten the new incumbent? In trepidation they carefully removed the cover. There was no sign of the squatter, but prior to departure the guest had carried out a few modifications. Luckily this damage was confined to the deck area only. The seats had been gouged out and uprooted, and large chunks of foam carpeted the floor, but as with their first encounter with

a marten's liking for mechanical things, the culprit appeared to have merely been interested in the possibilities of unusual take-away bedding, probably to line the maternal den. Les and Chris removed the remaining seats, and since then there have been no visible signs of any more marten boating activities, though they admit that due to the financial implications, they really daren't look too closely. The martens are not the only ones to favour boats, for brown long-eared bats were also found roosting quietly under the boat's cover. Happily, they are not destructive and were welcome to roost on in peace.

More about martens

The pine marten is one of four of the smaller native British mustelids that includes weasel, stoat and polecat, the larger members of this group being otter and badger. Each is brilliantly adapted and characterised by its bounding gait, playful nature and incredible strength in relation to its body weight. All are strong and well equipped with powerful jaws and limbs.

The pine marten, like the red squirrel, is a woodland gymnast, though the squirrel, being lighter and even better adapted to its forest habitat, has the edge by a long way. The marten's broad feet seem perhaps a little disproportionate to its slim body but this special adaptation, and its semi-retractable claws, means there are few trees that it is unable to climb. The strong bushy tail is often used for balance, much as squirrels employ theirs

whilst racing through the leafy canopy. Though the pine marten favours a woodland habitat, the demise of vast tracts of native forest, and therefore the loss of its previous strongholds, has forced it to adapt; it has now learnt to survive in surprisingly barren treeless areas, on moorland and open hill, providing there are plenty of rock crags where it can make suitable dens and take cover. Sadly, the paucity of connected woodland has been to the detriment of all of our native species. Indeed, the UK is now the most deforested country in Europe, though there are those who would argue this point.

The pine marten favours a den site above ground, although there are instances when it may make use of an outlying vacated badger sett, a situation that inevitably carries a high risk. Other than man, foxes pose more threats to martens than any other species, and a sett or a den below ground offers little security when a fox is on the prowl for food. Though on occasions foxes may endeavour to climb into the lower branches of trees, they are not arboreal, so for a marten a tree den site is far safer. In mature woodland martens find plenty of suitable havens – hollow trees and tree fork cavities and old woodpecker nests provide perfect locations, and on occasion abandoned squirrel dreys may also be commandeered, though resident fleas and mites left behind by the previous occupants can prove a hazard. In certain parts of Scotland, tall wooden nest boxes are put up on trees for nesting duck, such as the golden eye and goosander, and martens will frequently find these to their liking, and in particular females may use them for maternal dens. On occasions the unfortunate occupants may first face eviction, and broods of ducklings may end up on the menu in the process. Rock crevices and holes under tree roots are also used. It is vital for a female marten to find a secure site in which to give birth to her kits. However, like stoats and weasels, if she feels threatened she will quickly move her young to another, safer, place, carrying each in turn by the

scruff of its neck. Increasingly, female martens are making use of loft spaces in houses, or derelict farm buildings and haylofts where they are not always welcome, though their ability to keep rodents at bay is certainly advantageous. There appears to have been little documentation or study regarding the possibility of martens dying from the effects of secondary poisoning in cases where rodenticide is used on farms, where martens may consume already dead victims. However, it seems highly likely that where they live in close proximity to farms that use poison they, like barn and tawny owls, may also sadly fall victim. Outwith the breeding season a selection of dens may be used for daytime refuge; these are often merely boltholes that can be adopted in a hurry to escape danger, but each marten may have a particular favoured sleeping site as well.

Of all the mustelids, it is the pine marten that has the most catholic diet, and though a true carnivore, it is equally able to exist on a vegetarian-based diet of fruits and berries, particularly when the season dictates. With the increasing use of trail cameras and wildlife hides, several martens have been seen feeding on carrion together, particularly on deer carcases, but they may be equally as attracted to fallen fruit in an orchard, or to a wild bees' nest – for, like badgers and foxes, they love honey; grubs and invertebrates, small birds and mammals usually form a part of the diet too. Food choice will depend on availability, but for so many creatures – owls, raptors, foxes, stoats, weasels and martens – voles are one of the most important staples, together with earthworms and beetles. Martens living close to the sea will also forage for shellfish and crustaceans on the shore, and on occasion may steal the eggs of nesting shorebirds.

There may be a considerable size difference between males and females, with males often as much as a third larger, though this is not always a failsafe manner in which to sex a marten, for on occasion females may also be of a substantial size, or males

may be unusually small. However, after seeing martens on a regular basis, it soon becomes clear that normally males look much coarser and have large strong heads, whilst the heads of females are usually finer and more pointed, even slightly foxy – to my mind the marten in appearance is more vulpine than feline, though many people refer to them as 'catlike'. It is easier to tell the difference during the mating season, when it becomes blatantly obvious, as males' testes become far more swollen and visible, while during the lactation period, when a female is rearing kits, teats will be equally prominent. However, during winter when the pelage becomes densely luxuriant, with young martens in particular it may become harder to discern males from females.

Mating takes place between July and August, when the female comes into full oestrus. Males may mate with many different females in their territory, but after copulation are believed to take no further part in the raising of their offspring. However, as noted earlier, Les and Chris Humphreys have witnessed many examples, among the martens visiting their garden, of males giving their own food to begging youngsters, presumably their own kits. Mating can be a protracted and noisy affair as the martens emit a range of sounds. There is also much playing and nipping as they chase one another, often for a few hours. Eventually the male may hold the female down by biting the back of her neck as he mates with her, and there will also be considerable scent marking of one another in the process.

Like all mustelids, martens have important scent glands and use them as a means of communication, to mark their territories, signal to other martens that they are ready to mate, or perhaps warn newcomers venturing into an area to stay well clear. Happily, the pine marten is no skunk. Unusually amongst mustelids a pine marten's anal glands do not produce an unpleasant aroma. Even the domestic dog has anal glands that can produce a

far worse nauseating stink. Martens also have other scent glands in the middle of their abdomens, and during the mating season the male's gland become greatly enlarged and is obviously used to send out rampant sexual messages to receptive females in the area.

A pine marten's actual gestation period, when the embryo finally attaches itself to the uterus wall and begins to develop fully, is very short – only around thirty days – but like several members of the mustelid family, martens have delayed implantation. This means that though mating takes place during the summer, the subsequent kits will not be born until the following spring, a delay following mating of between five and six months. Many other mammals have delayed implantation, for example the stoat, but surprisingly, though closely related and very similar, not the weasel. The badger, and one of our native deer species, the roe, also has delayed implantation, and so do some species of bat. This strategy means that the embryo – known as the blastocyst – is not immediately implanted in the female's uterus and is maintained for as long as necessary in a state of dormancy.

In the case of the pine marten, the winter would not be a good time to be raising young, and she may be mated at a time when she is still suckling the young of that particular year. Since lactation takes a serious toll on the mother's body resources she will be thinner, and therefore perhaps at a low ebb. Another pregnancy at this time, particularly over the hard winter months, could perhaps even lead to her death. So though a female marten may mate when she is less than eighteen months old, due to delayed implantation her first litter will not be born until she is at least two years old. Obviously, delayed implantation (also known as embryonic diapause) is a highly complex scientific topic and this is but a simplified explanation. However, why some species and not others use this extraordinary natural strategy remains a

mystery; perhaps some mammals have simply not yet evolved to do so.

Like wildcats, pine martens do not produce large litters and between two and four kits is an average norm, though there are always exceptions. The kits are born almost naked, covered with only a little soft whitish fuzz. Soon after birth they start to grow fur of a similar colour to that of the adults. Their eyes remain shut for the first thirty to forty days, and they remain in the den with their mother for nearly two months. By the time they have reached three months of age they begin to leave the den, tentatively at first, but gradually gain confidence to follow her on her hunting forays. Through extensive play-fighting, and with help from the dedicated parent, they start to learn to hunt for themselves, but in many cases they will remain with her until autumn, when they eventually disperse naturally. At this time the young martens are vulnerable.

Martens can change in appearance quite dramatically as they moult out at the end of the summer into their thick winter pelage. Their fur is darker, richer and glossier in appearance during summer, and the individual throat patch, stippled with the unique markings that set each animal apart, can vary from cream through to a rich yellowy-orange. They can fluff out their tails when threatened, in a presumed endeavour to give themselves the appearance of being larger and more intimidating, and tails are also used for signalling. In winter the coat is of a paler brown, and becomes extremely dense. Some martens appear fluffed up, almost woolly, at this time. As I mentioned earlier, it was this luxuriant coat that made the marten such a prize; it was often described in the past as the most beautiful of all the fur-bearers, something that did little to prevent its near-extirpation in the nineteenth century.

Though females may mate with several males, the Humphreys have noted that the dominant female appears to be quite

particular, remaining faithful to the alpha male, rather than having multiple matings as previously suggested in text books. This would explain his close relationship with all their offspring and perhaps the reason why, when a new male does take over the territory, all the previous alpha male's offspring are driven away.

Spore and spraint (tracks and faeces) are the best way to look for signs of any mammal in a particular area. However, though martens may leave their spraint in prominent places – well-worn tracks through woodland, paths used by walkers and cyclists, on exposed tree roots, logs, or on the top of rocks or walls – it is not always possible to know if these are left by foxes or martens, for on occasion they may be very similar in shape. As martens usually travel at speed and have a light, almost dancing gait, they do not always leave clear spore either, and given that in recent years we have had little snow to help with tracking, it may take time to adjust to signs left by various mammals. Like the fox, the pine marten has a four-lobed pad surrounded by five toes, but in winter in particular, hairy feet can leave blurred splodges and the spore is not always easily identifiable. I can usually detect the intense musky aroma of fox with its fresh spraint, and usually find that it tends to be left in a more random manner. In the case of the pine marten, the spraint has little smell, and it is more frequently prominently placed so that it is hard to miss, as if the depositor wishes to announce its presence. These droppings carry the tell-tale signs of recent meals: beetle cases, remnants of small mammals – vole and wood mouse skulls – soft down feathers, partially digested berries and mammal hair. Marten spraint usually has a twist or curl, perhaps even forming the shape of a roughly drawn ampersand, and even on occasion a question mark. When you are struggling to pick up the right signs this seems appropriate, almost as if the animal is testing you: is it, or isn't it? Through careful observation and patience, eventually it becomes fairly clear as to who has left what.

Once I took a very serious couple out for a day to watch otters and eagles. Both species obliged and it was a great success, with some glorious sightings. The couple had learnt everything they knew from books and had seldom been out in the field, but that day we spent a great deal of time looking at spraint left by otter, fox and marten, gull and raven pellets, and various other tracks and signs. At the end as they said goodbye, still as serious as ever, they asked 'Do you have a degree?' I replied, 'Yes, I do.' 'Oh, in what subject?' 'Turdology,' I answered. They simply nodded but definitely did not get the joke, and I wondered later if they ever realised. The point here is that in order to learn about mammals and birds, you do indeed have to study copious amounts of turds, and it is only through doing this that you become proficient in the fascinating subject of tracks and spraints left behind by animals and birds.

The pine marten's role in the demise of the capercaillie is often mentioned. Together with corvids and foxes, they are thought to be consuming their eggs and chicks. A suggestion to trap them during the breeding season in key capercaillie habitats and keep them in cages till chicks are of safe size would prove disastrous, as pine martens too breed in spring, and live in close family groups – 'a richness of martens'. It is a worrying issue with few easy answers, particularly when capercaillie numbers have crashed close to a total demise. There are other factors at play here too: increasingly wet breeding seasons, loss and fragmentation of habitat, increased pressure on wild places from walkers, dogs and mountain bikers, and the continual march of urbanisation. It is always far easier to blame everything else other than ourselves, but the truth is that in most cases man is indeed at the root of all evil and is the reason for the declines in most, if not all, species. The pine marten almost certainly does not help the struggling capercaillie, but it is really the least of this large, turkey-sized bird's problems. Human disturbance has even led

to bizarre and unnatural, overly tame broody behaviour among grey hens (female capercaillie) unable to find a mate. Ridding an area of pine martens won't resolve that.

A sighting of martens, as with all wildlife-watching, is never guaranteed, but there are an increasing number of wildlife tour operators attracting them into hides with feed stations, and this can be the perfect way to become acquainted. Watching mammals such as red squirrels, pine martens and badgers is fast becoming a valued asset for wildlife tourism. Providing it is carried out with respect and there is no stress inflicted on the animals, it doubtless has endless beneficial knock-on effects. In recent years, as the marten population has steadily increased, and more amenity picnic sites have been made in forestry wood-land, on bike trails and in local beauty spots, martens have in turn taken advantage. Sadly we are a messy, wasteful species, often chucking food scraps on the ground and leaving our litter everywhere, and this sometimes attracts opportunists. After they have enjoyed some of our food, spraint may frequently be found in these populous places, even left cheekily on picnic tables for all to see. Some sites are becoming increasingly well known for attracting martens, much to the delight of human visitors, and it is not unusual now to see an animal that usually tends to be more nocturnal and crepuscular in habit, in broad daylight. One vis-itor centre that is famed for its delicious tea and cakes has started making special batches of scones for their visiting martens, but notes that they refuse to eat them unless they have strawberry or raspberry jam on board too. Needless to say, visitor numbers have soared since these marten tea parties have been publicised.

Of mice, shrews and weasels

Mice and voles, as well as shrews, are an integral part of life in the Glenmore garden, and peanuts kept in a large plastic bin in the stables are a frequent attraction, particularly for wood mice. Like all rodents, they appear to be innovative and frequently go in to help themselves if the lid is not on tight enough. One morning Chris opened the bin to find six fat little mice had been revelling in an overnight feast, having first nibbled a neat hole in the bin lid for ease of entry. 'Though the martens would in turn have relished the mice, we didn't have the heart to kill them, so we caught them up carefully and then transported them away some distance before releasing them again,' Chris told me with a laugh. 'I'm sure they soon came back again if the martens didn't catch them first.

'One day whilst having coffee on the lawn, discussing where we could site a run for our two guinea pigs, a weasel popped out of a hole in the wall, shot under a bird feeder, and then shot back out carrying a mouse before disappearing down a hole with it. It all happened so quickly. Needless to say, the guinea pigs were subsequently never given the chance to enjoy their outdoor run, the risks were just far too great, and anyway they might have proved very tempting for the martens too.' Chris was philosophical as she regaled me with the story of the guinea pigs. These two animals had an enormous run in the kitchen but great care was taken to ensure the door was never left open, particularly when at any moment a marten might appear to have a closer look. The guinea pigs, surprisingly, both made it to a ripe old age. Fortunately, there were no mishaps.

On another occasion Les and Chris watched a female weasel carrying something at great speed through the garden. At first they thought it was a mouse but after half a dozen trips using exactly the same route they realised that in fact she was carrying her kits, moving them to a new den. She moved in such a hurry that focusing on her was impossible.

'There was a large pile of stones behind the garage and one day we spotted a great deal of activity. A female weasel with five or six young was playing in and around the rocks. I hastily set up a tripod and video camera a short distance from the scene and we were lucky to watch their brilliantly nubile acrobatics for over an hour. They didn't seem bothered by Chris and me in the least, on the contrary, at one point some of them came to play all around our feet,' Les told me.

Stoats and weasels, and indeed all members of the mustelid family, are extremely playful and use their elastic agility to hone the important hunting skills they will need as adults in order to thrive and survive. Play-fighting when they are young is vital and is the way in which all these well-adapted mammals must

learn. I remember a very similar incident with weasels when I came across a very young kit in the long grasses on the grass verge. It was crying in a most piteous fashion so I bent down to have a closer look. Though its eyes were open, it seemed extremely young, its ginger-chocolate coat damp from the wet undergrowth, and it looked chilled. I bent closer and was in the throes of picking it up when, from out of the tunnels of sodden grass, flew a nutmeg-coloured missile. She was clearly furious with my intrusion and hissed and spat at me, making a surprising amount of noise for one so small. She then endeavoured to launch herself at my hand, and I have no doubt that had I not moved off quickly, I would have been on the receiving end of a sharp bite. A few minutes later there was more crying from the undergrowth, and another kit appeared. I stood well back, watching the scene with interest as the mother worked flat-out to ferry several kits from their hiding place, and disappeared with one at a time. She had obviously been disturbed and was now moving them to a new den.

I have witnessed a stoat dragging a full-grown squealing buck rabbit along a track, its wiry, sinuous little body forcefully pulling and tugging with great skill; I was in no doubt as to this diminutive mustelid's capabilities. The stoat is not significantly greater in size than the weasel. The rabbit's end came as the stoat held its head down in a deep puddle on the track – as if a savage bite to the back of the neck were not quite enough, the stoat employed the water to drown the rabbit. Mustelids are amongst the most intelligent, strong and extraordinary of all mammals, and their behaviour never fails to astound me.

Holiday cottage owners in Ardnamurchan often struggle to keep on top of a plague of rodent squatters keen to move into unoccupied houses during the long, wet, winter months. From a mouse's viewpoint, why wouldn't you? A little comfort, an ideal place with folded disused bedding, snug lining for a

nest, and stray crumbs hidden behind cupboards and cookers. Perfect!

Male mice are said to sing squeaky love songs to their mates. Like their close relatives, rats, their propagation rates are alarming. Their rampant sex lives and the fact that they can breed at less than two months of age, year-round, are only part of the issue. Their gestation period is a mere three weeks and just one healthy female mouse produces at least 120 mice annually; given that all the offspring in turn do the same thing, it is easy to deduce that this can lead to one hell of a lot of mice. Though a mouse's life is usually only one or two years and they are heavily predated, there is still plenty of time for mischief.

The word 'mouse' has ancient connections with various languages including Latin and Greek, and is thought to have originally appropriately meant 'thief'. Mice are good swimmers and superb climbers, and regularly take huge leaps of faith in an aerial direction to avoid trouble. Their frenetic disposition dictates that they must feed about fifteen to twenty times each day; with their catholic diet, they tend to be everywhere, all the time, and usually move into buildings in the late autumn.

On several occasions I took a pet tawny owl with me to Ockle. It doesn't take long for word to spread in such a place as Ardnamurchan – everyone appears to know what you are up to even before you have done it. Word spread about my owl. Soon I was receiving little parcels of newly trapped mice delivered to the cottage. When I went to the village shop, the friendly owner who had had all the trouble with the brandy-laced mince pie-eating marten winked at me and said, 'I have a little something special for you in the storehouse.' He was quite giggly about it and I wondered what on earth it could be, and so did one or two of the customers who had overheard, and they winked too. The shop was packed at the time, with a long queue at the till. Once we were inside, he pulled the storeroom door to and

then proudly passed me several individually cling-film-wrapped mice that had been hidden in a corner. 'I like to make sure I keep all my customers happy, and I love owls,' he said, 'and these are for your friend, but I didn't dare give them to you in front of the customers and simply add them to your basket as you can never be too careful with health and safety these days, and some of them are a bit fussy.' I thanked him profusely. My owl was extremely appreciative, and during the course of that particular stay on each shop visit, I was treated to the same routine.

We have three types of outdoor mice in Britain, the wood mouse, also confusingly called the long-tailed field mouse, the yellow-necked mouse, which is far less common, and the harvest mouse, which is almost never found in Scotland. And then there is the ubiquitous house mouse. However, most of the mice in Scotland are wood mice; confusing, as they too can come into houses. House mice, however, really thrive best inside, and in the presence of humans and our mess. Their strong, distinctive smell is enough to warn of a serious problem.

Until Les mastered his camera set-up he would bring the memory cards in each morning to check who had paid a visit, and often found dozens and dozens of entries in quick succession. One night there had been over eighty visits from something, but what? At first he thought the camera wasn't working properly. However, these turned out to be a constant relay of voraciously hungry wood mice dashing madly between a bowl of nuts and the garden wall, where they were stocking up a lavish larder. On other occasions a large feeding bowl full of kibbled nuts appears to have been a meeting and eating spot for a wood mouse, bank vole and water shrew, all at the same moment.

★ ★ ★

Water shrews, though fairly widespread, are far from easy to watch. Indeed, most shrew activity goes largely unnoticed by humans. Their method of rushing about doing everything at high speed does little to help with their study. I know we have them living on the burn in our garden in Highland Perthshire, but the only reason I know this is because on occasion I have found a dead one lying on the bank, and once one of the collies caught one. All shrews have a very fast metabolism and are in constant need of sustenance in order to stay alive. Their lives are short – most probably do not live for longer than a year, with adults dying at the end of the breeding season. For a shrew, there is not a moment to be wasted.

Water shrews are the largest of our British shrews, which include the tiny pygmy and the medium-sized common shrew. They are also the only aquatic member of the clan, and are specifically adapted and well insulated with thick fur to cope with their watery environment, and have stiffened coarse hairs on their feet to help with swimming. Les and Chris are fortunate to have them living in proximity to their garden pond, for they are attractive little mammals with dense black fur on top, and paler grey-white underbellies – this two-tone outfit is another distinctive feature that sets them apart from other members of the shrew family. They are also the only British mammal to possess venomous saliva, an extremely useful addition to help them stun their prey. Humans who have been bitten by water shrews whilst live-trapping to collect data have reported an extremely sore area around the bite, with an accompanying inflamed rash. However, unlike the deadly consequences for a shrew's prey, there are no long-term repercussions for humans. In a garden setting such as at Glenmore, water shrews favour freshwater prey: caddis and dragonfly larvae, invertebrates, pond skaters, and backswimmers, as well as young newts, frogs, tadpoles, and tiny fish. They also consume numerous earthworms and land-based invertebrates.

Wildlife encounters fill me with awe on a regular basis, and one particularly fine spectacle involved an extraordinary view of a large family of water shrews. It was early September and Iomhair, my partner, and I were walking on the shore near the oak wood with our collies.

We had been sitting by a tiny burn that runs off the steep crags in the ancient oak wood on Ben Hiant's flank. Ravens and hoodies were mobbing a golden eagle, and their rude obscenities had punctuated the stillness of a flat grey afternoon, their harsh *krrks* and cackles echoing through the trees as they taunted and chivvied high overhead. Over the Sound of Mull, a sea eagle had also put in an appearance. It emerged from the vortex, and then crossed the water towards Tobermory without a single wing beat, its great silhouette eventually vanishing into low cloud swathing the smudgy hills of Mull.

After we had watched in motionless silence we moved on, scrambling across black rocks where the shore increasingly becomes more difficult to negotiate. We were following the tideline to the place where eventually it is too vertiginous and difficult to cross, and a sharp climb up Ben Hiant's slopes is necessary to reach the far side. Instead we sat again to wait and watch. A large square rock provided an excellent viewpoint. The dogs leapt up, nuzzling against us, damp coats salty and pungent, their aroma soggily seeping into our clothing. They had been rolling in something deceased on the shore. We chatted quietly, watching a seal lazily enjoying the massaging motion of small waves, and oystercatchers probing rock pools. The dogs began to nod and sank low onto the rock for a snooze, now no longer interested and blasé about the seal. Then without warning they sat up again and began to quiver, their ears pricked as they stared intently in front of them, eyes like pickled onions almost popping out of pied faces. And then I saw too, my eyes suddenly attracted to a new movement.

There on a bank of pungently rotting seaweed were some shrews, at first perhaps half a dozen, impossible to count as they were moving so fast, legs invisible, clockwork toys fully wound in perpetual motion. They seemed driven and determined as they darted back and forth, perfect velvet bodies and tiny almost invisible eyes, racing, racing, racing. The seaweed was exploding with invertebrates and minute flies that bounced and erupted in random dance. And the shrews were bouncing with excitement, feasting on their finds whilst emitting tiny shrill, barely audible squeals, as they dashed back into a small rock crevice. They were reappearing milliseconds later, or was this simply a new shrew? We were mesmerised and so were the dogs, they sat fox-like, quaking all over. Above us fresh water seeped from a mossy fern-cloaked bank, amid vestiges of summer flowers, salt-bitten and crisped, and heaps of herring gull pellets, empty dog whelk shells and a lattice of tiny lichen-framed holes – an idyllic spot for water shrews. We raised our binoculars, trying to count as more and more shrews appeared. It was impossible, for they were moving far too fast and too close to us to make use of the magnified vision. We didn't speak, but sat motionless, entranced and smiling at one another whilst pulling questioning faces. It must have been a mother with her young taking advantage of this rich source of nutrition found in the putrefying seaweed. When it was all over and the tide of shrews had retreated we could speak again. We reckoned that there were probably at least fourteen. Sometimes water shrews may have as many as fifteen young. Though they never stopped for one second, I had managed to see that they were quite large, and dark on top with a paler colour beneath. Water shrews that live in close proximity to the sea often take advantage of such an abundant food source on the tideline, however, though they are adept swimmers and can stay underwater for around twenty-four seconds and can also dive fairly deep, as far as I am aware no one has ever witnessed

them actually taking to the sea. The sheer nature of the tide, with its constant pulling and pushing, and strong currents, would prove too much for these tiny mammals and they would quickly drown. I have relived that extraordinary view into the secret world of the water shrew over and over again, and it remains stored in the annals of my mind, together with many other outstanding wildlife moments.

Snipe by moonlight

It is a stormy December night as I drive out of Les and Chris's gateway heading back to Ockle. We have been watching the martens feeding on the smorgasbord, and enjoying film clips of fox, badger and hedgehog visits too. The headlights catch the glow of dozens of eyes. Hinds and calves are down low close to the house to forage on seaweed on the shores of Loch Sunart. They used to come into the garden but, as their indiscriminate pruning was unappreciated, Les and Chris now keep the gate shut tight at night. I stop to watch as at least twenty cross in front of the car. The darkness magnifies their size. They remind me of my earliest experiences of deer seen in the car's headlights when I was a child sitting peering out from the back. How large they

seemed then – how exciting! These spotlit glimpses always left me feeling awestruck – nothing has changed.

I drive on, rounding the sharp bends high above Camus Nan Geall. On Ben Hiant's lower slopes deer have come close to the road and cross without warning. The headlights dazzle as a stag turns his noble head to look before leaping away. At this time of year there is often an influx of woodcock too. Twenty years ago a night drive back to Ockle on the north coast through the stunted birch woods would have revealed literally dozens flitting up from the roadsides, where they have perhaps been eating grit, but tonight I only see a handful. Many birds need grit to help them grind up food in their gizzards; it aids digestion and also contains important minerals. Sadly, shooting parties, many of them from abroad, are increasingly coming here, for woodcock are still on the quarry list, and are challenging to shoot. Not that challenging, for their numbers have definitely fallen, and I see far fewer, though there are doubtless numerous factors contributing to their decline. I find it heartbreaking that they make their way here, travelling great distances from Russia and Scandinavia through tempestuous weather, crossing stormy seas, only to be felled by a gun soon after arrival. The lovely little snipe too might meet the same fate, and it is rare now for me to see golden plover at Ockle, though I often used to hear their plaintive calls from the rushes during the summer – they too remain on the quarry list. Why would anyone want to shoot any of these perfect little waders?

During a cold spell a number of years ago, Les and Chris were intrigued to find small holes in the light snow cover on their lawn. Their cameras revealed a few woodcock foraging on the grass, sticking their long bills into the deep, soft soil to extract worms and grubs. They came to the garden for several winters, but have not been seen for the past few. In the last decade they too have noticed a decline.

Many early naturalists and writers were of the belief that this curious member of the wader family, with its distinctive bill and cryptic plumage in tones of browns and auburns reflecting the woodland floor, left our shores to fly to the moon. It was widely assumed that it took two months to reach its destination, where it spent the next three, before embarking on the marathon return flight, and arriving back the following winter.

Woodcock have their round, dark eyes set far to the sides of their heads, and therefore have almost 360-degree vision. This helps protect them from predators, but sadly not guns. In many suitable wooded areas of the British Isles, woodcock are resident and stay to breed, but numbers are greatly swelled each winter with the arrival of others from further north and east to winter here. In November and December, when the winds are from an easterly direction, they may appear in large numbers known as 'falls'. Two other migrants that similarly add to their resident populations and overwinter with us, the tiny goldcrest and the short-eared owl, have associations with woodcock merely because they arrive at around the same time. Both were once nicknamed 'woodcock pilot'.

I am fascinated by the unusual courtship behaviour of both snipe and woodcock. Sometimes as a rosy glow and low mist rolls over the in-bye ground in the early mornings or at dusk, a 'roding' woodcock passes back and forth over the Ockle oak wood. Roding is the extraordinary sound the birds make during the breeding season – more frog-like croak than birdcall, it finishes with a couple of bizarre squeaks. The bird is erratic in its flight, often flying in a random movement, almost bat-like. This behaviour added to the belief that it was an oddity with lunar associations. From Ockle, watching and listening to a roding woodcock is further enhanced when viewed against the familiar island backdrop of the Small Isles, as the last rays of the sun are squeezed out like juice from a blood orange spilling gold

and pink over the gale-blasted oak tops of the wizened wood fringing the burn on its dash to the sea at Inverockle.

Whilst woodcock are glimpsed in and around the woodlands, snipe may frisk up out of a deserted bog in almost any part of the peninsula. They often frequent iris beds close to the sea, guddling for invertebrates with their long bills, but equally may be found high up the hill in the nutrient-rich bogs.

A walk to Bourblaige, a lonely, ruinous clachan on the eastern slopes of Ben Hiant overlooking the Sound of Mull and the hills of Morvern, will usually be punctuated by views of swiftly departing snipe. It was here, on this exposed hillside, that some twenty-six families eked out a meagre existence dependent on fishing whilst battered by unforgiving gales sweeping in from the west. The hillside is ridged and shaped by pattern and form, remnants of their ancient lazy beds, but their dwellings have long since tumbled into the rushes, and now only heaps of grey stones garnished with lichens of a dozen different shades remain. Bourblaige is a wistful place. It has the atmosphere and power to transport me momentarily back in time to the early 1800s, when the families were literally driven out.

I try to imagine the sound of voices, the cries of children, and the clink of a bucket, the high-pitched bleating of goats, the lowing of cattle, and the aroma of peat smoke curling hyp-notically from the tiny thatched dwellings. When I was a child, the late crofter Malcolm MacMillan of Grigadale told me that Bourblaige suffered the same fate as hundreds of other small crofting townships all over the Highlands, and others in this part of western Ardnamurchan, including Swordle, Tornamona and Choire Mhuilinn. The landlord responsible for the clearance of Bourblaige was one Sir James Riddell. Malcolm said that the end came during the winter, when life would have been hardest, their diminutive Highland cattle driven off the hill, their dogs and goats shot. The lazy beds ploughed up, valuable life-sustaining

potatoes left to rot. And finally the houses were set afire. The people fled to the nearby crofting townships on the north side of the peninsula until they were forced to relocate elsewhere.

There are memories here; memories, melancholy and history. Some of the buildings are clearly visible, their rounded cornices still standing firm against the elements, and now the impoverished ground that once would have grown thin crops has reverted to bog. Snipe and scuttling field voles are a haunting reminder of a place that would once have danced with human life too. Sometimes on a still summer evening as a snipe takes to the sky and drums high over the scene, it is as if its melodic winnowing is a lament for their souls.

Bourblaige is a place of nature. I have lain here sheltered behind the ruins watching ravens and eagles, or a harrier swaying back and forth over the ridged ochre slopes above. In summer, wheatear nest in knotty tussocks of grasses, and meadow pipits parachute through the sky, performing their annual bonding displays. They too will choose a grassy bower in which to raise their young. A tiny lizard warms itself on stones that once formed a dwelling, and the burn froths past chattering loudly, or barely trickling in a tiny whisper. Its water is particularly sweet, once the life-blood for this remote community.

Many years ago, as I clambered up the steep burn banks greening with awakening ferns and freckled with orchids, passing the nest of a hooded crow in a scruffy ash tree on my way to Bourblaige, a wildcat appeared on the path. It turned and looked at me and I caught the flash of its narrowed eyes, the set of its head before it vanished into the leaf shadows as if it had never been there at all. The burn has carved itself a sheer, narrow cleft graced by hazel, ash and rowan, entwined with ivy. It's a long time since a wildcat put in an appearance, but I sometimes see a pine marten instead. The dense mat of grasses surrounding the ruins provides valuable hunting ground and is latticed with

a maze of vole tunnels. A fox too was taking advantage late one sharp, clear February afternoon. I hid motionless and watched its skilful technique as the afterglow of the falling sun washed its thick coat with highlights of pure coral-gold whilst it listened intently, its head cocked to one side. Then in high, bounding leaps it dived headlong into the grasses, rising seconds later with a high-protein snack clutched in its teeth. Deer graze quietly on the slopes high above Bourblaige's ruins, and during the rut Ben Hiant echoes to the tune of tireless roaring, its corries magnifying the noise of the stags' continual battles for domination.

The people may have gone but the snipe remain, and as another little brown-flecked bird flits away in front of me, my thoughts head even further west than Ardnamurchan, almost west of the sun, far out into the Atlantic to another lonely abandoned village, a place also frequented by snipe. This was the location for the finest interlude I have ever experienced with this delightful little wader.

* * *

The St Kilda islands provide all and more that a snipe needs in order to rear its young. Even this harsh, fretful environment dominated by the Atlantic's sting-speared winds has benefits, for the island has no mammalian predators to jeopardise the success of a ground-nesting bird.

It was at the end of May, when an extended period of high pressure over the Atlantic was bringing glorious settled weather, that I spent a couple of days exploring Hirta, the main island of the St Kilda group, from a boat moored in Village Bay. During the day snipe frequently erupted from the sheep-bitten turf and ginger moorland grasses, giving their two-note staccato call as they sprang into the air cadging extra lift from the wind. All over the island, hundreds of lichen-covered stone cleats, many

still with turf roofs largely intact, cling to the steep ground. Built by the islanders to store their harvest of seabirds as well as some of their Soay mutton, since St Kilda was evacuated in 1930 the cleats have inadvertently become excellent facilities for both sheep and snipe. Whilst the former find shelter, a place to escape the rampaging gales and squalls, their dung and urine help to enrich the ground inside and contribute to making this a valuable, damp snipe feeding area abundant with invertebrates and grubs. Fulmars too make use of the cleats, nesting in their lee, or using them as lookout posts before taking off stiff-winged to cruise in the salty atmosphere, flying with a skill and dexterity that appears effortless. Watch a fulmar riding an extravagant gale, and the word 'effortless' becomes inadequate. Fulmars and gales are inextricably linked.

It is early evening, wind has died to an occasional sigh, and the island is still frenetic with activity, acrid with the aroma of guano, blowsy with the cacophony of breeding seabirds, sweet with the bleating of lambs and arias of St Kilda wrens. The wiry Soay sheep are shedding their earthy fleeces and seem like moth-eaten charity shop coats. Venture close and their take-off is equally as swift and agile as that of the fulmars. Soays seem more caprine than ovine. Lissom and erratic as the wind that domineers the island, this ancient primitive breed was once described as a living fossil. Since the St Kildans' departure, they have survived unaltered as a self-sustaining flock.

To the east a full moon is rising. The boat lies still in the bay. I am sitting with my back against a cleat, drinking tea from the flask and devouring rucksack-squashed sandwiches, fruit and nuts. The sea air has made me as hungry as a wolf. Puffins on nearby Dùn are flying in wheels, a rollercoaster of silhouettes against the darkening outline of the headland, a last whirl before nightfall. The moon is the colour of buttermilk, round as a

newly minted coin, rising up from an ocean that scarcely moves. And the snipe are beginning to drum. The moon starts to shine her spotlight onto the bay, and etches the boat in a silvered glow.

The moon now turns silver too. And the crescendo of snipe drumming surrounds me. The bay is alight with moon fire, the snipe alight with amorous intent. They fill the darkening vortex with their winnowing, whistling through the atmosphere with stiffened tail feathers extended, rising and falling over and over again, rising high and drumming as they descend in loops through the sky, perfect pinions at full throttle. I lie on my back, watching tiny dark shapes as more join in, filling the St Kilda night with avian passion. And I am drunk on snipe by moonlight, so small a bird, and so beautiful a sound. I long to retain this night and keep it safe forever. We think we are clever, in charge, sophisticated, with the greatest sexual prowess: chocolates, roses, wine, poetic words written in cards. No! Nothing can equal the seductive powers of this tiny wader. I am in love, intoxicated, watching encore after encore, joyous with the flirtations of rapturous snipe on Scotland's edge.

More visitors

Due to seasonal dispersal the Humphreys have a number of extra visiting martens, mainly during the winter, when natural food supplies are less readily available. However, even without these new martens it is obvious that there is a healthy and vibrant population of martens in an extensive area of Loch Sunart's oak woods. Obviously, tourists coming to the area are well aware of this and during their sojourns put out food in their cottage gardens in order to attract them. This gives them a unique chance to observe them at close quarters. For some it can be the experience of a lifetime, especially for those visitors who have travelled from the south of England, where there are currently no martens. There is no doubt that the marten is a mammal with the ability to instil awe and fascination.

The appearance of itinerant martens in Les and Chris's garden also seems to coincide with a drop in visitor numbers coming to stay in the nearby holiday cottages during the winter months. With this natural dispersal and a greater need for food, the Humphreys' regular marten population can more than double almost overnight. This gives rise to the inevitable disputes, with some furious battles and bad language as the residents show they are not keen to share their garden with newcomers. This in turn brings both amusement and concern for the watchers, and Les and Chris seem often as fraught about the newcomers as about their much-loved regulars.

It is not unusual for male martens to have an extensive territory, and many animals are known to travel great distances, particularly where food may be hard to find. Some visiting martens are therefore very keen to take advantage of the food on offer in the Glenmore garden, and after gorging themselves for a couple of nights, move on elsewhere, and may never appear again. A large majority of these animals are male. A few do stay for the duration of the winter and linger on into spring until the moment when the first new kits come to the feeding table with their mothers. Normally the resident martens feed in the early evening. After this the visitors are able to sneak in during the night undisturbed by the locals. They may also, on occasion, put in a daytime appearance, particularly if Les and Chris are not outside working in the garden. All visits are recorded on one of the many cameras. This is not a place where anything moves without it being captured first on film.

Most visiting martens find the hedgehogs intriguing; many will keep their distance but some, after sniffing them tentatively, poke them with a paw, quickly withdrawing it when it comes into contact with the spines. Most of the hedgehogs are well used to feeding alongside the martens, but if they are really poked and provoked do eventually react by hissing and rolling up tight, and

making sure their spines stand up like a pincushion. However, with a hedgehog food is always their first priority, so even with spines in their most erect state, eating continues.

Reggie, an elderly marten who became a regular visitor over a couple of years, often chose to sleep in peace in one of the hedgehog boxes during the day. Sometimes, however, he would catnap on the end of the plank, or instead might doze on top of one of the boxes. Refreshed from his snooze, he would then continue with one of his favourite pastimes: digging up the lawn in search of juicy leatherjackets – crane fly larvae. After many weeks of this activity the lawn looked more like a badly ploughed field, but it certainly helped get rid of the moss.

Les and Chris are often brought freshly caught mice from traps used by other local householders. Martens love to eat small mammals, so this bounty of mice is never wasted. The older residents usually take their delicacies away to either eat in privacy, or cache to enjoy later. Sometimes the mouse will be picked up first, followed by an unsuccessful attempt to pick up an egg, as despite careful placement of the first object, a mouth is simply not big enough for both. A difficult decision then has to be made. Would it be better to take the mouse and then return for the egg? Or would that mean that another marten might rush in and steal the egg? Perhaps it's simply not worth the risk. To get around this dilemma the mouse is usually placed in the corner of the board whilst the egg is taken away to a place where it will be cached. Then there is a frantic return dash back to collect the mouse before it is stolen.

Like cats, younger martens may spend a great deal of time playing with the deceased prey. They pounce on it, throw it up into the air, and then pretend to leave it for a while, only to return to make a dive on the dormant body before restarting the game over and over again. At times there are some surprisingly gymnastic manoeuvres, high somersaults and back flips before

the playfulness subsides and the now floppily limp mouse is either taken away, or hungrily and noisily devoured.

There was one memorably special encounter with a young visiting female just before Les and Chris were heading off to bed one night. The window was still open and the board stacked high with delicious food for overnight visits and midnight feasts. Les was in the hall and was just about to shut the window, whilst Chris was in the sitting room tidying up. A container with two chicks and two mice had been temporarily set down in the hall by the sitting-room door. A little marten, unperturbed by Les, came confidently past him and helped herself to a chick from the container. She then proceeded to eat it on the pale grey rug. The blood and guts spewed out, making a horrible mess. Tiring of the remnants of this first day-old chick she then took another one into the sitting room and jumped up onto the chair right beside Chris. This new chick was next for dissection but only the tastiest bits were eaten. After the marten had eaten enough she began a tour of the room. First she looked at the big television screen, then the coffee table, and next there was a closer examination of the sofa and chairs. It was as if she was looking for something – the cushions were even inspected and moved. After a few minutes she began to make her way back out again. She picked up both the mice from the dish and returned to the sofa. She then jumped up and carefully placed them both behind the back of the sofa seat, tucking them in neatly. She picked up a cushion with her teeth and placed it over the mice, before patting it down well with both her front paws. Chris was still sitting there feeling bewildered. Then without a backward glance the young marten made her way out through the open window and left. Les and Chris stood and looked at one another and simply shrugged as they began to clear up the horrible entrails and the two hidden mice. This marten now visits regularly, with frequent forays into the house, and particularly loves to climb up

the windows and, more recently, the banisters. During a spell of bad weather she came into the house, selected a mouse from the tray, and took it off to eat on the stairs. After this, she promptly curled up in situ and fell asleep.

When the study window is open the martens are free to come and go as they please. However, sometimes they are not content with the menu and, together with several new visiting martens, may decide to investigate what else might be around. Les and Chris have learnt from experience that it is best not to leave any boxes of eggs about. One evening a new box containing a dozen eggs was pilfered. Another evening, when they were unable to open the lid, a whole box was pulled off the table onto the floor, dragged about and the eggs scattered in all directions. This resulted in a glutinous goo of scrambled eggs plastered on the carpet, and a spectacular mess. Another major clear-up operation before they could turn in.

Chris's Victoria sponge cake has always proved a particular favourite, but it must be kept in a plastic container at the back of the study. She cuts it into neat portions and then puts the lid down firmly. Even though the outside board was well stocked with food, one enterprising female visitor managed to prise the lid off in order to help herself to a huge slice of cake before disappearing back out through the window. Not content with one slice, she returned soon after to steal more. It was a case of having your cake and eating it. Peanuts, biscuits and raisins are frequently found cached in very odd places in the study.

Serious injuries, happily, appear to be rare, though many visitors bear battle scars, nicked ears, scarred muzzles, an occasional missing canine tooth or claw, or perhaps a bent tail. However, Les and Chris have only ever seen two martens with the larger extent of their tails missing – one appeared in their garden, and the other was seen crossing the road near Strontian. Damage to eyes seems to be one of the more serious injuries seen – over

the years several partially sighted martens have visited their garden.

Foxes have never been regulars in the Glenmore garden, but when they do appear they also captivate the watchers. With beautiful pelts and luxuriant brushes, they are at times even more ingenious than the badgers. Les and Chris welcomed them to begin with, but now feel rather reluctant since often when they show up, it seems to coincide with the loss of an elderly marten, though this may be purely coincidental.

The first fox that came visiting was a glorious dog in the peak of condition. He did not seem nervous and ventured close to the house to partake of a dish of food. However, he was not content with this and began to watch the martens as they took their food away to cache. The fox quickly learnt that by putting a little pressure on the smaller animals and giving chase, he could force them to drop their food. This was instantly devoured with much smacking of lips and visible enjoyment. One evening he cornered a marten in the badger's kennel. Les and Chris heard the sound of major disruption and witnessed the poor marten trapped. It arched its back, hissing and growling in terror. Eventually, after a major row, the marten managed to make his escape and flashed past the fox's open jaws, disappearing with loud, harrowing shrieks. After this Les decided the best thing was to cut a small escape hole in the rear of the kennel so that this scenario could never be repeated. It took a few days for that particular marten to dare to return, and for a while the other martens seemed nervous.

Despite their belief that foxes and martens don't mix, Les and Chris have only occasionally witnessed arch battles between them; on the other hand, they have frequently observed a fox chasing after a disappearing marten. Younger, more agile martens are able to outrun the wily fox, and frequently escape to the safety of the nearest tree. Older martens are perhaps not

always so lucky. However, what is clear is that a fox's presence in the area makes all the martens uneasy, and the entire garden is subsequently disrupted. Now, whenever a fox appears, it also fills the watchers with worry.

Foxes don't last long in Ardnamurchan and are usually culled by crofters and shepherds due to their penchant for lambs and poultry. When I was child growing up here at the end of the 1960s, a bounty of £5 for every fox's brush was paid by the Department of Agriculture.

Of frogs, otters and shearwaters

The cameras in Les and Chris's garden pick up otters in the pond every frog season, and at other times of the year they come to rinse off the salt from their fur in the clear water of the little burn that runs past the house. One afternoon they watched as a dog otter chased a female round the garden – she was clearly in season. Eventually the pair took off into the woods behind and for some time they could hear the sounds of yowling and growling, as well as shrieking, presumably as mating took place. Recently the Humphreys captured outstanding footage of a female otter and her two cubs having a riotous time in the pond, taking full advantage of the amorous amphibians, a welcome seasonal change to their diet. Some nights a dog otter also visits and causes mayhem, splashing and playing like a child in a bath

as it scoops up unfortunate frogs in a two-for-one feeding frenzy. It's not only the French who savour frogs' legs; the martens, like the otters, also appear to enjoy them. 'I feel sorry for the poor frogs,' Les once said, wistfully.

By mid February, the pond at Glenmore becomes a soup of fornicating amphibians. The frogs arrive first and fill the water with copious amounts of gelatinous spawn. They come in droves, lured by the scent of glycolic acid on their annual passion pilgrimage, in which they become temporarily mad with their need to mate, the females large and swollen with eggs, the smaller, more active males rampant and ready to mount the first female they can find. They will cling tightly to her slippery, bulbous body, holding her with their front legs in a clasp known as amplexus. This coupling will last until she lays her eggs, so that he can then fertilise them. Sometimes it may last for a few days.

When I was a child, every year my friend and I biked up to a freshwater pool close to our primary school in Kilchoan to collect spawn for the classroom. Our wonderfully kind teacher, Mary Cameron, was always as excited as we were, and as the season approached would look out a large fish tank from a dusty cupboard in the hall. Then we would decorate it with waterweeds and large stones, and fill it with nutrient-rich water from a bog pool below the schoolhouse. One year the frogs arrived weeks early, and as I had no bucket, instead I filled a welly boot with spawn and transported it in that, balancing it on the handlebars of my bike. On another occasion, when the frogs came early, there was an uncharacteristically heavy snowfall followed by hard frost, and I found the pool littered with dead frogs. Stags had come down low to raid the crofts. There were a few at the poolside, and they were eating the unfortunate frogs. We think of deer as wholly herbivorous but on the Isle of Rum they are known to eat the carcases of Manx shearwaters on occasion too;

like frogs, they provide vital minerals when the deer are at a low ebb. Nature is adaptable.

Though the frogs arrive first, it is not long before the toads start appearing too. They are ponderous and the little males make higher-pitched croaks than the frogs. They leave their spawn in chains attached to pondweed further into the water. Whilst frogs are aquatic, toads are far less so, except during their short breeding season, and prefer dank, darker places during the rest of the year, frequently hiding away under stones in gardens and fields, and emerging at night to feast on insects, slugs, snails and copious invertebrates.

At this time of year, I have received calls from concerned gardeners that tell me of discovering waterweeds and plants strewn all about their ponds, the water stirred up and brown, and a splatter of mud, silt and spawn, and a few dead frogs and toads, all over paths. 'Who on earth can have done this?' Their tone is worried and they are sure it is some vandal, even a neighbour with a vendetta. When I tell them it is probably an otter, they simply don't believe me and remain unconvinced. 'Otters wouldn't do that, and anyway we don't have otters around here,' they tell me. But it is nearly always an otter that has been in for a frog-fest, and close examination will usually reveal spraint on exposed rocks and walls too. It is a surprise to find that so many people have little idea that otters live in such close proximity to them, on many of our rivers and lochs.

At the pond I visit each spring there are always copious amounts of otter spraint on protruding rocks and banks, yet I seldom see this outwith frog- and toad-breeding season. Herons appear daily to gorge themselves, their long gullets quivering with their still-alive snack. One drowsy spring afternoon I was sitting on a bank glittering with celandines, absorbing the scene of the water boiling with hundreds of tiny heads, the sounds of croaks and squeaks in the bubbling cauldron of spawn clouds,

when a weasel stuck its foxy little face out from between the stones of the crumbling drystone dyke on the far side. Shortly, it appeared at the pond's edge and then began swift sweeps of the grasses, looking for something. Within seconds it emerged with a fat frog in its mouth before racing off back to the wall. I watched it for nearly an hour as it ferried frogs back and forth to the same place. Yes, it's not only the French who love frogs' legs. I have not yet seen badgers at the pond, but I presume they too are not averse to taking advantage of such rich pickings.

* * *

I cannot remember the first time I saw an otter. What I do remember though is that at the end of the 1960s otter-hunting was still rife, particularly around the area of the Cheshire/Welsh border close to where we used to live. Due to the worrying spread of escaped mink from fur farms, otter hounds – large, shaggy, people-friendly beasts that adore water – were gainfully employed to hunt for the non-native, invasively destructive mink. Even at that early age, I wondered how a hound would know the difference between an otter and a mink when fired up by the chase. Numerous otters were doubtless brutally killed in the process, as well as many other species – foxes, hares, deer and anything else that the hunt stumbled upon, domestic cats included. Otter-hunting shockingly had a great many followers; it was one of the cruellest of blood sports. I had seen otters on television, on *Animal Magic,* presented by one of my childhood heroes, Johnny Morris, and the revelation that people actually went out especially to kill them came as a shock.

The publication of Gavin Maxwell's *Ring of Bright Water* in 1960 remains for many naturalists a seminal moment. It is a work of enormous influence and great beauty, which inspired an entirely new way of thinking. With its lyrical prose and

extraordinary story, it was also responsible for helping to change attitudes towards the otter. Following intense lobbying, the otter finally received legal protection in 1978, and has since become one of the best-loved wild mammals of all. It remains an excellent example of how our attitudes can be changed.

Unlike pine martens, otters were to be seen on an almost daily basis when we lived in Ardnamurchan. From the Kilchoan Hotel we eventually moved into Mingary House, situated in a glorious position overlooking the Sound of Mull. From my window I could see the ruin of Mingary Castle close by, and the hills of Mull – dominated by the distinctive rounded, almost child's-drawing shape of Ben Talaidh – and Rubha nan Gall lighthouse (the Tobermory lighthouse), close to the entrance to the island's bustling harbour. Some nights I sat on the windowsill and tried to count the flashes. This important little lighthouse was built in 1857 by Thomas and David Stevenson, and was finally automated in 1960.

I could also look right down Loch Sunart as it curved around the base of Ben Hiant's pleated folds, and McLean's Nose, a black buttress of rock at the point – almost in the shape of a face. Frequently I opened my bedroom curtains and saw otters in the bay below. We had a powerful telescope, and binoculars placed on the windowsills of our sitting room, from where we had a magnificent viewpoint and watched the activity on the shore and in the bay. Seals, like the otters, were present nearly every day, whilst further out there were occasional sightings of minke, or other unidentified whales, as well as basking sharks and frequent displays from porpoises and dolphins. It was the otters that I revelled in most.

Though Mingary has a rocky beach, as the tide retreats it reveals a small bar of silvery-grey sand. I learnt that if the otters were not there – usually a mother and her cubs – then they probably had been before I rose from my bed. Providing the state

of the tide was right, I could race down to the shore and see if they had left any tracks on the sand. Their webbed feet intrigued me, as their marks might be clearly imprinted, and sometimes if the sand was the right consistency, distinct enough to even see the webs between the pads. I could discover the mark of the tail-scrape too as it dragged along the wet sand. Soon the tide would return and wipe away every shred of evidence that they had been there at all; that was another part of the otters' presence that attracted me.

I would lug Mum's heavy binoculars and sit on a rock on the lookout for them further out in the kelp beds. When the sea was as still as a mirror and there was no wind, the sound of sharp teeth biting through shell and bone and rubbery scales could be heard. The otters had a holt in the rocks above on the far side of the bay, with a worn route up through thick banks of ferns where the rocks were sign-posted with spraint, grasses flattened and brown.

We all loved the otters, but we also had a few contretemps with them. One morning my spaniel Flo cornered a large dog otter in rocks on the shore at Sanna, on the opposite side of the peninsula. There was a blood-curdling yelp and she fled back to us, bleeding profusely from a nasty bite to her nose. The nearest vet was over fifty miles away in Fort William (as is still the case today) so instead the helpful district nurse was summoned and she adeptly stitched poor miserable Flo up. She soon recovered, though had been taught a lesson about the dangers of taking on an otter.

On another occasion Mum and I went to clean the hens out and found an otter in the henhouse engulfed in a cloud of feathers. A hen clung to a high perch in terror. As we opened the door, the otter made a low growling sound before diving out. A quicksilver dash, and it was gone. We had been just in time to avert disaster – if we had been merely a few minutes

later the bird would have been a chicken takeaway. Otters are certainly not averse to taking poultry and ground-nesting birds. Local crofters told me that they would lose the occasional small, sickly lamb to otters too. It didn't stop me loving them and I quickly learnt that all members of the mustelid family are honed killers.

Though I have watched otters in many parts of the west coast, the Hebrides, Shetland (they were surprisingly active around Sullom Voe oil terminal) and Orkney, and sometimes on the rivers around mainland Scotland, it is in Ardnamurchan where I have enjoyed the finest sightings. It is still here where I can *almost* guarantee to find them, with a little time and patience.

★ ★ ★

The bog squelches beneath my boots as I cross a landscape of sponge on my way to Achateny. This is a fine place to watch otters. My route across the bog is pungent with the aromatic perfume of bog myrtle, bees hum gently and a soft breeze is beginning to tease. It starts to play with the midges that are mustering their troops for serious battle, a few stronger breaths of wind and they will be temporarily defeated − or so I hope. Tiny sundews twinkle with dewy sap, their little round cherry-red faces freckled with midges caught in their leaves. Another carnivorous plant, butterwort, slightly larger and with purple flowers on a long stem, is also in flower. Both are specially adapted to attract insects with their sticky fluids, and once they are trapped, leaves enfold them in a tight shroud from which they will never re-emerge.

The day is still, the island views hazy, but at least they are visible − so often they have gone as if absorbed by the Atlantic, non-existent, hidden in blanket-dense cloud. The proud prow of Eigg's great pitchstone buttress, An Sgùrr, the highest point on

the island, dominates the scene, along with Rum's vertiginous peaks, their bare rock summits wearing a floating scarf of cloud, Indian smoke signals hanging in the grey sky. It looks as though the day will clear, the sun may slide in as the haze burns off. The names of Rum's most dominant peaks reflect their Norse connections: Askival, Hallival, Trollaval and Ainshval; Sgùrr nan Gillean is the Gaelic member of the party. Though not as high as Skye's neighbouring Cuillin, they are no less dramatic, rearing up straight from sea level.

As I near the shore, I stop to scan. Herring gulls are arguing over a flounder, and ringed plovers race over the tideline like clockwork toys. Statuesque herons and parties of mallard and merganser fringe the water. The tide is retreating far, far out as more and more sand is revealed, leaving slippery wet weed beneath which crabs hide until the sea returns to take them home again.

There is a dog otter on a rock quite close by. He is curled like a round brown cushion, using his long tail as a pillow under his chin. He has a small pink scar on his nose. Perhaps he has been nipped by a crab or been involved in a fight with another male – a frequent occurrence. He's an animal I have seen often frequenting this area of the coast. On several occasions when the wind has been in my favour, I have managed to stalk really close to him. Today I have no chance, as there is nothing between him and me, no rocks, and nowhere for me to hide, and the breeze is coming from the wrong direction. I content myself with admiring him through the binoculars. He has one eye open, and every now and then he gives a wide yawn, revealing his sharp teeth. Then without warning he merges with the sea, and I watch as he rolls over and over, limbering up in the water before he dives deep and then reappears briefly further out in the bay.

One warm, windless afternoon in late spring I was sitting above the Achateny burn listening to the sounds of the season's first

drumming snipe. They were rising higher and higher over the silage fields and then descending, extending their specially stiffened tail feathers to catch the wind, making the sound I consider to be one of the most beautiful of the natural world. This winnowing, vibrating courtship percussion is created in the slipstream of their dramatic aerial dives. I often hear it at night from the cottage at Ockle, for snipe frequent the rushy in-bye ground by the farm. It never ceases to send a frisson through me. However, their drumming was half-hearted, the birds not yet in full breeding mode, and shortly they stopped and landed in the long grass. Then I heard the two-note contact call they make once they have returned to the ground.

A hen harrier quartered the bog, flying low with slow wing beats, angling back and forth on the hunt for pipits. I returned to the burn's edge and sat on a rock. Following a night of torrential showers, the burn was bloated, the water dark amber, hurrying on to the sea, chattering in Gaelic as it cheerfully bounced over the stones. The waterfall above me bubbled and frothed, its pools beneath resembling freshly drawn Guinness with an impressive head of foam like meadowsweet. I was daydreaming when an otter appeared and drifted right past me, only a few feet away. It was being swept along entirely by the movement of the burn and didn't appear to have seen me. It then vanished and a little later it emerged further down the burn, sloshing out onto a flat rock where it transformed to a gleeful toddler in a paddling pool, splashing and playing, rolling and diving. It was cleaning its pelt, ridding it of the sea's sticky salt. All otters need access to fresh water and must regularly clean their thick coats to keep them in immaculate waterproof condition.

I once met an otter almost at the summit of Ben Hiant, and have frequently seen them high on the hills elsewhere. They often follow hill burns in search of small prey: amphibians, reptiles, tiny fish and eels, and sometimes voles and other little mammals,

or an unwary bird and its eggs. Somehow on the open hill their presence comes as a surprise, yet it shouldn't as otters may travel considerable distances. As they move with bounding, almost rolling gait whilst crossing open ground with their distinctive mustelid action, I have watched them being viciously mobbed by a variety of birds: gulls, hoodies and waders. Perhaps they are on their way to a favoured spot somewhere in amongst heather, bracken or moss, a couch where they may lie up to snooze for a while, hidden perfectly whilst partaking of the sun's therapeutic warmth.

★ ★ ★

The Small Isles – Rum, Eigg, Muck and Canna – have always seemed an integral part of the land- and seascape, and form a vital element of Ardnamurchan. From Achateny on the north coast their presence frequently has a dreamlike, almost ethereal quality, each island with its own particular character. Often they vanish from the scene altogether, making them all the more alluring. As a child in the early 1970s, I thought Rum austere and brooding, the mystery of the island further enhanced by the fact that during my early youth, when the Nature Conservancy Council owned it, permission had to be specially granted in order to land and go ashore there. Though we visited numerous islands in various small boats, Rum was not one of them, but we did sail around it. Its treacherous sea-girt cliffs merely confirmed my feeling that it was an intimidating place, and I knew too that it had exceedingly high rainfall, with midges said to have a bite as savage as that of a greedy pike. We saw eagles and ravens circling, and large herds of deer dappled its greener slopes. Sea eagles had yet to be reintroduced. Once we went close to the shore, where a large black and grey billy goat, its horns almost long enough to scratch its backend with one flick of its head, grazed on seaweed.

Its strong stench hit us and latched onto our thick, seamanlike clothing, remaining long after we had sailed past.

Rafts of Manx shearwaters (Manxies) drifted in the Sound of Canna and I learnt that they nested on the grassy slopes high on the hills. When the Vikings came to the island, they heard hair-raising shrieks emitting from close to the mountain summits, and were convinced the area was infested with trolls, hence the reason that one peak is named Trollaval. The famous author-biologist-naturalist Ronald Lockley described the sounds as 'a bedlam of wild screaming, a wind howling, or the crying of insane spirits'.

One shearwater has been recorded at over fifty years of age. In that time it clocked up literally millions of miles on its migrations. Indeed, many hundreds of thousands of miles will be tallied up by those individuals that travel back and forth between their birthplace high on a sheer hillside on a remote and savage Hebridean island and the seas off South America, a fact that adds to the Manx shearwater's supernatural aura.

I once found the dry husk of a dead Manxie on the beach at Achateny and kept its sun-bleached skull because its extraordinary 'tubenose' bill seemed weird. It became a prime exhibit on the school nature table. True pelagic wanderers, Manx shearwaters are skilled in flight but only come ashore to breed, being ungainly and vulnerable on land. Their name originates from the Isle of Man, where visitors in 1014 recorded a massive colony. Ironically, it has now all but gone from the island that gave it its name, due to predation: rats, domestic cats and human disturbance. But the name 'Manx' shearwater lives on.

Vibrant green patches visible from afar paint the slopes of Hallival. These 'shearwater greens' are evidence of the birds' lime-rich guano. This pigeon-sized member of the tubenose family, in the same group as the albatross and fulmar, returns to its burrows in March. By May a single egg is laid, and takes

fifty days to incubate. The chick is a slow developer, remaining underground for seventy days before embarking on its marathon maiden flight to South America. Rum's 100,000-pair colony is of global importance, making up a quarter of the world population of shearwaters.

It would be many years before I finally visited the colony; I went in 2015 with two companions, one with the legs and gait of a gazelle, who was exceedingly hard to keep up with. We had ascended almost to the hill's steep summit, to an area peppered with burrows perched high on Hallival's flank, when we heard the first weirdly eerie calls of a returning adult shearwater echoing across the vortex. It was late in the breeding season and most adults had already gone, abandoning their young. These fat-laden juveniles must first slim before they can be airborne. The calls continued, part cackle, part shriek, otherworldly, nature at its most glorious. At the peak of the Manxie season, the night sky fills with hundreds of catapulting, caterwauling birds crash-landing whilst communicating to their chicks.

Now when I stand alone on Ardnamurchan's northern shores, I may gaze across the water to Rum and momentarily imagine the surreal nocturnal sounds of this bird that proves equally as baffling and fascinating to us as it did to the earliest humans who stumbled upon its colonies, and first heard its ghoulish vocalisations.

15

Baffling badgers

Visiting badgers in Les and Chris's garden cause a great deal of amusement, and continual tests for Les's ingenuity. I have always looked forward to hearing the next instalment of these ongoing sagas. One night there was a loud bang that awoke them with a fright. There was no wind and everything was still and calm. By morning, though they looked all around, nothing had been moved, no sudden gust off the sea had dislodged anything, and everything appeared to be still intact. They thought no more of it. A few nights later there was another loud noise and they rushed downstairs to see what was going on. There was still nothing to be seen. It was mystifying. After a number of weeks had passed they arose to find the hinged lid on the hedgehog box wide open and blamed the strength of the wind. Later that week

it happened again, only this time the night was still and there was not even the whisper of a breeze.

Peanuts and some delectable pieces of toast and jam were placed inside the hedgehog house for both martens and hedge-hogs, in order to protect the food from the attentions of a group of voraciously greedy gulls. At this stage in the proceedings, the Humphreys were still not using trail cameras, so they were unsure of what was going on under the cover of darkness. They had their suspicions, but determined that the best way forward was to sit up and wait with a video camera and a powerful torch in an endeavour to catch the larder thief. They didn't have to wait very long before the visitor arrived. It was an elderly badger. He put his snout firmly under the edge of the lid and attempted to open it. A number of times it fell back down with a loud bang, but eventually he succeeded in swinging it wide open and then, much to their amusement, squeezed his ample figure inside and began to scoff the delicious contents.

This ageing brock became a regular visitor. Les captured some wonderful video footage as the badger prised open the lid and clambered inside. Then the lid would slam shut on his tail momentarily before it too followed the stocky body in. All would be quiet for a while then suddenly the lid would open and he would reappear with a piece of toast and jam in his mouth before trotting off into the shadows in a business-like fashion. The mystery was solved.

There was a clip on the hedgehog box that was normally left unlatched. One morning during the Humphreys' daily round of topping up bird feeders, they found that the clip was actually firmly secured. This was rather odd. Les opened it and found a very disgruntled badger inside. He seemed none the worse for his overnight stay, but when it happened a second time, Les removed the clip.

After regular visits over an eighteen-month period, this elderly

visitor began to show signs of increasing arthritis. It seemed as if he was keen to spend more time in the safety of the garden, where he could partake of the excellent bed and breakfast facilities. However, being most considerate, the Humphreys felt that the hedgehog house was far too small for a creature with sore joints. They set forth on an expedition to Fort William, where they brought their badger a rather salubrious and expensive wooden dog kennel. The new des-res, warmly lined with a bed of fresh straw and supplied with room service, was immediately adopted, and the old boy's visits became more frequent. He sometimes stayed on for long periods, slumbering noisily whilst curled up in his comfortable abode. It is likely that this retired badger had been driven out of his sett, ousted by a younger boar. It is equally likely that due to the Humphreys' thoughtful ministrations, his life was extended somewhat. Sometimes he was there when they went to bed and remained there until next morning, when he could be spied lumbering slowly off across the burn before melting into the surrounding woods. On the occasions that he had a sleepover and extended his visit to the day too, the Humphreys, considerate as ever, found themselves tiptoeing around their garden, keen to cause the least disturbance possible. The last time they saw the badger he had, unusually, remained in his kennel for over forty-eight hours. He finally rose in the middle of the afternoon, stirred lazily, had a good scratch and then set off on his usual route. He never returned.

After the elderly badger had shuffled off, oddly there were no more badgers for over ten years but in mid February 2017 another badger appeared on the lawn. It seemed that he was only partially sighted. Chris and Les could see this whilst viewing the footage from the night recordings on the infrared camera. Normally an animal's eyes show glowing white, but in this case there was no reflection from the boar's left eye. He put in a brief appearance and then was not seen again for three weeks,

returning one evening to eat hedgehog food from a dish on the lawn. Then he began to cause a little trouble and would carefully walk the plank up to the martens' feed table, where he devoured every last morsel. This was the bridge Les had installed many years previously, when old Sam had injured a hind leg and seemed to find it harder to climb up the original steep plank from the gravel to the window ledge. The new 3.5-metre plank stretched horizontally from the lawn to the window ledge and, being 40 millimetres wide, allowed much easier access for Sam. Over time a number of hedgehogs also made use of this easy access to food on the martens' table, but that is another story.

Every night before going to bed Les and Chris replenished the supplies on the table so all nocturnal visitors, the martens and hedgehogs in particular, had plenty, but two nights on the run the wily badger came soon after lights out and ate the lot. Something needed to be done. It became a battle of wills and ingenuity and Les devised a series of Heath Robinson contraptions as he made endless foils, baffles and devices in an endeavour to deter the bombastic Brocky.

Being fairly practical, Les made a wire-mesh tunnel in his workshop and placed this over the end of the plank. The badger hardly gave it a second glance and came effortlessly straight through it like a bulldozer through a mound of earth. So Les made the tunnel much narrower. That didn't work either, for the badger simply climbed over the top of it instead, bending and twisting himself into contorted shapes in order to do so. All this was captured on the camera.

As Sam was no longer coming, and the hedgehogs were all still in hibernation, Les replaced the plank with a narrow branch instead. The badger appeared, had a quick look, then managed to get three quarters of the way along it before he gave up and went smartly into reverse. He made several more attempts, and

then eventually it seemed as if he was defeated. This was not the case and instead he climbed the steep plank off the gravel, successfully reached the table and, hunger further fuelled by his challenges, simply set to and cleaned up all the food. So Les also replaced this plank with a narrow branch.

Next night the badger appeared as usual. He managed to walk halfway along the branch from the lawn, balancing precariously, then retreated. He then jumped down off the wall and began to scale the branch from beneath instead. Getting up, this was fine, but going back down was not so easy. He simply fell off, but not before his hilarious endeavours were caught on camera. He clung on, wobbling about at first, and then suddenly he began to whirl around several times in a most ungainly fashion, like a novice working on the bars in a gym, before landing with a large thump on the gravel. He brushed himself off, shook himself and cleared off into the night. The following evening, with a concerted effort, he managed to climb up the steep branch. The food was swiftly eaten and then he left the board using the long, narrow branch onto the lawn. Martens regularly came whilst the badger was feeding but didn't dare to join in. They were visibly nervy about his presence and always kept an eye out, watching the imposter's movements.

Now fed up with his foiled badger-baffling attempts, Les decided to reinstate the plank, adding a new wire mesh barricade with a 150-millimetre hole cut in the bottom for ease of hedgehog and marten access. This didn't work at all because the badger simply ploughed straight through the hole and slipped effortlessly through it like an eel in a rockpool.

Les was equally determined, and made the hole smaller. On the next visit the badger climbed around the side of the mesh. A far wider piece of mesh was added, but once again it was no problem for the badger to climb over it. Les decided to strengthen and reinforce the mesh. On this occasion the badger

did not get through for a number of nights but seemed to be hatching a new plan.

When he next appeared he had indeed worked it out and now, like a mammalian crane, simply lifted the entire mesh barricade with his snout, and trashed the whole thing. By now Les felt that he had run the gamut of his anti-badger armoury and was not quite sure what he should do next. Drastic action was clearly needed. He replaced the plank with a shorter one, leaving a half-metre gap. It seemed as if the badger was actually revelling in Les's nightly challenges. This time, however, he jumped the gap, devoured all the food and left somewhat heavier, but still managed to jump back onto the lawn. The plank was then shortened by another half-metre. The following night on his return though he tried to jump, he missed and fell onto the gravel. Picking himself up he returned to attempt another jump but again failed. Success at last!

The badger continued to appear nightly, but did not walk the plank, and after a few weeks hedgehogs also reappeared and were seen happily munching in close proximity to the unwelcome guest on the lawn. Les reinstated the plank once again and added a much larger reinforced mesh, allowing only access for hedgehogs and martens. For some nights all was well. Badgers, being the strongest and heaviest members of the British mustelid family, are often ingenious and can extricate themselves from or barrel through almost anything when they set their minds to it. This badger was not to be defeated and both Les and Chris felt he was concocting yet another plan. When he reappeared and eyed the new set-up, he smartly waddled up the barricade and with renewed effort lifted the entire contraption out of the way. Finally Les resorted to screwing it all in place, and it seemed that this time the badger had not managed to get himself through. Les is tenacious, but felt that it probably wouldn't be long before the badger beat him again.

For some time the barricade remained in place, and to begin with the badger visited most nights, taking advantage of the peanuts scattered on the lawn. Gradually over the summer the visits became more sporadic. In early September 2017, the Humphreys noticed a nasty wound on the badger's rump: a large chunk of flesh was missing – he must have been in a fight or come to grief in some other way. The wound was clearly visible from some distance.

A couple of weeks later Les and Chris were heading for the early ferry when they discovered to their horror that a badger had been run over and lay dead beside the road a short distance from their house, near the Ardnamurchan Natural History Centre and some busy holiday cottages. As it was beyond help they decided to continue their journey and examine it more closely on their return. They were greatly saddened by the probable death of their tenacious friend and thought of little else. If it was indeed their visitor, they were going to miss his clumsily determined antics, for he had kept them amused all summer long.

When they returned home there was no sign of the badger on the roadside; someone had obviously removed the battered carcase, and they were cross with themselves for not taking a closer look in the morning. That night another badger appeared on the lawn and followed exactly the same pattern as the previous one, eating the peanuts and glancing up curiously at Les's patent barricade. This one did not have the wound on his rump nor was he partially sighted, so they felt sure that it was indeed a different animal. However, it did seem very strange that it had appeared so quickly after their regular had most likely met a tragic end. This new badger continued to visit until the end of October but then it vanished too. Les and Chris had assumed there was only one badger visiting and had never ever seen two on the cameras at the same time. It was baffling. I was in Ardnamurchan around about the same time, and saw another badger run over on the

road some three miles further down the peninsula near Loch Mudle. I did stop to examine it, and found it was a young sow not fully grown, and in a very thin condition.

During my childhood, badgers, like pine martens, were seldom, if ever, seen in the area despite the ideal habitat provided by the oak woods. Ardnamurchan has few rabbits that would provide a good food source for badgers, foxes, eagles, buzzards and other birds of prey. Now badgers have become fairly prolific and have spread into many new parts of the Highlands, where they appear to be thriving; insects and invertebrates as well as carrion make up a large part of their diet. Though also legally protected, they are the frequent victims of illegal persecution and are generally disliked, and often totally misunderstood by farmers, shepherds and landowners. Their alleged link to bovine TB has added more negativity to their continuing bad press and it is worrying that this has led in some cases to an outright hatred. They are also frequently blamed for the massive decline in the hedgehog population, and indeed are not averse to eating this little mammal. However, hedgehogs and badgers have coexisted for millennia and it is hardly surprising, as more and more valuable habitat is lost, that the larger, stronger mammal should do better. Whilst badgers make extensive underground setts, hedgehogs are far more vulnerable to the loss of suitable places to shelter. Badgers too are better able to exist in areas around sterile commercial forestry plantations – in short, they are simply far more adaptable.

Badgers are frequently caught in snares set for foxes, as are numerous other non-target species, and it is time that the snare was relegated to history and banned altogether, for it is totally indiscriminate, a cruel death for any creature. When my son, Freddy, was still at primary school I once had an early morning call about a badger in such a condition from a concerned farmer. Freddy had never seen a badger before, but like me had been

weaned on Beatrix Potter's outstanding tales. In particular, we both loved *The Tale of Mr Tod*, in which a fox and Tommy Brock, a badger, get up to nefarious business. I felt that the opportunity for Freddy to see his first badger was a moment not to be missed, and certainly worth missing school for the morning. So we set off to see if we could assist in its rescue. The poor badger was none too helpful and must have been going through the fence where the snare had been hung, but luckily had only been caught around its fat middle. In order to extricate it from the constantly tightening noose we had to use a special grasper. The badly stressed animal was desperate and fired-up, and we did not dare risk a dangerous bite from its exceptionally powerful jaws. It growled and grumbled and was most uncooperative as it became more and more irate and stressed. The farmer and I worked as swiftly as we could to free it from its dreadful predicament. Eventually we had it by the shoulders and were then able to remove the wire. Relieved that there was no visible long-term damage, other than perhaps a painfully bruised stomach for a few days, we set it free. It took off with a fast, lumbering gait, looking back at us whilst emitting further expletives, with not a word of thanks, which of course was totally understandable. As it bumbled off after its horrible ordeal, I wanted to shout back to it that I was pitifully sorry and sad about man's continual cruelty and horrendous behaviour towards it and the rest of its kin. I hoped that it would survive another day. We could hear its complaints for several more minutes before it must have gone to ground. Once the racket had stopped, Freddy looked up at me and said, 'I love badgers Mummy, aren't they brave?' I couldn't have put it better myself.

I once worked in a zoo in Northamptonshire where they took in a large amount of injured and orphaned wildlife, and we frequently received road-casualty badgers. Not only were they fearless and feisty patients, but on numerous occasions we

would think they were at death's door and rise in trepidation next morning only to find they had risen from the ashes and taken off, having first excavated their way out of thick weld mesh embedded into concrete. It was astonishing, but such is the power and innovative nature of a mustelid. The badger is no exception.

Life and death

It is probably unnecessary to say that it was in Ardnamurchan that I first became passionate about red deer. Fortunate to be allowed to go out on the hill with the stalkers and shepherds from an early age, I learnt of the immense value of sitting still and watching in silence. I have always loved the rut and feel lucky that this annual spectacle takes place around the time of my birthday in October. 'What would you like to do on your birthday?' A question I was asked every year. The answer nearly always remained the same – a day on the hill with a flask and a piece, watching the rut. It is a tradition that we continue to carry out most years.

In autumn the frantic roaring of the red deer stags became an integral part of our lives in Ardnamurchan, and on windless

nights I might even be lucky enough to hear them going on tire-lessly all night from my bedroom window. From mid September until around early November, depending on the weather, the russet hills and glens fill with their rumbustious fevered roars. Yet throughout the remainder of the year, the red deer stag remains silent. This adds further to the excitement that makes the red deer one of the most intriguing of all land mammals.

So much is written about stags 'mustering' their hinds into harems, but having watched the red deer rut so many times, and in many parts of the Highlands, I don't feel it is exactly this way. Red deer have a matriarchal society and even during the mating season the hinds and their followers, made up of calves from pre-vious seasons, only seem to tolerate the presence of mature stags in their midst because of the breeding urge. Dominant stags behave like frantic over-exuberant collies with sheep, rounding them up whilst trying to keep them in order. It is a never-ending task.

At the end of summer the stags have grown fat and impressive. As their testosterone levels begin to rise, their necks become visibly thicker, enhanced by the growth of a dense mane. They are glorious beasts at their peak. However, the rut is a stressful time for a stag, a time when he will eat little or nothing, running himself ragged driven by lust and frustration as he tries to keep a group of hinds together, whilst battling to keep his equally testosterone-fuelled opponents away. By the end of the rut a successful stag that has mated with a few hinds will have lost his previously rounded, full shape, and will be drawn-up, his belly tight and thin, exaggerating his large shoulders and making him appear a different animal altogether.

Though I cannot remember an exact moment when I first heard a stag's reverberating, primitive sound, I do remember my father taking me out to stalk purely to watch the action. He wanted to infuse me with the same passion and fascination that he had for deer. All his adult life he had spent time on the

open hill watching red deer; he was also a keen shot and loved
stalking. He was an avid reader and devoured the work of deer
expert G. Kenneth Whitehead, who in 1946 began collating a
fascinating annual review of the stalking season, with informa-
tion garnered from almost every estate in Scotland. Whitehead
was also a founder member of the British Deer Society, and
wrote numerous books on the subject. Dad read them all. He
was particularly intrigued by antler formations, and the unusual
growth occasionally leading to extraordinary malformations,
many of which were recorded in Whitehead's work.

The first time we watched the rut together it was mid October.
Ben Hiant glowed golden and tan, the bracken on its lower
reaches now putting on its best face and quickly dying back.
All summer we curse and complain as we wade through this
obstreperous, tall and dominating member of the fern family that
provides a perfect habitat for ticks and other annoying insects.
The rut had started late due to a spell of Indian summer weather.
Dad had obviously chosen an easy spot for my initiation but I
was already used to walking long distances. From Camus nan
Geall we followed the shore path around the coast, wending
our way through a narrow gully of rocks that still always makes
me think of prehistoric creatures. My father was always a tireless
walker. It demanded a great deal of effort to crawl up the small
hill burn, and Dad kept stopping to check the wind direction so
that the group of deer he was taking me to couldn't wind us. I
was close behind him, copying his every move. All I could see
were his tweed-clad backside, his broad legs like brandy bottles
encased in their thick green socks, and the soles of his upturned
hill boots. Hooded crows were laughing at us and had a mean
look in their eyes, opportunists waiting for the next carrion.
Dad had located a suitable herd for us to watch on the side
of Stallachan Dubha, a small hill on the seaward slopes of Ben
Hiant where a large punchbowl provides a sheltered wintering

ground. Looking back, I am sure he exaggerated our subsequent crawls through the tawny tussock grasses, but this was all part of the process. We both loved it.

We were accompanied by a pair of ravens, and earlier had commented on their scruffy old nest threaded with litter and wool, on a crag as we passed. Dad had pointed out pellets on a rock amongst thickly spattered droppings and bones. The pellets were woven with deer hair and husks of grain, adding further to the day's excitement because I felt like a detective as we examined them to find out what the birds had been eating. He explained that the ravens were following us because, like all members of the crow family, they are highly intelligent, and probably viewed us as two stalkers, out to shoot deer. If that were the case then there would be a fresh gralloch (deer innards) for the birds after a successful shot was taken. I have never forgotten that, and thereafter, when I often accompanied the stalkers, always found this to be true. Soon after a shot was taken, a few ravens and some hooded crows would swiftly appear from nowhere. Grallochs provide an excellent seasonal feast for corvids, buzzards, eagles and hill foxes during the stalking season and are quickly devoured. The birds were disappointed on this occasion for we were only going to lie and watch.

As the roaring grew nearer and nearer, so too did the mounting butterflies in my stomach. I could now smell the deer. Roars echoed around the corrie and bounced back to us. Their loudness made me think that they were surely enormous stags, but I quickly discovered that even a small stag roars with intense resonance, indicating his frustration and intent. We lay on our tummies on a mattress of sphagnum and watched through Dad's telescope and binoculars. There were three stags, one larger with ten points on his antlers, what Dad described as 'a fine Ardnamurchan hill staggie', and two that seemed less impressive, though they were both persistent, desperate to take some hinds.

All were blackly plastered in wet peat. We had passed several peat hag wallows where the strong smell of stags' urine was overpowering. The hinds were gathered in a small group, some twenty with their half-grown calves. During the course of that afternoon, high above the Sound of Mull, my father and I lay and watched in silence. An underground burn tinkled close by, and several large flocks of winter thrushes – fieldfares and redwings – passed overhead. The bog seeped into our clothing but we were too absorbed by the activity to care. The stags chased one another as antlers clashed and tempers rose. Their roars grew more and more fevered until one almost lost his voice altogether and merely grunted, his head back against his shoulders, his mouth open and tongue lolling. The larger stag was not to be defeated and successfully sent a would-be usurper cascading down the wet hillside after a particularly vehement battle. We winced as we watched antlers hitting flesh, and blood rising to the surface. Dad pointed out an old grey hind standing on the edge of the group. She was keeping watch, and it would have been she who noticed us first and alerted the rest of the group. She had an elongated face and a hollow back, and together with her much paler coat displayed all the signs that she was an old girl. She did not seem to have a calf close to her, and was therefore what we refer to as 'yeld'. Above us an eagle appeared over the ridge, watching and waiting in the sharpness of the autumnal air. A little later a second appeared and we knew it was the pair that bred in the area. They landed on rocks in a narrow gully above, and then took off again without a wing beat and vanished over the distant summit.

Eventually, feeling stiff and hungry, we reluctantly, stealthily crawled away from the activity and began our walk back along the shore. Now we could chat freely, so many questions, so much to learn. Dad explained the importance of good deer management, the necessity of keeping deer numbers at a perceived ratio

that the ground could sustain, and the problems that would arise with winter starvation if the hill were overstocked and deer not selectively culled. He also told me that in his opinion it was vital to shoot only the poorest stags, to encourage a population with good strong heads and balanced antler formation, and not to cull the so-called trophy heads. At that time, during the late 1960s, the deer in Ardnamurchan had been well managed and reflected this. When we got back home and were devouring tea and toast and telling Mum about our day, Dad gave me a book. It was *A Herd of Red Deer*, written by the famous naturalist-ecologist Frank Fraser Darling, described by some as the father of the green movement. Though at that time I was too young to understand it all, it was to become one of the most valuable additions to my natural history library. Dad needn't have worried about enthusing me about deer. I loved them from the moment that we moved to Ardnamurchan.

In some areas of Scotland, having excessively high deer numbers is extremely detrimental. Together with the overstocking of sheep, intensive grazing and indiscriminate browsing knocks back any possible natural regeneration, whilst also causing severe habitat degradation. In the case of deer, population explosions also lead to a serious amount of suffering for the animals themselves.

The winter of 2014/2015 had been one of the wettest for many years, and deer in many parts of the northwest Highlands were reported to be dying in large numbers. Intense cold is not always the enemy. Though extended periods of deep snow cover will lead to numerous casualties, incessant wind and lacerating rain and sleet are far more likely to accelerate the demise of the weak. I have always thought of March as one of the harshest months for both wildlife and farm livestock. Though in some years it may be benign, in places such as Ardnamurchan and other exposed parts of the Highlands it is frequently savage. Spring is not far away,

yet there is still no green bite, and it is perhaps ironic that deer in particular can survive December, January and February, only to succumb when hope is but a whisper away in March. Witnessing the suffering of animals starving to death is harrowing.

<p style="text-align:center">★ ★ ★</p>

A dreich day in mid May and Iomhair and I are in Wester Ross, heading to the north shore of one of the wildest and most beautiful lochs of all. Loch Maree is also one of Scotland's largest bodies of freshwater. It is a part of Scotland that I also love, but unlike Ardnamurchan it is not a familiar haunt. In my teens I would come to know a few of its hills and glens a little better when I climbed some of the region's dramatic Munros with fellow pupils from Gordonstoun, the outward-bound school where I was fortunate to be sent.

To the east Slioch, a brooding 981-metre Munro, stands sentinel over the loch. It is an impressive, austere beast of a hill. Though lacking such dramatic shining screes as its neighbours on the Torridon side, Liathach and Beinn Eighe, Slioch is a formidable fortress, its vast silhouetted outline almost a castle that dominates the area and adds to its magnetism. On Loch Maree's dark waters stand some sixty islets, a few wooded with ancient Scots pine, oak and holly, precious remnants of the primordial forests that once covered a greater extent of this landscape. On windless days in spring and summer, the eerie, melancholic cries of black-throated divers, and the calls of cuckoo and willow warbler can be heard as they add symphonic orchestrations to the scene. It is almost as if to compensate for the moaning of the midges, and to appease the manic behaviour of a walker who hesitates too long, admiring the dramatic views.

We are following the River Ewe from Incheril, near Kinlochewe, on its travels to Loch Maree. Fences bordering the

riverbanks drip with detritus from recent spates: fallen trees, grassy tussocks as big as hay bales, a bloated dead sheep, the skeletal remains of a stag, antlers poking out of the mêlée as if in defiance, ubiquitous grim black plastic silage wrap amid strands of coloured baler twine. Yesterday we climbed Beinn Alligan in a heat wave with an extrovert sky of cloudless blue. Today the landscape is monotone, the hills smudgy and shy. We are surrounded by a stockade of gale-bruised gorse, its acidic yellow flowers working hard to bring colour to the day. Their delicious coconut pungency fills the air and temporarily knocks out the aroma of another winter casualty washed-up close by.

We have been seeing evidence of the bad winter everywhere, but we are unprepared for what we are about to witness on the loch-side. All along the high-water mark the loch's lapping shores are littered with wood, entire trees, large branches and birch limbs pock-marked by woodpeckers, whilst the curvaceous roots of ancient pines sprawl in weird abstract shapes. A raven is perched on a decaying sun-bleached pine. Its throat hackles are raised, giving it a thick-necked appearance as it strokes its broad bill back and forth against a branch to clean it. It has been recycling a vintage carcase.

Every few yards we find more and more deer – hinds, calves and many small stags. Someone has removed antlers using a hacksaw. Somehow this mutilation makes the animals' premature demise even sadder. There are wild goats in this watery graveyard too, lying with legs akimbo, their long matted coats caked in wet leaves and sticks, pinecones and sodden vegetation. Some reveal their leathery skin, as horns and hooves protrude from beneath rocky coffins. We have never seen more evidence of winter's casualties and wonder if these unfortunate beasts have been washed down the loch, or simply died where we now find them. We suspect the former. These are not fresh carcases. It has indeed been a depressing winter. The dogs are excited by

the lingering stench that catches us unawares and makes us hold our breath. We have to put them on their leads to stop their temptation to roll, or we will be treated to the smell for days. They rudely pull and all have their muzzles in the air snuffling loudly and inhaling in tail-wagging delight.

High above us on the lower slopes of Slioch, a few wild goats are grazing, whilst several more are lying on steep crags watching our progress and casually cud chewing. These are the lucky ones. We cross a small burn that bubbles and froths into the loch. A grey wagtail dressed in colour-coordinating gorse yellow is waltzing on a rock platform shrouded by alders and rowans. The burn banks are dappled with primroses. The collies are paddling again and Maisie, the youngest of the three generations, is messing about grubbing under rocks.

A large pine marten with a fabulously dense coat and a flamboyant tail explodes from beneath, and departs without a backward glance. We watch as it races up a Scots pine skewed to the prevailing winds. It takes a leap into precipitous cavernous crags dripping with ferns, and is gone. We grab all three dogs and hastily clip on their leads again, and then climb the bank to crouch low behind rocks. It is starting to rain, gently, softly, a mere smirr. A second marten shoots across from the shore and crosses the burn right in front of us as if oblivious to our presence, and we hear aggressive mewing calls from higher up the crags. The new marten jumps across a series of large rocks, using them as stepping-stones. It appears to be looking for something and is oblivious to the tuneless songs of rebellion emanating from the crag. We scan with binoculars but cannot see from which lookout post the singer is watching from. Then the new marten finds a mossy rock and lies down, curling up as if to have a sleep. It has chosen a rock right in front of us and we are struggling to keep the quivering dogs still, for they are intent on giving chase.

We cower lower and make the dogs lie down. The rain is now falling in earnest, and fugs up the binoculars as it drives over us in curtains across the loch's surface. It is heavy and laden with malice and we struggle to warm our hands, shivering as it seeps in down our necks. The dogs couldn't care less. Then we suddenly see the first marten on a contorted pine tree that seems merely to have a toehold on the sharp rocks, its roots searching like fingers creased with age. The dozing marten takes off and disappears in the direction of the complainant, moving with effortless speed as it bounds up the hillside and straight onto the crag. There is a shriek and a brief scrap as the two martens engage in a fizzing tussle before the first one, defeated and visibly nervous, escapes into the pines from where it continues to send out verbal abuse, whilst the other stretches and yawns and runs back to its moss-upholstered rock as if nothing has happened. It curls itself into the form of a dark brown doughnut, and dozes. A wren ticks irritably, and a stonechat lands in a small rowan tree. The rain is ceaseless. From across the loch a cuckoo calls, and receives an almost instantaneous response from a clump of trees close to us. The marten does not stir.

We continue our vigil until it rises and disappears into the wood below. We are saturated and satiated with our experience, glowing despite the cold. We have experienced the intensity of nature – the death on the loch-side, and now the life. Two pine martens in the environment to which they are so perfectly suited, a rare daytime encounter on the shores of Loch Maree.

Small miracles

In spring and summer, as the sun warms the mossy stones in the Glenmore garden, the sun-worshipping slow worms begin to put in an appearance. They have spent the winter hiding in burrows and crevices beneath rocks, and especially love colonising a scattered heap of stones in the yard. As the days lengthen, a quiet meander around the garden may reward with a glimpse of them basking peacefully. The females have a rich coppery sheen to their smooth skins, with a dark stripe running their length, whilst the males appear more uniform in colour, and with close observation reveal a slightly larger, more defined head. Newly born slow worms are perfect, paler replicas of the adults – silvery-gold rather than bronze, with the long dark stripe clearly visible on their equally gleaming skins. It is as if slow worms have

all been carefully dipped in varnish. A slow worm reproduces by viviparity – the female retains her eggs inside, and they hatch out into immaculate young as soon as they emerge. Sometimes she may have many, and stumbling upon a clutch of writhing newcomers slim as a whip is a rare and magical occurrence.

Captive slow worms in zoos have often been long-lived, though in the wild survival rate is short for many birds and mammals predate them. Once nicknamed blind worm due to their small eyes, unlike snakes, slow worms have eyelids and can blink, and can therefore see perfectly well. They are not snakes though are frequently thought of as such, and are in fact legless members of the lizard family. Buzzards in Ardnamurchan, as elsewhere, are very keen on them for they provide a good source of protein. I have watched a buzzard standing on a sunny bank close to crags on the tawny slopes of Ben Hiant downing several wriggling slow worms in greedy gulps. Buzzards also consume large numbers of earthworms, and are frequently seen standing expectantly over fresh molehills, taking advantage of the newly turned worm-rich earth.

Like lizards, slow worms can shed part of the end of their tail vertebrae without damage. This is a defence mechanism, and though when I was a child I was told that they could grow a totally new one, it won't actually grow back the same. This adaptation is called autotomy and can help to save them from predators that make a grab, leaving the grabber instead with merely a small piece, whilst the rest of the slow worm slithers to safety.

At home currently there seem to be no slow worms, but I continue to lay down a couple of sheets of corrugated tin on the old pastureland adjacent to the house in the hope of one day finding slow worms beneath it. So far I have had no luck. Instead as I carefully raise the sheet from its indent embedded amongst the tussock grasses, I find scurrying short-tailed field

voles, the occasional wood mouse with eyes as black as bram-
bles, and sleepy baby toads dressed in camouflage kit, as well
as numerous heaps of empty hazelnut shells with their perfect
round tooth-marked hole. The cosy confines of the corruga-
tions make a convenient safe venue for a small mammal to have
a feast, far away from the keen eyes of foxes and tawny owls. So
on my forays to Ardnamurchan, the gorgeous slow worm is a
welcome sight.

Common lizards are also numerous in Les and Chris's garden.
They are keen sunbathers and are found all around the peninsula,
yet often all I see is a whisper of movement as I sit on a sun-
warmed hillside, or on the sand dunes as a lizard dissolves into
the grasses. The males with their bright orange bellies are easy
to recognise, providing you can actually see their undersides, but
like many reptiles and amphibians there is a wide colour variation
depending on habitat and local population. Frogs in particular
seem to vary enormously in colour; some that I have found
on acidic ground have been bright shades of orange, brown,
emerald and yellow, colours so vibrant it is hard to believe they
are not straight out of a jungle. These are all common frogs, but
their colour variations are misleading.

The common lizard is unusual, for most other types of lizard
lay eggs. Instead, like the slow worm, it reproduces by vivip-
arity and gives birth to live young. For an expectant lizard, the
amount of time spent in the sun dictates the time it will take for
gestation; normally this fluctuates between six weeks and as long
as three months, and it is sunlight that helps with the healthy
development of young. The tiny lizards are born encased in a
membrane from which they quickly break free.

During a long winter walk from Ockle to Gortenfern and
the Singing Sands, having crossed over a large dry area of lanky
sprawling heather and purple moor grasses, I was sitting eating
my piece and drinking tea by the burn in a little birch wood.

Vulnerable and eternally exposed to the constant ire of northerly gales, a few trees had tumbled into one another's arms and were in a state of advanced decay. As I leant against one the bark fell away, revealing a group of lizards of varying sizes that were using it as a hibernaculum. Their tiny delicate bodies massed close together. I longed to study them closely to admire their perfect forms and their little feet and bright bellies, but as the day was cold, after a cursory peep, I hastily repacked them with little pieces of wood and moss, and hoped they were none the worse for my sudden intrusion into their peaceful slumbers.

★ ★ ★

A small pond provides an astonishing environment for a wealth of life, a diverse community that pulsates with activity. Our smallest amphibian, the palmate newt, is another miniature delight found in abundance in the Humphreys' garden, and in many of Ardnamurchan's freshwater pools. They lay their eggs singly and carefully wrap them in plant material in the water, folding a leaf over to protect it from predators. It depends on the weather as to how soon the tiny newt tadpole, an eft, will hatch out. During mild spells this may take place in as little as a fortnight.

In summer iridescent dragonflies flit over the water surface, in particular one of Britain's largest, the easy to recognise golden-ringed, its yellow-and-black-striped body busily working back and forth. It is one of the most common in the area and may put in a dramatic appearance almost anywhere at any time when the sun is out in summer. Then there are the vibrant turquoise common blue damselflies, dainty and elegant, that dance over the bleeding bogs, a splash of fluorescent glitterati in a sea of reds.

Dragonflies and damselflies belong to an insect group known as Odonata, meaning tooth-jawed, more commonly known

simply as 'dragonflies'. They are totally harmless, neither bite nor sting and pose no threat to us in any way. How I wish I could say the same for us, for we continue to be an enormous threat to them. Yet far away from the perils of pesticides, artificial fertilisers and insecticides, where the peninsula's acidic bog pools and secretive hill burns remain unadulterated by humans, many important species abound. Some favour slow-flowing fresh water, whilst others prefer the warm standing peaty pools associated with bog and heath. Dragonflies may be primitive but they are the acrobats of the insect world, aerobatic, agile and adept at extraordinary feats of manoeuvrability. Watching them closely leaves me awestruck. Aside from their visual allure and undisputed enchantment, theirs is a complex and fascinating life cycle.

The common names of some that may be found in Ardnamurchan in the right conditions, including the two already mentioned, add further to the intrigue: keeled skimmer, azure hawker, brilliant emerald, black darter, common darter, emerald damselfly, large red damselfly, common hawker, four-spotted chaser, and the damselfly I love best of all, the beautiful demoiselle. Who could resist creatures with such names?

Walking through the hills following a small burn through Glendrian to the sea to the east of Sanna, the peninsula's best known beach, can reveal an astonishing array of dragonflies during fine summer conditions. Whilst the last part of the walk is often tricky, glutinous with its deep peaty plunge holes that suck and pull and threaten to engulf, it's worth the effort of extra circumnavigation simply for the flashes of brilliance that dazzle and intoxicate as they put in continual appearances. No bog is ever simply a bog, for these are its secret jewels: turquoise, emerald, ruby, yellow-amber and gold. Bog treasure that in many parts of Scotland is swiftly diminishing. Dragonflies are highly vulnerable and should be valued as never before to ensure we

protect pristine habitat where they can thrive. Ardnamurchan remains a stronghold for many important species.

★ ★ ★

Achateny on a still June afternoon, and finally after a week of rain and wind, and days dominated by semolina grey and midge clouds, the sun has appeared. All is forgiven. It's warm, even beginning to veer towards hot, and an elderly couple are swimming far out in the sandy bay. I'm tempted but first have a paddle up to the waist accompanied by frolicking collies that charge through the water yapping with glee, spraying me in their excitement. Now soaked, it's time to go for it. The dogs swim too, heads held high above the water, paddling furiously, suddenly aware they are out of their depth. They always come far too close to me, circling with their sharp, extended claws catching my arms and leaving red scratches. Our swim is shortlived for in my opinion it's still cold. I think I am getting soft but it's enough to bring on that fabulous afterglow, the tingling sensation and enlivening effect of swimming in the sea.

We cross the drystone dyke to the further side of the beach, the dogs racing on the sand, shaking off beads of salt water in halos. The blackie tups are grazing on the opposite side of the burn. They look up, bodachs* bespectacled by their gnarled horns; one has had part of his trimmed to stop it growing into his face and causing damage. Seeing we are of no immediate concern, their heads all go down again, intent on eating. Wily old devils!

The collies are slinking low, eyeing up the prospects of a neat little round-up to show off their skills. I grumble to them to stay close and, rather struggling burdened with half my clothes,

*Frequently used Gaelic word for old man.

camera bag and binoculars, nearly measure my length as annoyingly they cross in front of me to come to heel. I growl at them.

Yellow flag iris is in full flower and fringes the shoreline in a pelmet of flamboyant yellow and green, campion adds its red-pink highlights, and a snipe jinks up out of the salt marsh, giving its two-note call as it disappears over the field. A small group of greylag geese are sunning themselves by a stinking brackish pool, their gossip filling the afternoon. I find a quiet spot to sit to doze by the burn, my feet dangling into deep, dark water where, as my eyes grow accustomed, I can see tiny orange-spotted trout.

The dogs are flat out, bodies stretched idly in full extension, already warm from the sun. There is indeed real heat in it today. I have not been here long when an iridescent damselfly appears. It plays low over the water and lands on a reed about a foot from me. The sun catches its metallic sheen, turquoise wings and an emerald, or is it a turquoise, body? Its colours seem to be changing as the light hits it. It looks glassy, its hues electrifying. Then it takes off again and begins to perform an extraordinary water ballet, flitting fast and erratic back and forth over the dark stage beneath. Now it appears to be more emerald than turquoise, and I can see dark patches on its wing filaments. I dare not move, for it is utterly beautiful, turquoise and emerald, yes, both colours. I needn't worry because it then comes close to my face and lands on my nose for a second, and then instead chooses my foot, where it stays for at least a minute. Then it is airborne and the dance begins once more, as a second perfect damselfly appears from nowhere. The pair waltz together over the pool and I can now see that this new arrival is different, perhaps a little less brilliant in colour, a softer green. It is a pair of aptly named, beautiful demoiselles. What a name, what a damselfly! Beautiful demoiselle. The female lands on the same reed that he first chose, whilst once more he lands on me, this time on my bare arm, perhaps enjoying its saltiness. It's as if I am being kissed

by an unearthly being. And then he is gone, and she is in the air again and they are waltzing together in a complex dance that mesmerises me.

A dipper, dapper with its white dicky shirtfront calls and flies past in a rush. As if I have not already been treated to a glorious display, there is more to come. Act two and a new male beautiful demoiselle appears on the scene. He flies low over the water, almost as if about to dive in, but appears to be holding himself millimetres above its surface, hovering, showing off his ability for total flight control. Precise perfection on the wing. The two males start another chase and the female lands back on the chosen reed beside me quivering, her long, elegant body now revealed as the brightest emerald green, shimmering like newly spun shot silk. I have lost track of the two males and no longer know which was here first, for they fly so fast and so elegantly, and look identical, two water sprites. And watching them brings that familiar lump to my throat. Then one appears again and this time lands on my leg.

The dogs are snoring in the sun, snapping occasionally at passing flies, oblivious to the world in which I am lost. The other male has vanished and the female rises again from her reed and takes to the air. The male lifts off from his perch on me and joins her, and they link together head to tail, forming an oval shape over the water, a brief glimpse of the mating wheel as she accepts his advances. They fly united for some moments but soon disappear over the bank, leaving me breathless with a memory of their ethereal water ballet romance, witnessed on a still afternoon by the Achateny burn running down to the sea in Ardnamurchan.

Walking the plank

Hedgehogs have always come to the Humphreys' garden, though their visits may be sporadic. They are quite common throughout the area's oak woodlands, though even on this predominantly single-track road, often come to grief. As the climate in Ardnamurchan tends to be mild, they usually emerge from hibernation in mid March. Hedgehog fights are often picked up on the cameras and may be highly amusing. One fight in particular involved two furious hedgehogs rolling around, pushing each other about like Sumo wrestlers. The more aggressive one actually managed to shove the other around like a football, using its body to rudely manoeuvre and bully. As the victim was expertly rolled about the lawn, its erect spines acted as a brush. When the battle was over and the victor had departed for a

well-earned snack, the loser was so wrapped in leaves stuck to its prickles that it was almost unrecognisable.

The peculiar hedgehog trait of self-anointing has been recorded several times on various cameras. On one occasion there was a dead toad close by and Les and Chris wondered if it could have sparked off this behaviour. Having spent much of my life working closely with injured and orphaned hedgehogs, I have always been fascinated by self-anointing. It's a bizarre trait that we still do not fully understand. I rather like the idea that even though it is a common occurrence and I frequently see it in my wild hedgehog patients, there are still things relating to natural history that keep us intrigued and guessing, and for which there are no definitive answers. We will never know it all – and thank goodness for that. There have always been a great many theories on the subject.

Self-anointing involves a hedgehog turning around in a twisted fashion, covering the spines on its back with frothy brown saliva. This is no mean feat, given the shape of a hedgehog. Even tiny hedgehoglets in the nest will at times self-anoint. Usually when one starts, they all quickly perform exactly the same ritual. It was once believed that any hedgehog doing this had contracted rabies, and was actually going mad. It was even believed that in this case it might be dangerous and would turn on the onlooker, giving them a fatal bite. Incidentally, this has never happened. It was also thought that perhaps the animal was covering itself with toxins to deter predators. However, as few other animals can crack in through the tough spines of a hedgehog to eat its soft body parts, with the exception of the badger (some become hedgehog specialists), and the occasional fox, this theory seems unlikely too. In orphaned or injured hedgehogs kept in captivity, it may simply be triggered when the animal comes into contact with something unusual: shoe leather, salty hands, strong aromas such as garlic, and often a cigarette stub discarded on the grass,

or indeed a smoker's hand. These can be enough to trigger a self-anointing frenzy.

I have had tiny orphans with their eyes tight shut brought to me when a nest has been disturbed and perhaps the mother killed. On one occasion the person who brought them to me said that first she heard the high-pitched peeping sound and thought it was a baby bird in trouble, and when she found the disturbed nest of tiny hedgehogs in a heap of leaves and branches, all of them were behaving in a strange fashion. 'They were plastering themselves in spittle – it was rather repulsive, it looked as if they were going mad,' she told me in a worried voice – and then added, 'Do you think they will live?' They had simply been self-anointing, and another theory is that in this case they do it to help keep predators away and therefore there must be something in the saliva that acts as a deterrent. Even this is unverified and only a suggestion. It is something that has proved mystifying for a very long time.

Other theories on the behaviour suggest that it may be sexual – but that would not explain why tiny babies do it too. It is indeed a mystery, but one that makes the ancient hedgehog, a mammal that has altered little in thousands of years, all the more alluring. Sadly, hedgehog numbers across the UK have plummeted in recent years and it is estimated that now only around a million survive. Loss of habitat, increased industrialisation and more and more traffic are thought to be the main factors, and doubtless also toxic pesticides and slug pellets.

Les and Chris certainly do their bit for hedgehogs. And like me they love and nurture them with a passion. They often over-winter those that are too small to hibernate. They keep them in luxurious conditions – five star, no less – in their stable, and release them in spring. Ideally a young hedgehog should reach 600 grams in weight if it is to survive the winter. It needs to lay

down enough brown fat so that it can sleep for longer periods in hibernation, and must be able to survive during that time with no food.

After the long level boardwalk plank across the lawn to the feed table was installed for old Sam, one intrepid little hedgehog started wandering along it to have a meal at the study window. It quickly adapted to the marten food – hedgehogs are omnivorous too and consume a wide range of nourishment that in the wild will include fruits and berries in season, vast numbers of earthworms and other invertebrates, birds' eggs and on occasion fledglings. They have also been seen in some places feasting on carrion. To begin with the martens were none too keen on the hedgehog and it was noted that they were extremely wary. The kits found it alarming and always stayed well clear. All the adult martens gave it a very wide berth too. The hedgehog remained oblivious, noisily munching for about ten minutes every night before it trundled back across the plank to the lawn. After a while kits, being equally as inquisitive as their parents, edged closer and closer. As they became a little braver they gradually stretched out a rather tentative paw to pat at the hedgehog. However, it was swiftly withdrawn again as it came into contact with the sharp spines. When a hedgehog feels threatened or in danger it will immediately erect its prickles. This unwanted attention from the martens was more than enough to make the hedgehog roll up tight, but it wasn't long before both hedgehog and martens learnt to tolerate one another, and from then on all fed amicably side by side and never took any notice. However, one night when the hedgehog arrived, there were already five martens on the board and they seemed to be munching all the food. This was too much for the greedy hedgehog to bear so it puffed itself up, drew its spines up taut and then muscled into the middle of the five surprised martens, and simply helped itself to the food. Other hedgehogs have tried to get up the boardwalk plank with

less success. Many misjudge its width and instead plummet to the ground. But as they are tenacious where food is concerned, they will continue to try despite more falls.

Though they tolerate the martens, hedgehogs seem very intolerant of one another and some have learnt to roll opponents straight down the lawn like croquet balls, sending them directly over the edge of the wall onto the gravel below. There are never any ill effects, except perhaps a great deal of sound as they huff and puff at one another in their displeasure. Sometimes both hedgehogs will end up rolling off the wall if the stronger of the two pugilists has perhaps put a little too much weight behind its final push. Seeing this action on the Humphreys' cameras always makes me think of *Alice's Adventures in Wonderland*, by Lewis Carroll. Alice finds herself party to an extraordinary game of croquet with the Queen of Hearts. They use live flamingos as mallets, and live hedgehogs as croquet balls. The hedgehogs continually fight with one another between shots, and then scamper off before the next shot can be taken. In the wild, fights between hedgehogs frequently occur, though with such armoury damage is minimal.

One night when the badger was feeding on the board a hedgehog came up behind him and tried to find a way to get past his large bulk. The badger ignored this and continued to eat, but when he turned to go he inadvertently knocked the hedgehog backwards off the plank with his ample rump. It was rather a case of a taste of your own medicine, and the hedgehog now on the ground could be heard to snort and hiss in its annoyance.

Cuckoos and golden eagles

The cuckoo has awoken me early and I lie in my bed at Ockle hypnotised by its calls. It started before 4 a.m. and as I listen to the rhythmic rush of the burn below the cottage, a second bird answers. The pair engage in verbal ping-pong, two players batting skilfully back and forth, their unmistakable onomatopoeic calls instilling terror into meadow pipits, willow warblers, dunnocks, reed warblers and other small songsters. Yesterday I watched a cuckoo perched on a birch stump, its wings outstretched, its long tail fanned upwards. It was being violently mobbed by a host of campaigning tweeters. These potential cuckoo hosts have no love for it but despite their visible annoyance, the mobbing does nothing to deter the brilliantly adapted cuckoo from sneaking in to plant an egg in their immaculate little nests. A hen cuckoo

will usually choose the same host every year. Nature has given her the power to adapt her egg's coloration so that it matches those already in the host bird's nest. Once a meadow pipit specialist, she will tend to stay with this species, whilst a cuckoo that chooses a willow warbler, for example, will always lay her egg in that particular species of bird's nest. The cuckoo is our only avian brood parasite, and its extraordinary behaviour has baffled and intrigued naturalists and birders for centuries.

The cuckoo is indeed a fascinating quirk of natural history. It returns from its long African migration to the UK towards the end of April, though it may be later, or even a little earlier in various different parts of the country. People love cuckoos, and its arrival date has always been the subject of conjecture and competition: who will hear it first? Records are sent in to various national newspapers, and the bird is still surrounded by myth and folklore in some parts of the country. In recent years there has been a worrying decline thought to be due to climate change, habitat loss globally and a lack of suitable food on their arrival back in the UK due to our increasingly wet, cold springs. In this case it is a deficit of one of the cuckoo's main prey items, hairy caterpillars, which are now hatching out a little later in the season. Though the cuckoo is a chancer, it will never come to a bird table. Compared to many other species, we therefore seem impotent to help.

However, Ardnamurchan currently remains a stronghold. On one of my scrambles down the beautiful steep burn, Allt Choire Mhuillinn, I watched a pair of fraught willow warblers struggling to keep pace with the voracious demands of a goliath of a baby perched on a fence post. The cuckoo chick, its fat feathery body speckled in tones of grey barred with auburn, was the epitome of gluttony. Its bill gaped wide, flashing an angry red-orange as it constantly begged, its need and greed eternal whilst the obliging warblers ferried insects in relays. The willow warblers have a

long migration, similar to that of the cuckoo, and now a gutsy foster child cunningly foisted upon them by the Machiavellian cuckoo, dominating these tiny birds. It's a trick that works every time, and it loads an inordinate amount of strain onto the dutiful hosts. It seems their long aerial treks are doubly fraught when subjected to such demands on their arrival. No wonder the cuckoo is seen as a threat by small birds. Cuckoos only give their distinctive call for a little over six weeks, then it begins to dwindle to a hiccupping chortle and for the remainder of the year the bird will no longer emit its cuckoo-ing sound. That much the bird has in common with the red deer stag, whose impressive voice is only heard for around the same amount of time. Whilst the cuckoo enchants us in spring and early summer, the stag in the Highlands heralds the autumn.

The Allt Choire Mhuillinn, as it nears the sea below the Kilchoan road, is a paradise for spring migrants as well as wild flowers. Oaks and hazels cling to its steep banks, and there are places here where even the indiscriminate mouths of deer and sheep, cannot reach. Ivy hangs in curvaceous trails where tiny fern fronds and leafy filaments unfold, providing perfect nooks for breeding birds, secret nesting cavities in which to hopefully avoid the perils of cuckoo fostering. As the sun rises higher in the sky and before the leaf canopy closes in and the bracken stifles all in its wake, the burn's sun-speckled banks and dells become lavish with brilliant yellow celandines, the gentle faces of primroses and the delicate white flowers of wood anemones, wood sorrel, stitchwort and mouse ear. A smoky haze of bluebells carpets pasture close to the shore, and I will usually find the season's first early purple orchids. It is here too that an otter may often appear, bathing gleefully in the burn's clear fresh water. Buzzards mew as they ride the thermals cruising over the bank of oak trees, and common sandpipers call shrilly from rocks in the burn's bubbling heart, never still as they bob up and down as if on springs.

By the end of May the deer have at last shed their thick, tatty brown-grey coats, and transformed into the colour of a gleaming, burnished conker. The hinds are heavily pregnant, the stags in groups high on the hill avoiding the misery of battalions of assorted biting flies. Having shed their antlers in spring, new growth of the fastest mammalian tissue of all remains covered in velvet, and the boys seem tetchy, keen to avoid conflict and attention until the process is complete. At this stage in their development the burgeoning antler is vulnerable and easily damaged. Flies are attracted to the temporary bleeding mess on their new headgear, and buzz around annoyingly, driving the stags to distraction. They venture to the high tops, or lie low in the shade flicking heads defensively whilst cud chewing. Once the process is almost complete, they fray antlers against rocks and branches, frantic to be rid of the itching protective layer of velvet, often appearing with it hanging in strands like partially stripped wallpaper. Sometimes I have watched them picking up the discarded velvet to chew on it, for like their shed antlers, it provides vital minerals. The rest of the herd will benefit too.

A few calves have been born towards the end of May but most will make their appearance in June. From a distance the hills still seem bare, though bracken is now on the move, green flushes adorn burnsides, and close examination reveals carpets of wild thyme, its pungently delicious scent released by my boot-fall. Tiny rocky bog gardens are adorned with the yellows of tormentil and bird's foot trefoil, and the dark blue of milkwort. Fleshy roseroot clings to bare cliffs, and the brown cushions of thrift are transforming back to green and dotted with tiny pink buds that will soon open into tissue paper florets. Little freckled orchids of pink and white will also emerge, kept low to the ground due to the wind. Some parts of Ben Hiant are snowy with bog cotton, its white tufty flower heads swaying to the tune of breezes off the Sound of Mull.

The first time I found a newly born calf was on Ben Hiant, close to a sheltered knoll that I came to recognise as a favoured place for calving hinds. I stumbled accidentally on its perfect curled form. It lay all eyes and spots, motionless, merely blinking. I noticed the darkness of its huge pupils framed by long lashes, its long ears and aquiline head. It was secreted carefully amongst rushes and purple moor grass, its tan coat dappled with spots. As I looked down, it was as if the pale spots adorning its coat immaculately mirrored the swathes of cotton grass all around. I crept away in a hurry, desperate not to disturb it, knowing the hind would be nervously watching.

I had always wanted to hand-rear a red deer calf, but though over the years I found several in Ardnamurchan lying silently awaiting the return of their mothers, nothing would ever have made me take one away. It was many years later that a hind calf, less than a fortnight old, was brought to me to rear, having been found in a near-death state lying in a ditch plastered with ticks. She has proved to be one of the most rewarding of all the wild animals that I have reared, and unlike the others has stayed with us, living as part of the family with our small flock of sheep. Affectionate and overflowing with character, she continues to teach me so much of the ways of another mammal that left its imprint on me, with that initial calf found high on the side of Ben Hiant.

There are a few small populations of roe deer dotted around the peninsula too, though it is the red deer that dominate the area. I have seldom seen them on the open hill as I often do in other parts of Scotland, for here they seem to prefer the shelter of the woods. One small group that I watch favours the birch scrub around Swordle and Ockle. Their fawns are born a little earlier than the red deer calves. Some years there are twins. Whilst red deer seldom give birth to two offspring, roe deer frequently do, especially where there is good feeding. One summer at Ockle, a

doe with twins stayed around the scrub woodland and its thickets of bog myrtle on the seaward side of the road.

* * *

I have always been an early riser, and in spring and summer there is no better time to be abroad than at dawn. It is a time when nature reveals more and more of her private life. Cuckoos are early risers too. One morning at Ockle, after the cuckoo clock had gone off in what most people would consider to be the middle of the night, I wandered down the single-track road. A song thrush on the top of a newly greening birch trilled to serenade the sunrise, repeating his phrases over and over. Soon a melodic chorus of chaffinch, wren, robin, blackbird, dunnock, and willow warbler accompanied him. A hooded crow needed to put some work into its tuning efforts and was way off key. The sun rose over the sprawling forestry that runs up behind the farm, and on to Loch Mudle and Glenmore. The doe was exactly where I had seen her the night before, browsing, low rays of light embracing her back with a tinge of saffron. Through the binoculars I watched and then saw two little heads close to her. They were all quietly picking at emergent growth: wild rose, honeysuckle and bramble leaves, their legs hidden by bog myrtle, only heads and necks, big ears and darkly framed eyes visible – roe deer wear mascara and eyeliner, like foxes; their eyes are laden with allure. The doe too, like the red deer, had moulted into her golden summer coat.

Roe bucks differ from red deer stags and shed their antlers during the winter, so the period when they are in velvet is fly-free, and by spring the protective layer has been rubbed off, leaving a magnificent new set of antlers. I have always wondered why our only two native species of deer should differ in so many ways – roe deer also have delayed implantation, whereas red deer don't.

Behind the contentedly browsing trio, Rum and Eigg were awakening too, kicking off sheets of low cloud, and clearing their heads in readiness for a warm day. Midges are early risers and were whining at full throttle in a most tedious fashion. I watched the roe for a few minutes but soon the tiny fiends became intolerable. I needed to keep on the move. Reluctantly I left the deer and began to walk back towards the shore, where I hoped a breeze might send the midges back to their bog.

A skylark rose high above Dougie Cameron's fields where his ewes and lambs were quietly grazing. Many people refer to the skylark as a brown 'nondescript' bird but more has been written about the sweet magnificence of its song than probably any other British bird. On a personal note, I feel the skylark and blackbird far outstrip the famous nightingale when it comes to melodies. I stand and listen, so overpowered by this tiny bird's voice that I am temporarily oblivious to the mad swarms assaulting me from every direction. Skylarks bring hope and optimism, but they too are in serious decline in many parts of the country, particularly where there is industrial-scale farming.

There has been a pair of sea eagles around all week roosting in a clump of oak trees at the bottom of the fields. Dougie says that though they are here much of the time, he doesn't think they have ever taken any of his lambs, but he cannot say the same for foxes, and frequently tells me of the ewes and lambs he has lost to them. I have sometimes watched the sea eagles eating afterbirths, and like the golden eagles they quickly clear up any casualties. Carrion is important for so many species and, perhaps surprisingly, even song birds, including robins and blue tits, are not averse to taking advantage and will often pick at carcases, and also pluck hair, wool or feathers to line their own nests. Many birds relish the associated maggots and invertebrates that are working to recycle the dead.

I frequently see golden eagles at Ockle, and though in recent

years the increased number of sea eagles means the larger eagle has become the more common sight, it is the golden eagle that I will always associate with Ardnamurchan. Whilst there is nothing derogatory meant by my earlier comments that a sea eagle seems vulture-like, the same cannot be said for the golden eagle. The two species should not be compared. They are both extraordinarily beautiful, supremely adapted, and magnificent in their own ways, and seem to coexist, filling different niches as seen in Ardnamurchan, and on the neighbouring Isle of Mull, and other areas of the Highlands and Islands.

As a child I heard numerous tales about the golden eagle from the locals, and we saw one pair in particular with great regu-larity. My father had an elderly stalker friend who had retired to a cottage above Loch Sunart, at Strontian. He had a large collection of antlers and could relate a long story associated with each stag that had shed them. Best of all, he had a huge stuffed eagle with badly faded plumage, and odd overly vibrant glass eyes; she peered unblinkingly from out of the dark corner, filling me with macabre curiosity. She had flown into a wire and been found dead beneath. He also had an eagle's talon, a great lion-like claw, and I couldn't get over how big it was. He had kept a brooch belonging to his late wife. It was a pure white ptarmigan foot set with honey-coloured Cairngorm stones, and it too had a touch of the macabre. The old man was always dressed in immaculate tweed plus-fours, with a shirt with a turned collar, and a smart tie. He had myopic, rheumy eyes of intense blue, and like many countrymen who have spent their lives quartering steep ground and waiting in bogs in torrential rain, had become as creaky as a bed with burst springs. There was a brass spyglass by his armchair, and he would slowly get up and hobble over to the window, fix it on something on the loch below, and point it out to us – a seal, an otter or some whooper swans, and frequently 'a wee hill staggie'. He and Dad

had a rapport and they never drew breath, except to sup copious amounts of tea from a flowery teapot crazed with age, whilst I chomped my way through biscuits that had long lost their spark. Dad always said how much more he learnt about deer and their management from time spent in his friend's company. Stories poured forth like a burn in full spate, and once he realised how drawn I was to his dowdy-looking eagle sitting motionless and dusty in the corner of the room, he told me how clan chieftains once favoured eagle feathers to adorn their headgear, and that the feathers from the eagles of Loch Treig, east of Fort William, were supposedly superior. There were tales too about the varied prey eagles took, including foxes, marten cats and wildcats. And then on our last visit, for he died soon after, he opened a drawer that always seemed to regurgitate heaps of yellowed papers, and took out an eagle feather and gave it to me.

Later I learnt of a rather curious eagle-related incident that took place at Fascadale on the north coast, where the MacLeod family owned the wild salmon fishery. They were close friends and I had been invited to go out in the boat to bring in the salmon nets. I loved going to Fascadale as they had a large tele-scope in their sitting room fixed on the sea, and recorded whales, dolphins and basking sharks from their windows. They had a fascinating icehouse too, perched close to the headland, and sent all their healthy shining salmon away to clients packed in special boxes of dry ice. Mrs MacLeod was a keen gardener but had personal battles with the local sheep that pruned and ruined her determined efforts. She referred to them constantly as 'bloody sheep', and loathed them, though on her visits to us in Kilchoan, she was very polite about my pet blackface, Lulu. They had a woolly Scottie called Gus – a dog with attitude – who added to the attraction of my visits. Unlike many of his show-bred relations, Gus was a free spirit. He was always out and about on his own, covered in mud, and had burrs like hairpins sticking to

his dark coat. He certainly did not own a tartan jacket, and had never seen a set of clippers, and therefore did not sport the typical Scottie pelmet trim that I had seen on pampered members of his clan. Gus had apparently had a narrow escape . . .

I was over-excited because I had never been out salmon netting. The sea was benign, with only a gentle swell, as we puttered out around Fascadale point. I loved watching the nets coming in bulging with fish. The salmon were different in appearance from the lythe and saithe I had seen when I had been fishing with an elderly friend from Kilchoan. Their silver scales shone like immaculate glittering chainmail. I remember being told not to touch the nets as they were pulled in, because they might have jellyfish tentacles stuck to them. And of course I did, and was promptly stung. The men were wearing thick waterproof gloves. We also collected lobster creels, and I watched as they were pulled in dripping with water, and hanging with shells and weed shining in attachments, and a few crabs larger than I had ever seen before waving fat intimidating claws. My jellyfish stings hurt like hell but I was trying hard not to cry, especially as I had been told in no uncertain terms not to touch the nets. The boat swayed and rolled as the men moved around, working quickly to gather the harvest, and as I knelt to peer over the side my wellies filled with seawater from a pool in the bottom of the boat.

When we came ashore and they had hauled the heavy boat up on the shingle, there was Gus waiting for us. His tail wagging took my mind off the burning on my hands. After tea we took him for a walk along the headland. He raced ahead full of his usual exuberance. It was then that I heard the story of his brush with death. The MacLeods had been out walking when suddenly an eagle came over the rise, and within seconds – before anyone had a chance to think – made directly towards Gus. With an effortless glide, it grabbed hold of him in its extended talons and lifted him right off the ground. Everyone yelled, and the

startled bird immediately dropped him unscathed. Gus was a very solid wee dog, very portly around the girth, and must have been fairly heavy. The eagle vanished as fast as it had appeared and they wondered if they had imagined it. It was highly unusual and no one was sure why the bird had been so brave, coming so close to people on that particular day. Gus was unharmed and lived on, enjoying his life of freedom with no further incidents. I remained fascinated by the story. I have never heard of a golden eagle going for a dog since, but cats may end up as a repast.

There is a place that I visit when I am in Ardnamurchan, a place rather like my otter spots where I can *almost* guarantee a golden eagle sighting, with a little patience. Often the first view is of a shape against the skyline, a silhouette that perhaps might be simply a piece of rock. Then, with binoculars, the outline of a resting eagle is revealed. Perhaps a second bird is picked out on the cliff face, perched close by. Underneath, in the rocky overhangs, kestrels frequent a dripping black crag. Once our commonest bird of prey, the kestrel, like many other species, has plummeted in number in areas of intensive agriculture, and the buzzard has overtaken it as our commonest bird of prey, simply because it is far more adaptable. I used to have injured and orphaned kestrels handed to me on a regular basis, but now probably will not even average one a year. I miss them, for the kestrel is a delightful little falcon, a vole specialist, and hovers high above the ground with its long wings outstretched before it tumbles elegantly to Earth. They may fail many times but I watch them in this remote and airy spot, rising triumphant, and returning to a rock ledge to devour their catches.

Then a dark shadow may pass over the boulder field; one of the eagles has left its perch and is quartering the ground. It may fly low or high, but when it is not against the skyline, its camouflage is surprising and often it is harder to keep track of

its progress as it crosses the open hill. The great broad wings are outstretched with seldom a beat, for the eagle is king of the wind, in harmony with thermals and up-draughts, using them to save valuable energy whilst travelling in some of the harshest terrain. When they ride the rocky ridge above I may first see the pair as silhouettes gliding across the horizon before they rise ever upward and become dots in the airspace.

I was out on the hill here with one of the stalkers during the hind shooting season when we witnessed two eagles harrying a weak deer calf over and over again, clutching its bucking back end with outstretched talons, until eventually it was driven to its neck-breaking death on the rocky scree far below. In January and February on sharp clear days when the sky is aquamarine and the sea a matching blue, a pair of eagles can be seen in court-ship display talon-grappling and tumbling in locked embrace, sky dancing and renewing their pair bond. The golden eagle will always remain, for me, the true symbol of Ardnamurchan's wildness.

20

On the track of the marten

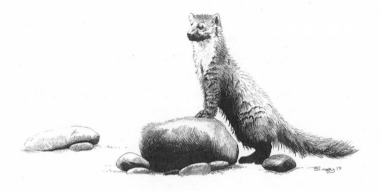

With regard to wildlife, there are some people who not only leave their mark, but also become important mentors with their extensive knowledge, experience and anecdotes. As a naturalist I find it invaluable to talk to others, for it is the only way to continue learning. During each of my visits to Les and Chris, they are always adamant that the information they record is purely unscientific and therefore may be inaccurate, while I have conversely always felt that this is not the case and that their findings have a valuable part to play in our growing knowledge of the pine marten. However, I was extremely keen to speak to my close friend and wildlife mentor, Rob Coope, who has been working with martens from a scientific angle for many years. I felt it important to find out if two totally different approaches

to marten study converged. First I must tell you a little about Rob's family and the world in which he grew up, for it has a bearing on some of the natural history musings in this chapter, and indeed in this book.

Rob's father, the late Professor Russell Coope, was a Quaternary scientist who achieved international acclaim for his work on climate change using fossil beetles. He was an expert on the Pleistocene era, and his extraordinary discoveries challenged many previously held theories. He was a lecturer of world renown, and his numerous talks, given latterly to local groups, always proved highly entertaining – none more so than the occasion when he brought a pair of his breeding polecats into a packed church hall, and with boy-like devilment, revelled in making a few squeamish audience members wince at their pungent aroma.

Russell's study was akin to Merlin's den. It contained a cornucopia of treasure, including chests of drawers bulging with fossils and hundreds of minute beetle remains, and he could tell you exactly which beetle had come from where, and exactly what this revealed about life on Earth at that time. The walls were covered with wildlife art, and overflowing shelves of books and journals, falconry equipment, skulls and skeletons, as well as home-cured animal pelts, teeth, claws, and other intriguing artefacts relating to a man whose life revolved around the natural world. And he had a mammoth tusk that had been found in a remote bog in the depths of England. Russell had an affinity with birds of prey, and was also instrumental in saving the rare polecat from extinction in parts of England and Wales. His love and fascination for all members of the mustelid clan included a wide knowledge of the pine marten.

Together with his long-suffering retired-GP wife, Beryl, and their four children, he had hand-reared just about every British species imaginable, including martens. The family had also

constructed an artificial osprey nest on their ground at Loch Tummel, and had a successful breeding pair in residence. The surrounding area had a vibrant population of martens that had quickly commandeered nest boxes erected on trees for golden eye duck and goosanders. Russell's son Rob had a pet red deer hind, Morvern. If the back door was left open she occasionally tried to get into the kitchen, where she caused mayhem. 'Shut the door quickly,' Russell might yell as he grabbed hold of the collar of his unruly, over-exuberant dog, 'or else Morvern will get stuck in the passage.' And then he would grin from ear to ear, adding mischievously, 'Though it is rather fun.' Eventually Morvern had to be kept in a paddock because the gardening neighbours were unenamoured of her horticultural prowess. Rob had witnessed Morvern's birth and subsequent unusual abandonment, and had hand-reared her. She remained an adored family member for nearly twenty-five years.

Russell hated red tape with a vengeance. If a species needed help to recover its dwindling population, then why spend years and waste vast amounts of cash on pointless surveys and reviews? Simply get on with it. To that end, most fascinating of all, he had a collection of pure-bred wildcats, some of which had their origins in remote parts of the northwest Highlands during an era when wildcats were frequently persecuted. With his extensive knowledge of the problems faced by the wildcat, increasing concerns over their hybridisation with feral cats, habitat loss, disturbance and persecution, Russell kept a few strong breeding pairs whilst secretly releasing their offspring in suitable places. His efforts proved remarkably successful, but make no mistake, his cats were never pets and always retained their aggressive, defensive wild traits. This was something of which he was exceedingly proud. Some of the remaining wildcats in captivity, which now form part of an official breeding programme, originate from Russell Coope's stock. Though it is not acknowledged, it is

perhaps largely due to his silent efforts that there remains a small gene pool of wildcat blood that is as pure as can be found today. He always reckoned that Ardnamurchan had some of the finest wildcats of all, and quite a few of his kittens were released there.

This, then, formed the backdrop for Rob's colourful upbringing, and his own subsequent life working in the field of natural history, at first conducting research, and latterly working as Environment Manager in the Forestry Commission. Frustrated by not being able to spend enough time in the forests and woods, Rob became an independent consultant in 2015, freeing up more opportunity to indulge in hands-on natural history instead of ever-increasing paperwork. He is someone whose opinion and knowledge I greatly respect, and in particular his experience of pine martens is encyclopaedic. There was therefore no one better qualified in Scotland to talk to on the subject. I was also fascinated to learn more about his marten radio-tracking work.

Rob's first glimpse of a pine marten was during a visit to a forest at Dolgellau in mid Wales. 'I was about twelve at the time, and I saw what I thought was a fox cub sitting confidently on a branch swishing its tail, and I rushed home to tell my father, who said it was a pine marten. Thereafter I felt I had discovered a mythical animal, and I became besotted.' During the early 1970s there were very few martens left and they were occasionally killed in England and Wales, as in Scotland. There was a haplotype – a marten that was unique to the small remnant populations – however after the 1970s this type had completely died out and even legal protection did not help.

During numerous holidays to Dumfries and Galloway, and Lairg in Sutherland, the Coope family never saw martens. Then in 1976, during a visit to Fort Augustus, they found an abundance of marten scats in the woods there, proving that there was obviously a healthy population recolonising a large area north of the Great Glen, and spreading out into the Highlands.

Whilst studying for a degree in zoology, Rob chose to do his dissertation on the contents of pine marten scats. It was widely believed that martens lived on a diet broadly based on rowanberries and red squirrels, yet he remained unconvinced and set to work at Inchnacardoch, a large area of forestry south of Fort Augustus. 'I thought of great titles for my study findings, including *Down in the Forest Something Turd*. I loved the detective work involved in my new venture having always been fascinated by owl pellets and badger dung pits. I trained my first dog to hunt for marten scats. However, if I wasn't fast enough when he found them, he swiftly consumed them.'

Evidence-based information is important and he realised that a marten's diet was not what the local experts said it was, and with regard to red squirrels, though martens were blamed for killing them, no one appeared to have actually seen them in pursuit. The forest at Inchnacardoch had healthy populations of both red squirrels and martens, but in the many hundreds of scats that Rob analysed he only once found squirrel remains. Even then there was nothing to prove whether the marten had found the squirrel as carrion, or if it was actually responsible for its death. Over many years of working with martens Rob has become convinced that they are no threat to red squirrels. He astutely claims that the two species have evolved together, lived together, and have an ecological harmony that might be far more complex than we can understand. In southern Europe pine martens hardly ever touch red squirrels, but in the forests of Finland they form quite an important part of the diet, although even there they have never exterminated squirrels, except perhaps in fragmented habitat where there is only a tiny isolated population. In most red squirrel strongholds in Scotland pine martens are therefore not a threat. Domestic and feral cats are far more likely to have a serious effect on a red squirrel population, and goshawks relish them too. 'Nature is always a little unstable. If we were to believe

that nature can and should be left to its own devices, particularly in the case of the relationship between these two mammals, then a balance would be struck,' Rob has said.

In 1980 the Forestry Commission caught eight martens from Inchnacardoch and translocated them to Dumfries and Galloway to help re-establish a population there. During the trapping process Rob was thrilled to view the martens up close, and was able to assist with the venture unofficially. They used venison as bait because once fixed to the cage trap it has to be tugged at by a marten, and this vigorous action ensures that the trap door springs. With softer baits, an animal can grab part of it, and rush out again before the trap goes off. A few other mammals were caught, including a Jack Russell terrier and hedgehogs, but never a wildcat.

Rob continued to survey the martens at Inchnacardoch and found that rabbits seldom featured on the menu. However, he was surprised to find that the field vole, not a woodland animal, formed the staple part of the marten diet, together with beetles. Though martens live in woods, in Scotland they also visit fields and grassy areas, whereas in Europe this is less likely to be the case. As well as numerous beetles Rob also found other insects and the remains of small birds, and wild bee and wasp grubs. As previously mentioned, martens are very partial to honeycomb and the larvae it contains, though it must be a daunting prospect for so small an animal to venture into a seething mass of irate wasps.

Despite all the previous theories, it was blatant that the martens' diet was extremely varied, had seasonality to it, and that they exploit any relatively digestible food, from a dead deer to a tiny beetle. Due to his father's extraordinary knowledge of beetles and their habits, they noted that all the ones the martens had consumed lived on the ground or forest floor, and were not found in trees. One particular scat contained over 300 small chafers that thrive in the roots of tussocky grass. Rob is also

sure that earthworms feature in the diet, but because they have few indigestible parts other than tiny bristles known as chaetae, it is possible that they were under-represented in the droppings that he analysed. Many areas of the Highlands where martens thrive are not particularly good habitat for earthworms, as they have thin soils. Martens do, however, eat slow worms, lizards and frogs, as the Humphreys have also noted.

Rob ran trials on a captive marten he had in order to find out how many days it took for it to digest its food. Using non-toxic shavings from children's coloured wax crayons he added them to jam and was most surprised to find that they passed through within about an hour or so. He was expecting it to be at least a day, possibly even longer. He found that fruit went through the system really quickly too. It is unusual to find a marten that weighs over two kilos. He was brought a very heavy animal that had been hit on the road. It had a grossly distended stomach, and inside was over half a kilo of rowanberries. Rob has found barley in scats, and as more people lure martens into their gardens, copious nuts and raisins are commonplace.

Recently Rob has been radio tracking in the forestry and oak woodland around his home in Duror of Appin, close to Ardnamurchan. His findings have dispelled many previously held theories on marten behaviour, and do indeed run parallel to those mentioned by Les and Chris, the most pertinent relating to the martens' diet, and also to the fact that contrary to old belief, this is not a solitary animal.

When he is trapping martens to fit them with radio-tracking collars, Rob prefers to use the cheapest jam and peanut butter rather than meat. Not only do the martens love it, it also eliminates the problems of attracting non-target species such as birds and hedgehogs. It is interesting to note that while Les and Chris have found that peanut butter tends to stick in a marten's throat, Rob has not. In Rob's opinion male martens are not so bright

and intelligent as the females and are therefore not as careful, making them far easier to catch. He thinks that perhaps they imagine they are tougher than they really are. When he has been using trail cameras he has recorded females suspiciously approaching the cage traps, then running away, whilst males almost run straight in.

In earlier studies, when he began to trap the martens in order to fit the collars, each had to be anaesthetised, but Rob felt it was stressful for them, with a slow recovery time. Being adept at handling wild animals, he quickly devised a far better method, and he and his wife Becky now work as an efficient team, fitting the collars without any anaesthetic. The whole operation is over in minutes. The marten is encouraged to leave the cage trap and climb into a sack. Inside, it feels relatively secure but perhaps more importantly, it can be handled through the hessian. Whilst Rob carefully holds the marten's head in one hand to stop it struggling and biting, and holds all four feet with the other, it is then relatively easy for Becky to fit the transmitter collar swiftly. The marten can be released with no apparent upset.

Like the findings from the Humphreys' records, Rob has clear evidence that martens do indeed socialise far more than was previously thought. He has had some problems with transmitters and when he re-traps a previously collared animal he has found that some collars have been badly chewed. Though martens are agile it's a physical impossibility for any animal to chew its own collar. All martens are thoroughly checked before release, and it has been noted that the chewed collar-wearer is in peak condition, with no bites or wounds that might indicate it has been involved in a fight with another marten. On the contrary, this points to the fact that the two have been interacting. In some cases the wire radio aerials have been chewed right through, and the collars are covered in tooth marks. This could only have happened during a non-aggressive mutual grooming session

between two animals. A pine marten specialist in Finland refers to this behaviour as 'martelism'.

Just as Les and Chris Humphreys have deduced, Rob's evidence proves that occasionally martens will indeed share a den, though sites may be highly individual – one animal he has been following chooses a new one nearly every day, whilst another female uses the same one for weeks. During spells of very cold, frosty, but sunny weather, another female uses a high tree because the sun hits it earlier in the day than most of the other dens in her favoured wood; it is obviously a warmer place to sleep. Males and females may use the same den, and that too was not supposed to happen. 'It most certainly does. To me the evidence from the chewed collars is conclusive, and I have been really pleased to see this as an observation as I always felt that this type of socialising, including mutual grooming was highly likely.' Rob tells me.

The radio collars weigh less than 5 per cent of the animals' own weight. One of Rob's problems is ensuring they are tight enough, but yet not too tight, and this is difficult as males' necks alter during the season. The battery lasts for around twelve months but when it's all working properly it provides an extraordinary insight into the movement of each individual.

He has one collar that has been transmitting for over a year. He suspects that the marten may now be dead as he was old when first caught, and he has been in the same spot for a couple of months. However, it's not a good place for Rob to check and perhaps there is a simpler reason for this apparent immobility. As the site is close to a large source of rubbish the marten may have found a safe location to lie up, and plenty of food by raiding the bins. He could be living there, eating and sleeping, simply too old now to hunt, no longer territorial, merely surviving.

From conversations with Rob, I have learnt that it is clear that whilst martens are territorial, they do indeed socialise more than we thought, and also have home ranges. The home range is the

furthest they might venture, whilst the territory is the area that they defend. A male in Argyllshire habitat, close to the sea where there is a mixture of native and non-native woodland, and permanent pasture, could easily have a home range that covers ten square kilometres, overlapping that of several females, whereas a female's home range will be around three square kilometres, but there is a huge variation within this. Females tend not to like each other too much, but in amongst these ranges there will also be a group of teenagers that all interact. This is exactly parallel to the records from the garden at Glenmore, proving once again the importance of what is currently referred to as citizen science.

One of the exciting things is that we are still learning all the time – we now understand far more about a marten's diet and what they need from a habitat and for den sites. Though they are indeed powerful, compared to other predators such as foxes and badgers they are fragile. Rob is sure this is why they are such skilled climbers. This ability undoubtedly helps them to escape from trouble. He doesn't feel that their ability to climb trees is to enable them to hunt, as his scat analysis has proved that almost all their prey is found on the ground. However, if a marten finds unguarded nestlings or a fat pigeon squab, this is an opportunist that will take full advantage.

Martens are extremely clever. Pied flycatcher projects in the Argyll oak woods with nest boxes put up to encourage this lovely migrant, have led to martens quickly learning how to push their paws in to grab the chicks. Boxes have since been modified to make them as safe as possible. With regard to some types of nest box, it is important to remember that red squirrels may simply chew a hole and then take chicks straight out too, as will greater spotted woodpeckers. The point is that everything eats everything. It is all simply part of the natural cycle.

Rob believes that martens do, however, have an impact on grey squirrels. In Ireland a study was carried out on populations

of both red and grey squirrels and pine martens. It was found that where there was an increasing population of martens there was a decreasing population of grey squirrels. It is important to note that this is in an area where there is no problem with the fatal squirrel pox carried by greys, but lethal to reds. For a red squirrel population if there is a pox outbreak, then it is a disaster. There will be no survivors. In this case it is not the pine marten that is the red squirrel's problem. In the examples Rob has mentioned where there was no conflict between pine martens and red squirrels, the areas were completely free of squirrel pox.

There is even little evidence of the martens eating grey squirrels, though there has been one account from the Trossachs. The Irish survey found few examples either. As red squirrels are so much lighter, and can run out onto smaller branches, they have a better chance of getting away if chased. Rob's guess is that the reason that grey squirrel numbers fall where there are pine martens might not be related to simple predation, and could be far more basic. The red squirrel and the pine marten have a long-standing relationship, having coexisted for centuries, whereas there is no such relationship with the introduced non-native grey. It seems likely therefore that the two have not yet evolved to coexist. 'Perhaps the grey lives in a landscape of fear where there are martens and cannot cope as well as the red,' adds Rob.

He remains convinced that the pine marten/red squirrel/grey squirrel relationship is one of the really good examples of where, if you let nature work, it is very good at looking after itself. When we begin to interfere we frequently disrupt the balance. He puts forward the suggestion that it would be fascinating to know what might have happened had the pine marten been widespread at the time when the grey squirrel first appeared in this country, and wonders if perhaps we might have not had a problem with the continual spread of the grey, and only had red squirrels present now.

Unfortunately, there is still a great deal of mythology surrounding the pine marten, for example there are those that believe it has a lethal barb in its tail, and sadly there are still plenty of people willing to cull it. The more Rob watches martens, studies their habitat requirements and follows their behaviour in the forest, the more he realises that the evidence suggests that in reality these beautiful animals are a fascinating and valuable part of Britain's wildlife. His scientific findings are indeed remarkably similar to those recorded in a totally different way by Les and Chris Humphreys. Both widely differing approaches have a valid part to play in our growing knowledge of this attractive mustelid. One thing is indisputable: both the Humphreys and Rob Coope share an unsurpassed passion for the pine marten.

The storm

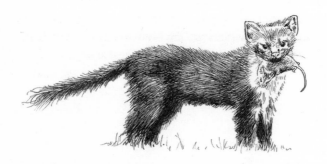

Ockle in February, and after two days of settled calm, the wind has risen during the small hours and screams like a soul possessed. It comes in great tenacious gusts banging and thrashing; the slates on the cottage roof are doing the Highland fling. The rain is of the horizontal variety and is accompanied by hail, then there is a momentary lull before the elements muster energy and roar ever louder. A tuneless percussion of metallic crashes indicates that the bin has broken free of its moorings by the gate. Perhaps it will be buffeted into the burn below, and bob out to sea on its journey towards the Isle of Muck. When we lived in Kilchoan, my mother optimistically put up a greenhouse. It vanished in the first determined gale, smashed into fragments last seen heading in the direction of the Isle of Coll.

I can hear the three dogs whining nervously in the kitchen below, scrabbling at the door. The extractor fan is emitting a frightening shriek as the wind lacerates it with icy blasts and sends it whirring in a panic. Earlier the electricity went off with a loud crack; there is thunder and lightning too. I rush down to rescue the dogs. My torch sends pools of eerie white light onto the steep staircase; the wind is a beast at the door desperate to barge in, driving the rain beneath to soak the carpet, leaving a dark, spreading stain like a dog's piddle patch. The collies explode forth, nearly knocking me over as they gallop straight up to the bedroom. They pile together in a heap, cowering close to my bed. They hate thunder, and fireworks too, as well as gales as rampant as this one. The forecast is for a storm force eleven. I lie wide awake. Another ear-splitting crack and Molly, followed instantly by her mother and daughter, catapults onto the bed in terror. It's going to be a long night. Soon I am pushed to the bed's furthest extremities, whilst three snoring dogs luxuriously stretch out. Despite the gale's determined racket, they are no longer fretting. But I am, because they have stolen the duvet.

When we lived here we sometimes went to Ardnamurchan Point to experience the true severity of the elements, though there are many gales that are so savage that it's not even wise to drive. Britain's most westerly mainland point, a great sea-girt buttress sticking out into the Atlantic, is the place to witness the terrifying magnificence and sheer wrath of nature. Its 36-metre lighthouse, engineered by Alan Stevenson, has protected shipping in this wind-crazed seascape since 1849, and stands aloft flashing its life-saving warnings, sometimes sending out ghostly blasts from its foghorn, situated in a rock cleft on the prow of the cliff. When I was a child, one of the lighthouse keepers, aptly named Mr Mainland, told me that during severe storms the entire light tower swayed ominously back and forth. Later, when visiting other remote rocky outposts, I heard similar stories from

the keepers there. It must have taken great fortitude to work in such conditions, terrifying to be inside, wholly reliant on the mercy of the elements.

If it is tempestuous elsewhere around the peninsula, then at the point the force of the Atlantic will be a thousand-fold more aggressive. It becomes brutal, foaming in a mighty malevolent maelstrom with waves as high as skyscrapers that smash violently against the vertiginous headland, loading the sky with spume and spray, salt-blasting the landscape for miles inland. Tawny marram tussocks take flight, together with fronds of weed, leaves in whirl-winds, and copious amounts of shore detritus washed here from afar, dumped by boats. The sea is a gigantic washing-up bowl tossing enormous sandy soapsuds high into the atmosphere. The gulls seem oblivious, almost as if they are enjoying it. However, during the nesting season the severity of the weather can lead to catastrophic devastation for all cliff-nesting seabirds around our coasts, including kittiwakes, shags, guillemots, razorbills and ful-mars, and they will fail spectacularly and rear no young. Puffins too may be affected, as chunks of the headland are eroded and the ground housing their burrows tumbles into the sea.

By morning the gale has died to a murmur; this one has been shortlived. Whilst I am feeling rough, the collies are ecstatic with energy. The dustbin hangs in the hedge, and the birds' peanut feeders have fled, but below is a tousled pine marten eating greedily, perhaps clearing up spilt peanuts. It has been coming most nights for mice I have caught in the airing cupboard, but I don't normally see it, only its fresh scat. It stays for but a few moments and then does a vanishing trick. We wander through the wood and down to the shore at Inverockle to view the storm's destruction. There are hanging clouds over the islands, and herring gulls suspended over the cliff top. The little oak wood has been browbeaten into submission, and several elderly trees lie with their feet in the air. A robin appears, cocks his

head, and sings a brief lament from a fallen bough, then drops
to the newly exposed earth and returns to its perch with a prize.
The soil is littered with lichen.

Since my last visit the ocean has rearranged the raised pebble
beach and it has gained several new levels. Inverockle is in a con-
stant state of flux as burn and sea, like two house-proud women,
constantly move the furniture to a new position. The sea has
left a fresh mark, a winter high, close to the cliff edge where
mountains of creamy shaving foam bounce idly over the rocks.
The smoothly massaged stones are covered with heaps of weed,
and a scatter of pale driftwood, as well as the ever-present plastic
horrors – fish boxes, a headless doll, and numerous bottles and
bags – a barrel, pipes and sacks associated with the increasing
number of fish farms. At the far end of the shore, hemmed in by
the bay's black cliff, a large log is wedged into rocks. Bleached
and worn smooth, it has been in the sea for a long time. The
complex vermiculation of ship's beetle has carved out a fretwork
of intricate patterns. And on it hang bizarre crustaceans with
long tentacle-like stalks encased in beautiful hard bluish-white
shell, edged with delicate apricot, and fringed by weirdly waving
leggy parts. Usually only found far out to sea clinging to flotsam,
goose barnacles are sometimes a prize found after severe gales. I
have only seen these peculiarly prehensile protrusions a handful
of times, and on every occasion relish closer examination. On
the Isle of Barra, I found some attached to a green wine bottle.

The attractive little barnacle goose is a dapper black and
white bird that comes to Britain from its Arctic tundra breeding
grounds to spend the winter in vast flocks at wildlife reserves
such as Caerlaverock on the Solway Firth, and the island of Islay,
with smaller flocks dotted about in other parts of the Hebrides
too. In ancient bird books, some dating as far back as 1185, it was
said that these pied geese had their origins in goose barnacles.
Fantastical tales proliferated and eyewitnesses even claimed that

they had seen the long necks of the young birds hanging down out of the shells attached to floating timbers brought in by the sea. Once the geese had disappeared in spring it was imagined that they found the floating wood far out in the ocean and flew up on to it. One unnamed expert wrote: 'When the firwood masts or planks of ships have rotted in the sea, then a kind of fungus breaks out upon them: in which after a time the plain form of birds may be seen, and these become clothed in feathers, and eventually come to life and fly away as Barnacle geese.'

Despite the fact that no one actually saw this phenomenon, it was widely believed. Now peering down on the newly arrived filter-feeding crustaceans, even with my vivid imagination I am still unable to transform them into any goose-like form. They are curious. As well as bringing perilous and destructive conditions as they strip bare, storms reveal some of the many mysteries from far out in the deep ocean.

It is said that if you want to live in Ardnamurchan, you must first experience a winter there. If you are still upright and upbeat by the time spring appears, then you are partially equipped to make the move. A certain degree of self-containment and self-sufficiency help to ease what can be an exceedingly long drawn-out and desolate affair, certainly for some people enough to bring on a serious attack of melancholia. Indeed, my poor father struggled with it. Sometimes it can be dark for weeks at a time, and frequently is. So what is it about this place that keeps me hefted to it like an old blackface ewe? I was not born here but yet it lures me more than any other part of the country. It is the place I regard as home, a place that grabs me by the throat and moves me more than anywhere else I have ever been, a place where my heart is anchored. Is it because I have come to know a certain part of it so well?

When I drive onto the peninsula off the Corran Ferry I am overwhelmed with childlike excitement. Even now all these

years later as I travel slowly around the dozens of sharp bends and switchbacks, I catch a glimpse of yet another extraordinary view, a fleeting vignette of its fauna and flora. This peninsula is achingly beautiful in all weathers. It is Ardnamurchan that has fed the fire for my passion for the natural world; it is not only the magnificence of its herds of red deer, its eagles, otters, pine martens and seals, it is also its innermost secrets.

It is the fleeting, low sprint of a sparrowhawk as it bolts over the top of a tousle of gorse bushes latticed with dewy spiders' webs. It is the discovery of a hidden glade deep in an oak wood where every tree has a window box overflowing with polypody ferns and wood anemones. It is the discovery of the waxy whiteness of tall grass-of-Parnassus flowers with their delicate green veins shining from out of the sourest of bogs. It is an astonishing close-up examination of a furry emperor moth dressed in khaki and cream stripes, with bulls-eye spots and red splodges, clinging to a wind-blown rush. It is lying on my tummy on a cliff top on a frosty afternoon watching a dozen great northern divers painted by the sun's last glowing apricot rays. Or standing on a headland fringed by marram grasses at Sanna, watching a pod of common dolphins joyously performing oceanic circus tricks. It is walking through its suppurating glens and resting on tumbling stones – the ruins of a remote shieling – and it is feeling the melancholy and desolation amongst the scattered ruins of Bourblaige. It is struggling against the wind to stand on Ben Hiant's craggy summit to inhale a 360-degree panorama of islands and mountains, whilst watching ravens tumbling off its dizzying cliffs to frolic in the air currents. It is the dark form of a wind-honed birch curvaceous with witches' brooms fringing a distant shore. It is the knowledge that chaffinches here, as elsewhere around the country, have regional accents. It is turning over rocks in pools, relishing the bounty of these perfect vibrant marine gardens, and the fabulous creatures therein till my hands

are numb, my boots full of icy sea water, and I have forgotten the time and am frantic with hunger. It is being holed-up in the cottage at Ockle with the collies in rain and sleet, having time to think and simply 'be' – true peace – and then battling against the horizontal elements on a brisk walk to the shore. This is why my heart lies in this visceral land and seascape, and always will. And it is also the edginess that accompanies experiencing such wild beauty, knowing the importance of safeguarding the natural environment at all costs, whilst being filled with concern for its very fragility. And it is also, all too frequently, doubting that we are indeed capable guardians.

Fifty years ago, from time to time, we saw wildcats. Now it is nearly a decade since I had a definite sighting in Ardnamurchan, and it seems worryingly likely that they have faded from view even here, in one of their recognised strongholds, as in most of their previous haunts. However, fifty years ago pine martens were exceedingly rare, and now we must celebrate that they are back firmly where they belong. Though 2018 marks the hundredth anniversary of the sea eagle's extinction in Scotland, we must celebrate its dramatic comeback too. Elsewhere in Scotland we have succeeded in easing the safe return of the glorious red kite and osprey, and more recently the beaver. If we can successfully bring back these vital elements to a healthy ecosystem, then, as the late Russell Coope would advocate, we must strive to rectify the situation for the wildcat too, though this presents greater, but as he believed, not insurmountable, challenges.

As a naturalist it becomes increasingly hard to remain posi-tive, with habitat destruction and loss of species occurring on a stomach-churning scale, but it is vital not to lose hope and the will to enlighten and persuade others of the basic fact that without nature we are nothing. Things are indeed beginning to change, albeit slowly. We are becoming more aware of the damage we are doing, and more aware of the urgency to plant species-rich

hedgerows, and native woodland linking habitat and providing vital corridors for our wildlife to exist in safety. Understanding the pine marten and the wealth of other creatures that frequent Scotland, whilst understanding that we need predators just as we need prey, is also of paramount importance.

Thanks to the precious time I have spent in the company of Les and Chris Humphreys at Glenmore, I have indeed come to know the pine marten a little better, but there is so much more to discover. Learning about the natural world is a continual journey and every day reveals more surprises. If we are ever to stand a chance of restoring our struggling ecosystems to once more flourish with life then we must join forces and work tirelessly to respect and replenish. Nature can indeed heal the gaping rifts we have made, but only if we let nature have her head.

Family Tree

Freda and Graham

2004	1 kit	
2005	Horseshoe, Ringpull and Zippy	
2006	Buttons and Bows	
2007	Craig, Clive and Chloe	
2008	Dan	
2009	no kits	Last saw Graham 12/12/2009
2010	Fred and Frodo	

Freda and Sam/Taff

2011	Gus and Glen	First saw Sam and Taff 02/2010
2012	no kits	Last saw Freda 28/01/2012

Kiera and Sam/Taff

2013	Hettie and Hamish	First saw Kiera 09/03/2012
2014	K1 and K2	Last saw Sam 05/06/2014
2015	Josh	
2015	Hettie had 2 kits, Jack and Jill	Last saw Taff 27/05/2015

Kiera and Towy
Hettie and ?

2016	Kiera had 2 kits, Kim and Kevin	
2017	Hettie had no kits	

Hettie and Towy

	2 kits, Leo and Letty	Last saw Kiera 18/05/2017

Pine marten duration of stay

Name	First Seen	Last Seen	Duration
Graham	Resident 2004	12/12/09	5 years 3 months
Freda	Resident 2004	28/01/12	7 years 4 months
Nelson	Resident 2004	05/06/06	1 year 8 months
Horseshoe	13/06/05	25/01/06	7 months
Ringpull	13/06/05	16/04/06	10 months
Zippy	13/06/05	19/04/07	1 year 10 months
Buttons	05/06/06	10/03/09	2 years 9 months
Bows	05/06/06	01/07/06	1 month
Craig	28/05/07	20/06/10	3 years 1month
Clive	28/05/07	07/04/10	2 years 11 months (returned 2013 for 2 months)
Chloe	28/05/07	27/04/09	1 year 11 months
Dan	31/05/08	07/04/10	1 year 11 months
Sam	02/2010	05/06/14	4 years 4 months

Taff	02/2010	27/05/15	5 years 3 months
Fred	07/06/10	19/09/10	3 months
Frodo	07/06/10	08/10/10	4 months
Gus	06/07/11	16/01/17	5 years 6 months
Glen	06/07/11	30/08/11	7 weeks
Kiera	09/03/12	18/05/17	5 years 2 months
Towy	04/11/12	Still coming	
Hettie	03/06/13	Still coming	
Hamish	03/06/13	26/01/14	7 months
K1	14/05/14	14/07/16	2 years 2 months
K2	14/05/14	22/03/17	2 years 10 months
Jack	21/05/15	02/08/15	10 weeks
Jill	21/05/15	02/08/15	10 weeks
Josh	04/06/15	12/05/17	1 year 11 months
Kim	04/06/16	Still coming	
Kevin	04/06/16	05/09/16	3 months
Leo & Letty	24/05/17	Still coming	